Banksy

building castles in the sky

an unauthorized exhibition

First published in English in the United States of America in 2022 by

Rizzoli Electa
A Division of Rizzoli International Publications, Inc.
300 Park Avenue South
New York, NY 10010
www.rizzoliusa.com

in co-edition with

Sagep Editori
Piazza San Matteo 14/4
16123 Genova (Italy)
www.sagep.it

Copyright © 2022 MetaMorfosi NY Inc.
11 Broadway, Suite 865 New York, NY 10004
www.metamorfosiny.com

Graphic design and layout by Sagep Editori, Genova
Printed by Grafiche G7 Sas, Savignone (Genova)

For Rizzoli Electa
Publisher: Charles Miers
Associate Publisher: Margaret
Rennolds Chace
Editor: Klaus Kirschbaum
Assistant Editor: Meredith
Johnson
Managing Editor: Lynn Scrabis

For Sagep Editori
Editorial director:
Alessandro Avanzino
Account: Paola Ciocca Bianchi
Graphics and layout: Barbara
Ottonello, Matteo Pagano;
Fabrizio Fazzari
Editor: Giorgio Dellacasa

ISBN: 978-0-8478-7293-0
Library of Congress Catalog Control Number: 2022937889

2022 2023 2024 2025 / 10 9 8 7 6 5 4 3 2 1

Printed in Italy

Visit us online:
Facebook.com/RizzoliNewYork
Twitter: @Rizzoli_Books
Instagram.com/RizzoliBooks
Pinterest.com/RizzoliBooks
Youtube.com/user/RizzoliNY
Issuu.com/Rizzoli

Banksy

building castles in the sky

an unauthorized exhibition

New York

By Stefano Antonelli and Gianluca Marziani

With contributions by Paola Refice, Pietro Folena, Francesca Iannelli, Chiara Canali, and Acoris Andipa

Ban Ksy

an unauthorized exhibition

building
castles
in the
sky

Exhibition Schedule:
**250 Bowery
New York, NY
5.28.2022-12.31.2022**

MetaMorfosi NY

Pietro Folena
President

Vittorio Faustini
General Manager

Exhibitions Office
Chiara Barbapiccola *and*
Elisa Infantino,
Project managers
Guido Iodice
Giuliana La Verde

Press and Communication Office
Maria Grazia Filippi

Administrative Manager
Antonio Opromolla

Legal Advice
Andrea Catizone

Insurance
Rotas srl (Italy)

Transport
Montenovi, Rome (Italy)

Translations
Parole Sas

Exhibition graphic design
4DRG snc, Fiumicino (Italy)

New York Office
Sandro Paternò
Pasquale Maio

Paterno & Associates, PC

Exhibition and Catalogue
curated by
Stefano Antonelli
Gianluca Marziani

Catalogue designed and published by
Sagep Editori srl, Genoa (Italy)

Many thanks to Andipa Gallery, London

Contents

We are

longe

ourse

re no

er

elves

Gilles Deleuze and Felix Guattari, 1980

The exhibition we are presenting here is the latest, richest, and most well-documented production that our group has ever staged on the artist known as Banksy. For our exhibition space, we chose 250 Bowery in New York, which formerly housed the International Center of Photography, right in the heart of one of Manhattan's most interesting artistic communities, where so many urban artists have left their mark. *Banksy Building Castles in the Sky* is a scholarly and cultural project that, thanks to the curators Stefano Antonelli and Gianluca Marziani, makes a significant contribution toward critical interpretation of the artist from Bristol.

The exhibition is strictly non-commercial and pursues analytical and cultural purposes.

After the COVID-19 pandemic, and with great confidence in the importance and resiliency of culture, our group— created in Rome in 2009—is pleased, with this exhibition, to inaugurate MetaMorfosi NY. In the coming years, we will bring more exhibition projects across the Atlantic for display throughout the Americas. We are known in the world for our work relating to the most important figures in Italian art: Michelangelo, Leonardo, Raphael, Botticelli, Caravaggio, Canaletto, Canova, De Chirico, and others. Some of these exhibitions were staged with great success in the United States. Several years ago, we opened our own department dealing with Street Art, which we treat with the same scientific and exhibition criteria we use for the major classical artists. At 250 Bowery, you will find Banksy on exhibit as if he were Raphael or Caravaggio. MetaMorfosi aims to realize only high-quality products.

We are honored to present this exhibition and this accompanying publication.

Pietro Folena and Vittorio Faustini
MetaMorfosi NY

Archetypes

The Time is Out of Joint

W. Shakespeare

Piero and Banksy: Between Art and the Market

Paola Refice

If it had been up to Vasari to create a biography of Banksy, he would have depicted an image of a unique character, unrivalled by his own teachers, the undisputed champion of the workshop in keeping with the well-known scheme of the lives of excellent artists like Giotto, or Michelangelo. He would have celebrated Banksy's independence and spirit of social-conscience, taking advantage, from his perspective, of that unfortunate lack of data that today, for us, the public, circumscribes his essence. After all, even Piero della

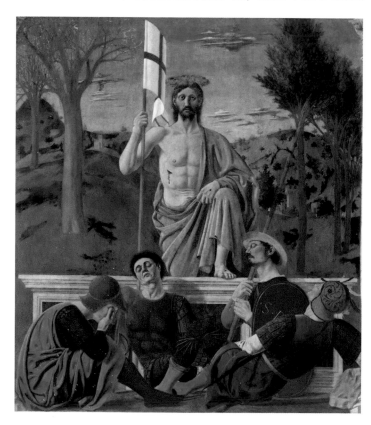

Piero della Francesca
Resurrection
about 1460
Mural painting
San Sepolcro, Museo Civico

Francesca is described by the Arezzo historian as an unknown talent, remarkably unmarried and childless, known by the legendary name of his mother, a native of Monterchi, to whom he would take the liberty of dedicating his *Madonna del Parto*.

As we take our distance from Vasari—and embrace a more contemporary art historical lens—we might wonder, as Giulio Carlo Argan would have done, whether the categories of genius and ingenuity can be applied to them to Piero and Banksy. In his famous Manual in the 1970s, Argan in fact defined Michelangelo a *genius*, and Leonardo *ingenious*: in our case, "ingenious" is certainly fitting for Piero, and "genius" for Banksy. But upon closer observation, each shows a perceptible tendency to encroach into the other's territory, with Banksy showing ingenuity in seeking the occasion and the gesture, just as Piero can generate meanings that transcend his immediate boundaries.

Both of them—Piero and Banksy—use walls, with some isolated exceptions: the former with the technique of the fresco, for structures that can last many, many times longer than the lifetimes of those who commissioned them; the latter by articulating the images quickly, not letting himself be tempted by the eternal. Both embody a profound and—to the extent that can be grasped of it—sincerely anti-opportunist ethic. Both are secular artists with a powerful sense of the sacred. Both attract the gaze. They do not decorate, they do not describe, but they proclaim authoritative statements.

Both are capable of envisioning a great tenderness. Both engage with the market: Piero always late with his deliveries, obsessed with deadlines and threatened penalties; Piero with prosperous finances, who seems to look after his own business, but likes to delegate agreements and collections to his direct kin; and Banksy, a true phenomenon triumphing in the art market precisely when he appears to be taking his distance from it. Some decades ago, we would have defined them as a couple of snobs. Now, in the fulness of time, we are forced, perhaps against their wishes, to acknowledge in both of them a precious, ineffable vein of nobility.

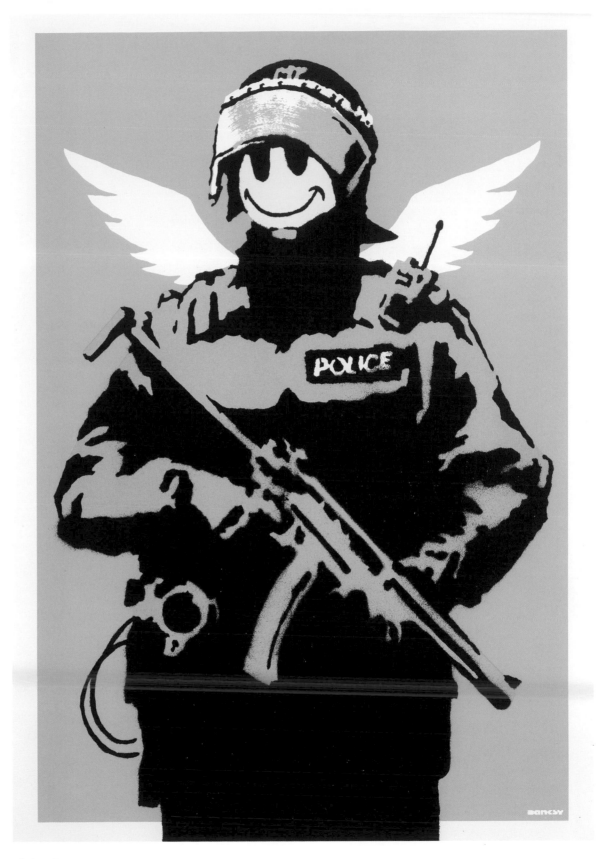

Flying Copper
2003
Silkscreen print

15

Capit
alist
Rea
lism

The Banksy Function

Stefano Antonelli

Banksy is a ghost: not the kind of ghost that haunts a castle or cemetery, but more of a glitch—someone called to mind when we speak of a *phantom limb* (mind) or a *ghost town* (pandemic). Something that we experience in real life, but that we *should not have experienced*. Ghosts are something weird, something disturbing.

The properties of a ghost are also the properties of Banksy: the incorporeal presence, an appearance that can only be explained as a manifestation of the supernatural. His works are traces, and his images a descriptive *compendium* of an existential condition.

Coming to us from Ancient Greek, by way of the Latin *phantasma*, our word "phantom" expresses the idea of appearing or of showing in reality something that does not originate from within our reality but from the exterior, from an *outside*.

Banksy represents himself as a ghost: dark and unknowable. One need only to observe the mural *Tourist Information* in the London suburb of Tower Hamlets, or *Hoodie with knife and wound like a rose* which he produced for the Cans Festival. In the latter work, a white figure emerges against a black, gloomy background, sitting on the ground, strangely posed, and brandishing a knife. The figure looks at us from the dark depths of his hood, without our being allowed to draw his gaze. You will say: how do you know he's looking at us if we can't see his gaze? Look at the work and you will tell me whether or not I am right. It looks like the figure is looking right at us. It feels *weird*.

These are codes of anxiety and of a whole set of unsettling feelings: ambiguous, fuzzy, unclear sensations that the British graffiti artist deploys when depicting and being depicted. In 1919, Freud dedicated a famous essay, *Das Unheimliche*, to these sensory registers. The German

Unheimliche is normally translated as "uncanny" but also as "creepy" and, more recently, as "bewildering." However, it also refers to what is unfamiliar, unhomely, *what should have remained hidden and secret, and that instead emerged*. Banksy defined his Los Angeles show in 2002 as an exhibition of "Graffiti, lies, and deviousness"—but with "deviousness" being understood as ominous, even menacing.

Banksy's ghostly nature places a weird condition before us: he acts both as the presence of something that is not there, and as the absence of something that should be there. Is this what Banksy is for us? And for art? Something that should have stayed hidden, but instead emerged? He maintains that art should comfort the disturbed and disturb the comfortable, and with this epigram he guides artistic action toward a single horizon: unease, a perception of the real and not a concept of transcendence or the ideal.

The media and the public wonder whether what Banksy does is art or marketing, and this is because viewers perceive these two categories as separate concepts, belonging to different domains. Banksy's action is never clearcut, but always ambiguous; the order that first separated appears to be replaced by an order that allows boundaries to be blurred, thus instituting territories that unify, at the perceptive level, such constitutively (morally) separate practices as art and marketing. When we observe Banksy's work, more than establishing *what it is*, it appears necessary to pass by way of *what it seems*. It seems to be art, but it also seems to be marketing. With Banksy, nothing is clear. Nothing is transparent, and what is there is often contradictory.

In 2004, he spelled it out clearly in his book *Wall and Piece*: "Copyright is for losers", a noble gesture; then, on the website of Pest Control Office Ltd. (the limited company with which he administers his work and his output) we find: "*Saying 'Banksy wrote copyright is for losers in his book' doesn't give you free rein to misrepresent the artist and commit fraud*," thus affording a glimpse of little-concealed threat.

The road that leads to Banksy is paved with contradictions and paradoxes—the first of which being the one by which he appears as a protest artist. Banksy is not protesting against anything, but is showing us the world as he sees

it, from outside our reality that guaranteed him the practice of anonymity, from the dark abyss of his hoodie, and he pretends without protesting: "[...] *call for things... like peace and justice and freedom*" he wrote in his 2004 book.

The world as Banksy sees it is a world of children playing with a bullet-proof vest, a rat-infested world, a world governed by monkeys, where assault helicopters with pink ribbons on their rotors spray bullets at you, where the dog grows fed up with listening to "his master's voice" and points a bazooka at the old gramophone, where the Madonna poisons her son, and where little girls hug bombs and let love go.

The sensation one has when engaging with Banksy is that of not knowing what to feel; so we smile, although in reality we do not exactly know what type of phenomenon we are dealing with. And this is precisely why it is crucial to study an artist like him, to understand the scope of what he does as an agent foretelling broader changes, because his work bears artistic witness to an increasingly pervasive feeling enveloping us all: this dismay, and even this fear before a reality that can no longer be decoded using the keys handed down to us from the past.

The way Banksy successfully presents us the consequences of this reality might look like irony, but it is not. It is sarcasm, and the two terms are not to be confused. Irony is a defusing mechanism, while sarcasm comes from the Greek *sarkàzein*, which means "cutting flesh."

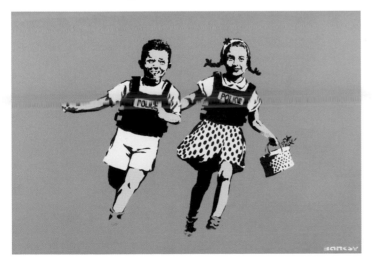

Jack & Jill (Police Kids)
2005
Silkscreen print

The fact of the matter is that, on a daily basis, we are dealing with a *weird world*; we are crushed by anxiety, depression, phobias, social ineptitude, where a certain form of economics appears to have percolated into the lexicon of feelings and knowledge; one need only consider the concept of "emotional *investment*" that we evoke when describing a love affair, or of a student's falling behind in school as a debtor might fall behind in paying their creditors.

In this way, everything connected to our destiny, everything apocalyptic and, in the final analysis, *dystopian*, that the so-called genre subcultures—science fiction, horror, pulp fiction, mondo-film, etc. etc.—told us in the twentieth century, takes place in reality.

9/11 is a "disaster movie" dystopia; Donald Trump being President of the United States is a political-science-fiction dystopia; the attack on Capitol Hill is dystopian; the pandemic is dystopian; Elon Musk wanting to move to Mars and to land missiles like a 1950s television show is dystopian; the climate apocalypse is dystopian; the extinction of the human race is dystopian; the metaverse is dystopian; information is dystopian (fake news). War is perhaps the least dystopian event that Banksy deals with; but its reasons are intrinsically dystopian. At times, dystopia has a surprising way of infiltrating reality: Ukrainian president Volodymyr Zelensky became Head of State by acting in the lead role in a television series in which he played the president of Ukraine. Television fiction was transposed into the real, thus constituting a "real" party that then went on to win the election and is now leading an army fighting against aggression by a nuclear superpower. It seems like the plot of a political-science-fiction dystopian series for young people. The problem here is that reality goes beyond imagination—and in fact annihilates it, abolishes it. The problem is that we do not know whether the "real" party is the fictional one or the one that won the elections; both are probably "real," and this is dystopian to an even higher degree.

Dystopia appears as the bearing frequency upon which the contemporariness of our world-building is modulated; it is an anti-utopia, an interpretative force that opposes utopia, driving it back, to the outside. Think about it: where are the utopias? In the future, of course. They are visions we project into the future, and that (at times), from the future, we cause to act upon the present in order that that

future might come to pass. Utopias are the alternatives capable of *discontinuing* the real. The difference in itself, Deleuze and Guattari would say, is what allows us to transcend reality, to think about alterity, to renew our gaze on the world as it comes into being.

There is no trace of utopia in Banksy's work. You will find tons of utopias in all contemporary creation, but not here. His work is activated by the *principle of reality*, or by the rhizomatic level of absolute immanence—it is a matter of perspective. It is not *futurizing* desire; it is not a dream to be realized; it is not a *future to come* that interests the graffiti artist from Bristol, but the *future "as" becoming*. Not transcendence but immanence. In realism, nothing truly is. Everything is becoming.

The images he produces are not symbolic representations, but the *true* image of the real. Although the technique for elaborating the images is in fact that of situationist *détournement*, the outcome is not that of *diverted* images, which *mean other than the self*; to the contrary, they are *true* image—images of the real. When Banksy shows us a monkey wearing the sign "*laugh now, but one day we'll be in charge*," he is not producing a trope; rather, he has *Planet of the Apes* in mind (the back of his banknote dedicated to Lady D bears the portrait of Charles Darwin, and not Thomas Hobbes). The painting of the chimpanzees sitting in British Parliament is not a metaphor, but the world where monkeys *truly* dominate and we, perhaps, are extinct, or reduced to a servile state by another species.

The tripartite division that Lacan imposes on human experience contemplates three orders: the symbolic, the imaginary, and the real. Western art (expression) operated for centuries on the symbolic order (those who operate on symbols operate on power), and then, in modernity, preferred to shift its weight to the imaginary, leaving the symbolic increasingly to practical interest.

But in the neo-modern, the question has settled on the real. For the reasons described earlier, the real has overcome the fantastic. We still see the symbolic and the imaginary in action, but at the hand of industry (hyperindustry), while a certain contemporary art has preferred to modelize rather than to represent, essentially moving to Pluto, allowing the imaginary of entire generations to be colonized by the culture industry (hyperindustry).

Bernard Stiegler maintains that "*our epoch is characterized by the seizure of the symbolic by industrial technology, where aesthetics has become both theatre and weapon in an economic war. This has resulted in a 'symbolic misery' where conditioning substitutes for experience.*" The *symbolic*

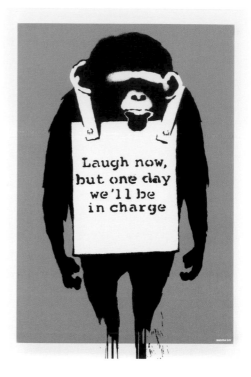

Laugh Now
2003
Silkscreen print

misery the French philosopher speaks of is that caused by art's withdrawal from the territory of representation, and in the final analysis from politics, leaving the field open for strategic marketing, for economic interest, for the profit principle. The Banksian operation consists of recovering the representation by starting from strategic marketing, which is to say from the large advertising billboard that was at the end of the street where he grew up, wondering about the only image that dominated his horizon, and literally reterritorializing its representation, bringing it to where the billboard was, and therefore into communication, and into the real.

The real in which he works projects a future where one can "realistically" live, "realistically" love, "realistically" wage war, and "realistically" make art, running the risk that, in the realistic world, *everything* is *weird*. This is a sensation that can only exist in the real, because it is this precise reality that disarticulates, placing us in that condition of bewilderment, of *unheimliche*.

But this is not a future; a *realistic* future is not a future. The future is, by its very nature, unrealistic; otherwise, it is forecasting, planning, at most, *upgrading*. By contrast, making art *realistically* in these conditions is not a bad idea at all, and it suddenly appears as the only possible art, the only *realistic* one.

Banksy's images are *weird, disconcerting, and sarcastic* because they are real.

But who stole the future from Banksy, casting him into the most inescapable realism? According to Mark Fisher, it was Margaret Thatcher. The British Prime Minister who governed from 1979 to 1990, which is to say the years when Banksy was formed as an artist, secured her power through a political programme summed up by a slogan: "there is no alternative"—a slogan so successful that, in Western liberalism, other European political groups adopted it. In essence, an entire Western leadership class agreed that there was no alternative. All right, then, but what was there no alternative to? To the economic system, to capitalism.

For Fisher, this is where the problem of the absence of the future—a problem that darkened the years of Banksy's training—got its start. As we have written, conceiving utopia means conceiving the alternative to the real; but by the same token, discovering there are no alternatives means discovering there are no more possible utopias—that is, the future can no longer act upon the present. The artist's images, then, recount the present that is folded upon itself, in a Baroque movement to be interrupted with an idea.

When there is no alternative, depression spreads. Unease spreads. Everything that seemed solid crumbles (in public relations) and then there is no longer any certainty. Truth becomes post-truth, and we are witnesses in the news of events that should be on Netflix.

The turn of the twenty-first century: this is the world that gave shape to the thinking that Banksy pours into his *Black Books*—small, self-produced philosophical publications that came out between 2001 and 2004: pages imbued with sarcastic realism, dissipation, frustration, and the first forms of these ideas. In it, one intuits that the lodestar of Banksy's creation will be mass marketing, the one that reaches the greatest possible public, because the situation is compromised and the public must be addressed. He says this and confirms

it several times in his 2010 film. The biggest possible public must be reached. If you are wondering why, it is simply because the conditions of possibility exist.

At the 2006 *Barely Legal* exhibition in Los Angeles, Banksy presented an elephant painted with a damask motif against a red background, just like the wallpaper and upholstery with which the artist furnished the room. The preview's attendants received a flyer that read:

"There's an elephant in the room. There's a problem we never talk about. The fact is that life isn't getting any fairer. 1.7 billion people have no access to clean drinking water. 20 billion people live below the poverty line. Every day hundreds of people are made to feel physically sick by morons at art shows telling them how bad the world is but never actually doing something about it. Anybody want a free glass of wine?"

Aside from Banksy's overestimation of the number of the planet's inhabitants (there are 8 billion of us; how can there be 20 billion people living below the poverty line?), the author speaks to the public of *physical pain*.

It is advertising that *truly* speaks to the public. Unease, and advertising of well-being, which instead produces more unease: although this type of spiral appears to offer life. It is not art that speaks to the public, but marketing. Banksy need only assume the *modus* of *graffiti writing* that operates precisely where advertising operates (urban public space), and use it to implement his plan to conquer the world that he describes in detail, as a *hyperstition*, in the small volume he called *Banging Your Head Against a Brick Wall*. It is an image that effectively recounts an entire generational condition as may be easily seen in Simon Reynolds's impassioned analyses.

Banksy often describes himself as frustrated, unloved, alone. Don't these sensations seem familiar? When he puts his screen print *Girl With Balloon* up for sale on picturesonwalls.com in 2004, he writes: *"This tender little fella, has an almost poignant message, Banksy was never his mother's favourite—and he was an only child."*

Returning to the scene of creation are the *mal de vivre,* the *taedium vitae,* the *spleen* fed by the usual questions, loneliness, frustration, depression, disorientation—only that

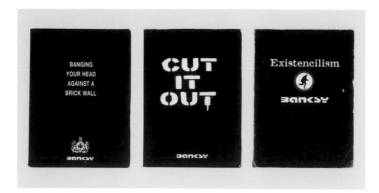

Black Books
2001-2004

this time around, they are immersed in a paradoxical framework. Loneliness is no longer loneliness, but paradoxical loneliness. Frustration is paradoxical, depression is paradoxical, and so on—as if a psychedelic multiplier had been added to unease. If you add that there is no longer an alternative, all we can do is pretend it's nothing, go mad, or disappear.

Banksy's realism has its origins in its unreality.

There is no alternative to capitalism, says Thatcher, and according to Fisher this idea is interiorized to the point that *"It's easier to imagine the end of the world than the end of capitalism"*—as if capitalism were a state of nature, as if limitlessness as a principle of human action were acceptable. And so now we find ourselves coming to terms with the end of the world. Reality is like that: it comes knocking at the door and threatens you with extinction. Realism is the discovery that reality does not need us, and that something outside is ready to sweep us away—the same *outside* that Banksy invites us to pursue with *Better Out Than In*. The artist's interpretative strength is not *of* capitalism, but *in* capitalism, and this is his principle of reality, his *true* image. From the darkness of the unknowable, of the unknown, of the unattainable, Banksy is either the unexplained starting from which everything must be explained, or he is not. The type of capitalist realism that Banksy interprets is speculative, in the true sense of the Latin *speculum*: a mirror. It is a realism that reflects itself, and the realism of the reflected act is what it consists of. This is why we will never experience Banksy but only the *Banksy function*, because we are not shown what that which exists consists of; we are only allowed to believe—in ghosts, of course.

Hyperartist: The Capital of Realism

Gianluca Marziani

The family relationship between Art and Realism is a Hamletic dilemma, but an athletic one, too. The *Device Society* updates the Shakespearian doubt with an approach saying "To be there or not to be there," thus removing every trace of moral atonement, limiting the metaphysical boundary to a video screen, and preferring the constant blast of the instant over the stormy lessons of history. The human terminals of the digital society, with their rites of gesticulation on *mobile devices*, drain Hamlet of any implication of judgment, preferring the tactical noise of having and of being there, without the ethical essence of being. And here, the dilemma becomes athletic: whoever realizes the Hamletic reversal leaps into the athletic field of urban gears, the new, secular church, where the artist finds his gymnasium of aesthetic militancy, a display in 3D format to direct operations that are antagonistic but also agonistic in the true sense of the word, embodying in cities the idea that the works are

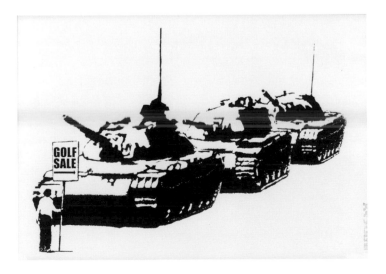

Golf Sale
2003
Silkscreen print

chemistry to be shared, and not only possessed by the individual.

Banksy's realism rewrites the archetype of the (super)realist artist, creating a *hyperartist* that integrates social apparatus with figurative codes, the high with the low, the exclusive with the inclusive, solid matter with the digital process, the old terms of the twentieth century with the parameters of the newly plausible. Integration takes place through a fact so obvious that it becomes unsurmountable for many—that is, the capacity for concrete speculation within realism, bestowing massive doses of status quo while the final alternative to epochal instability is practiced. Banksy's *sticky* mode attacks reality with an ironic frontal face, remaining muscular in the issues, but gentle in reaction; concrete and cynical in registering discomfort, but poetic and serious in dosing the selfishness of emergency. His operations resemble the militant texts of Mark Fisher, Nick Land, and Bernard Stiegler, a long, dialectic endowment that records social defeat and starts anew from the world's negative datum—from awareness of evil, from the (post)anarchic clash against the Capital's institutional façades. When everything goes wrong, it is better to just go shopping: a Banksian *mantra* that contains more morality than much false rhetoric, a hymn to joy amid the waves of a planet navigating its atavistic evils, in its soaking inflammations, in its dragging itself toward a destiny that has already been inscribed in the prologue. The artist has always dictated the strategies of telepathy, indicating on canvas the maps of a psychogeography of continuous destruction; for some time, in a geography of digital maps, the artist has been transforming into a hyperartist beyond pure clairvoyance: a new, evolved species that affects the summary of time with the clairvoyant measure of a still practicable space.

For Public Space

Pietro Folena

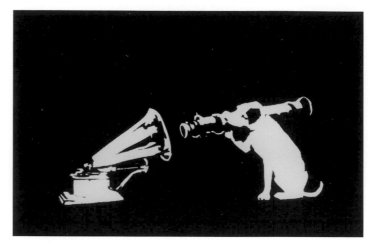

HMV (His Master Voice)
2003
Silkscreen print

It was 2011 when the sociologist Luciano Gallino published *Finanzcapitalismo. La civiltà del denaro in crisi*. The great Turinese intellectual attempted to coin the term "finanzcapitalismo" in order to recount the gigantic change taking place in world capitalism. Facebook had recently begun to assert itself, and corporate oligarchies building boundless power by appropriating individual data were starting to take shape. This trend only accelerated as the decade progressed. Gallino, who died in 2015, could read only some segments of it. Created with the objective of maximizing the value that could be extracted from the human and non-human being and from nature, *mega machines* have imperilled civilization and placed Planet Earth's future at risk. They have progressively emptied the liberal democracies and fostered autocratic and decisionist tendencies. They have caused an unprecedented global asymmetry between this *finanzcapitale* and labour, which has become broken up and precarious. They have globalized the market, but not social and human rights. They have triggered immense migrations towards the centers of power and the wealth they produce, only to cast them to the bottom of the sea or to the other side of a wall. They have dismantled or weakened—and at time subsumed altogether—health and social security systems overwhelmed by the era of the new pandemics: HIV since 1981; SARS in 2003, Ebola in 2006, swine flu in 2009, and then Covid-19. In their obtuseness, those who govern the wealthy countries did so under the illusion that they were living in the best of worlds. Having believed Francis Fukuyama's prophecy—later to be retracted by its own author—about the "end of history" after the fall of the USSR, they generated religious and then nationalistic fanaticisms, which were in turn the midwifes of terrorism, violence, and wars of devastation, culminating in the one utterly disturbing in its size and scope currently underway in Ukraine.

Everything, then, appears to demand a new way of thinking, a new human civilization, a questioning above all of the digital

mega-machines that "ungovern" the lives of billions of human beings. "Stay human" (as journalist Vittorio Arrigoni wrote before being kidnapped and murdered in Gaza) is much more than a moral invocation. It looks more like a program—unfortunately not appropriated by any large party or political movement in the Western countries.

This is where what Mark Fisher has called "capitalist realism" is born. "For most people under twenty," he writes in his pamphlet, "… the lack of alternatives to capitalism is no longer even an issue. Capitalism seamlessly occupies the horizons of the thinkable." This presents a clear, reverse symmetry with the notion of "socialist realism" or, better, *really existing socialism*. This young genius, who died by suicide in 2017, in his awareness of human fragility and of mental illness during these times, went on to write that "Really Existing Capitalism is marked by the same division which characterized Really Existing Socialism." As it was for the Soviet State system, private companies are presented as "socially responsible and caring;" however, like the large bureaucracies in Communist regimes, "they are actually corrupt, ruthless."

Until gaining greater inner individual consciousness, the world embraced the slogan that Margaret Thatcher coined in the early 1980s: "*there is no alternative*."

In this context, the explosion of Street Art outside the circuits of the museum system and the art market, alongside that in music born on the streets and reaching its peak with Manu Chao's "Clandestino" in the early 2000s, was an insurgency

of the greatest significance—an insurgency that with words, ideals, and even feelings filled the frightening void left by "elevated" politics, starting from the Left that was born to change society and the world, and was left managing this absence of alternatives.

January 2000 saw the publication of *No Logo*, the cultural and political manifesto by Canadian journalist Naomi Klein. During the previous month of November a large-scale, wholly new movement broke onto the world political and media scene in Seattle, bitterly and even violently protesting the Ministerial Conference of the World Trade Organization and the underlying logic that had inspired the new season of limitless, borderless market globalization. Some days earlier, on the European side of the Atlantic, the newspaper *La Repubblica* wrote that on 20 November 1999, Florence had seen the birth of "the third way of the global Lefts." Six world Heads of State or Government had met to celebrate a liberal reformism with an emphasis on globalization—precisely the opposite of what the multitudes in Seattle were about to protest. With Bill Clinton and Tony Blair leading the way, a not better defined "new economy" was upheld: one made of equality (psych!) and opportunity (for whom?). After ten days (Seattle) or a few months, when protests were spreading around the world, and when they roiled Genoa in the summer of 2001 (Florence's new world Left, in its Italian version, had lost the elections, delivering the country to the Right), Black Blocs lay waste to the city—and, in some dark hours for which justice has yet to be served, human rights were suspended and scores of young men and women were raped and tortured by law enforcement.

Klein's quoted text, alongside works by other authors—of the many, I would particularly emphasize such other women as Vandana Shiva and Arundhati Roy—became one of the most important inspirations of what was called the anti-globalization movement, alter-globalization (around a group of French intellectuals), the Global Justice Movement, or "new global." In her introduction to *No Logo*, the Canadian journalist wrote that it was an "attempt to express a position against the policy of multinationals." What is most significant about this text is actually its title. It is not the rehashing of the old anti-capitalist toolbox, but the proposal of a new, conceptual pairing in the era of mass consumerism: consumerism (formerly capital) *versus* civic duty (formerly labour). The emphasis is to be placed on brands. The bursting onto the scene of the large,

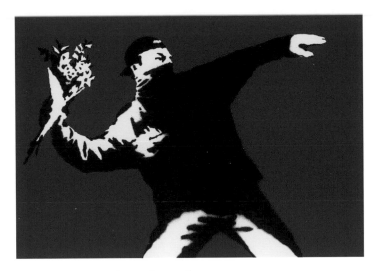

Love Is In The Air (Flower Thrower)
2003
Silkscreen print

global brands—which, as Klein bitterly denounces, have a supply chain of global exploitation (north/south, women, children, mass job insecurity, digital control) behind them—requires a new struggle. The enemy is the Logo—behind which lies the capitalism of data, the multinationals taking over the world and our lives—and therefore its vehicle of ideology, communications, and aesthetics: advertising. *No logo* thus becomes a brand against consumerist brands. In the Italy of the 1980s, we grew acquainted with the explosion of television advertising which—in the only case in Western democracies—became a political party affair in the 1990s. In the new millennium, the logos themselves are great signs of belonging, communities, and ideological systems. The case of Apple, before and after Steve Jobs, is actually sensational, as are the continuous evolutions of the new private entities—which I would call the *brandocracy*—that controls and dominates the planet, starting with Facebook, Google, Microsoft, Amazon, Ali Baba, and the list could go on. The parallel world thus comes into being, the *metaverse*, controlled by these new global powers (and we worried about Russian oligarchies!) that mint currency, taking hold of the new, blockchain-based monetary systems.

It must be recognized, however, that even those who maintain, then, that "another world is possible" are forced to withdraw into the private realm or into the precious and creative action of small groups, because that claim has not taken a new, universal political form, the only one—writes Fisher—able to counter unfair globalization.

The whole phenomenon of urban art, as Stefano Antonelli and Gianluca Marziani explain, is connected to criticizing the aesthetics of this consumer capitalism. But for the anonymous artist from Bristol, the reconquest of spaces *manu pictoris* becomes systematic and antagonistic, going against all mediation. If we read Banksy's texts, which are of such great importance for comprehending his political art, we are struck by their absolute harmony not only with Klein's narrative, but with the everyday interpretation—from the building of the wall on the West Bank to the proliferating climate crisis, and onto the collapse of healthcare systems overwhelmed by the recent pandemic and by the fierce wars in recent months—of a viewpoint of criticism against the time's dominant powers. The twentieth-century Left, which ran its course in Florence on 20 November 1999, is like a little point fading in the distance. There is a new magma, doubtlessly with values of the Left, but wholly alternative to the intermediate bodies built by the social Left of the last century—including in those of art and culture. One cannot fail to see that both the spread of museum systems and the new art market that expanded beyond belief in the second half of the twentieth century and in this first fifth of the twenty-first, belong to this history to a great degree. As Banksy writes: "The Art we look at is made by only a select few. A small group create, promote, purchase, exhibit and decide the success of Art. Only a few hundred people in the world have a real say. When you go to an Art gallery you are simply a tourist looking at a trophy cabinet of a few millionaires." It is this immediacy—in/mediacy, if you will—that gives power to the Banksian aesthetic. The weapons are stencil and brush, the setting, the nighttime, the theatre, and the urban crisis, with episodes in museums and "elevated" places: the armed struggle of signs and colors. This revolution without bloodletting establishes a new artistic populism— against critics, mediators, galleries and museums, against those who set the prices of an art accessible only to the wealthy, a true status symbol of the capitalism of logos. Some great artists have themselves become brands, starting with Andy Warhol, the brilliant accomplice and critic of the world of advertising and image. Pop Art is the parent of Street Art, but the latter is a rebellious child, a runaway, cross-pollinating first with rap, with street music, and then onto trap music of recent years. The parent is inside the system, in fact exalting their own intermediate bodies. The child criticizes them. And the grandchildren like Banksy counter this system with their strength. They produce artworks, signs, immediately comprehensible messages, all derived from the imagery of

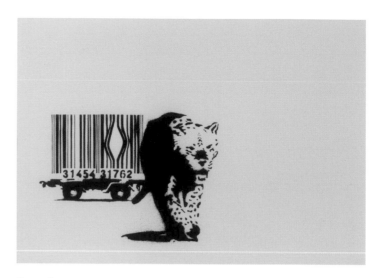

Barcode
2004
Silkscreen print

advertising, comics, or information. But they immediately raise questions of "why." They produce critical thought and they raise reflection: not only in the well-to-do person admiring the artwork in his or her living room, but in the worker going to work, their grandparent going shopping, the student going to school. The fundamental "why" is the revelation of what is true and what is false. The gigantic campaign of "fakeness" that produces *brandocracy* every day legitimates the force of a conceptual overturning. This is to be investigated in Banksy. After the anthropocentric break of the Renaissance, Caravaggio disclosed the revealed truth of art deposited in the Holy Scriptures and in religion, and, during the time of the Counter-Reformation, gave the Madonna on her deathbed the face of a sex worker drowned in the Tiber and immortalized cheats and murderers as new princes of reality. In the same way, Banksy demystifies the great aesthetic construction of advertising and the market of the second half of the twentieth century. He makes it his own, he knows its codes and paradigms, he overturns it. In some way, this phenomenon— which we call *artistic populism*—accompanies a trend in this phase, inherent to all national democracies and to the global *brandocracy*. There is an affinity between this artistic insurgency—in which the prominent figures are young people who have worked in design and advertising—and the crisis of the old mass parties. Populism in any context is typically a transitory phenomenon. Antonio Gramsci, in a note in his *Prison Notebooks* of 1930, wrote: "the crisis precisely consists in the fact that the old is dying and the new cannot be born; in this interregnum, a great variety of morbid symptoms

appear." This is a very current reflection. Populism expresses the crisis of the old order. But for this crisis not to lead to tragic consequences as took place a hundred years ago, to wholly new morbid phenomena, a change is needed. In her last paper, Klein expanded her gaze to the environment (*This Changes Everything: Capitalism vs. the Climate*). And in a certain way, the phenomenon of Greta Thunberg and her Fridays for Future—with all the abilities, typical of these times, to build herself as a brand—confirms this direction. And in other ways, this is not unlike the neofeminist direction advocated by the Me Too movement. The Bristol artist is also on this road, and I am convinced we will find him at all the crossroads in a new thinking of criticism and change. Of course, to do this, Banksy himself becomes a system—not only in order to market his works; not only due to the authentications (his) Pest Control company gives to the works on the market; not only due to the *Girl with Balloon* shredded at auction; and not only due to the *temporary outlet* opened in London with his merchandising. But because the years go by; value increases; the perception Banksy has of himself changes. One would hope that it will not be institutionalized, that he will be able to maintain his rebellious,

unconventional spirit materializing the new trends of today and not just capitalizing his criticisms of yesterday. We shall see. What is certain is that he is an artist who has swiftly conquered the global stage at a time of great crisis and of great transition.

Capitalist realism is therefore the thought that springs from the "pessimism of the intellect," as Gramsci taught us. The "optimism of the will" takes the shape of that "there is always hope" that Banksy wrote beside *Girl with Balloon*, painted in 2002 on the South Bank stairs of London's Waterloo Bridge. Fisher tries to give words to this hope.

"The goal of a genuinely new left," he writes in the final pages of *Capitalist Realism*, "should not be to take over the state but to subordinate the state to the general will." But what is the general will? Resuscitating the concept of it means reviving and modernizing "the idea of a public space that is not reducible to an aggregation of individuals and their interests."

Let us liberate, then, and let us—not only with the brush or with musical notes—conquer the new public space.

The Second Principle of Banksy

Stefano Antonelli

PART ONE.
THE ISSUE OF TRUE AND FALSE

1. In 2003, on the occasion of the collective exhibition *Backjumps. The Live Issue* at the Bethanien Kunstraum in Berlin, Banksy created a mural artwork showing three police officers with smiley faces surmounted by the inscription "Every Picture Tells a Lie".

2. "Certainly the present age prefers the sign to the thing signified, the copy to the original, representation to reality, the appearance to the essence" (Feuerbach, 1843).

3. The whole life of societies dominated by the modern communication conditions, appears as an enormous repertoire of images. These images aim at mediating relations among people.

4. Placing images in the world has unexpected consequences: "At the end was a giant billboard, and underneath it girls were doing tricks and cars were dumped. The billboard showed a toothpaste tube three times bigger than the houses, and none of the money from those adverts went back into the street" (Banksy, 2006).

5. All the images reaching us are produced by the Culture Industry creatives (Horkeimer, Adorno, 1947), it is the attention engineering, and they lie. The age of hypermediality creating the global world through communication technologies generates "a simulation world that erases the distinction between real and imaginary, an aestheticized hallucination of reality without depth" (Featherstone, 1994).

6. The images statute produced under these conditions is the equality of all images.

7. When Banksy sampled the image of the fleeing girl burned by napalm—the iconic image symbolizing the war in Vietnam, originally shot by Nick Út—and flanked her with Mickey Mouse and Ronald McDonald, he *compressed reality and imagination on a flat surface by erasing distinctions* and setting the scene on a grey monochrome background characterized by the absence of depth, thus generating what Featherstone defines as an "aestheticized hallucination of reality without depth".

8. Banksy is the artist showing forms of this hallucination to the broadest possible audience. In an age where dreaming becomes sleeping, economic culture becomes destiny, time becomes a commodity, experience becomes a representation (Debord, 1967), the truth of art is replaced by the advertising of art.

9. "A wall has always been the best place to publish your work" (Banksy, 2005).

10. Unlike the contemporary artist, Banksy's aim is not so much to convince the *Artworld* (Danto, 1964) but rather to convince the public. In the age where all images lie, Banksy's entire work is set to become the most significant global advertising campaign in favor of truth (apparently, with some success). As such, he borrows its grammar and syntax, which nevertheless give back semantics able to oppose the lies of the advertised world, through "necessary plagiarism" (Debord, 1967) to create new perspectives recovering sense.

11. There are artists who are at the same time emblems of an era and main suppliers of the raw material useful to decode the concept of world expressed by such an era. Sometimes, it is just a single image that can represent the societies which lived in it, through an impressive visual synthesis encompassing lifestyles, values, ethical and aesthetical morphology. But, often, they are answers, as if the world talked to artists and they replied to it by revealing the truth of their time.

12. In 1917, considering the nonsense of twenty million deaths caused by the first modern war, what does the truth of one's time represent if not an industrial urinal? In 1962, less than fifty years later, in front of the life of a society claiming to be a promise of happiness in the form of a massive accumulation of goods, what does the truth of one's time represent if not a pack of canned soup repeated, and repeated, and repeated?

13. "If you repeat a lie often enough, it becomes ~~true~~ politics" (Banksy, graffiti on a wall).

14. Grasping the truth of one's own time is not easy; truth itself is a social factor that, over time, has been entrusted to different agents. For centuries the leading provider of truth was religion, then we decided to assign the mandate of truth to science. By the sentence "it is scientifically proven", we mean that the question is indisputable, that it is an objective and universal truth. Our time, however, is characterized by the questioning of scientific truths.

15. It is not unreal to state that our time is facing the dissolution of the universal mandates for truth. In a time marked by pervasive communication, the true and the false no longer seem to oppose each other but rather to deceive each other, thus returning us a fragility of the real mainly reflected in the identity.

16. The founding theme of Banksy's work is how to set a truth affirming relationship between communication and society. In the booklet *Existencilism* published at his expense in 2002, Banksy wrote: "If you want to say something and have people listen then you have to wear a mask. If you want to be honest then you have to live a lie" (Banksy, 2002). These two concepts offer us both a horizon within which understanding artist's work and an operational manifesto. Below, I will refer to these two aphorisms as Banksy's first principle and Banksy's second principle.

17. Banksy's first principle states that he has something to say, the second that what he has to say is a truth.

18. Having something to say is the artist mandate by definition, whether what is said is true, is not granted at all. The truth affirming statute of art is a postulate of Hegel's idealism according to which art, philosophy, and religion are three different ways of grasping the absolute, three experiences of truth. According to the German philosopher, religion offers us truth as representation, philosophy as the supreme form of concept and art as the form of sensible. From this perspective, we can therefore assert that the entire work of this artist is a truth he conveys to our senses so that we can perceive it. Hence, the only thing left is to figure out what truth is. However, Banksy's second principle suggests that the artist shows the truth under the guise of a lie. And now, the plot thickens.

19. "The field of art is not a pluralistic field but a field strictly structured according to the logic of contradiction" (Groys, 2012).

20. The two principles guiding the artist's entire work are connected to the paradox and the contradiction, which are also the two conditions best representing both our present and the state of the art. Therefore, paradox and contradiction seem to be the two key words interpreting both our time and the work of this artist. If so, only the most significant artists succeed in this synchrony, triggering through their artworks individual processes of re-enchantment of the world. Among these, only very few trigger collective re-enchantment processes.

PART TWO.
RESISTANCE? NO, COUNTERATTACK

21. "The people who truly deface our neighborhoods are the companies that scrawl giant slogans across buildings and buses trying to make us feel inadequate unless we buy their stuff. They expect to be able to shout their message in your face from every available surface, but you're never allowed to answer back. Well, they started the fight and the wall is the weapon of choice to hit them back" (Banksy, 2005).

22. Banksy's way to deal with the issue of the true and the false is vandalizing these two ideas. The artist knows the power of vandalism practice, he is a graffiti writer, a vandal for the society where he is growing up. A world where writing one's own name on a wall with colors and shapes, resulting from joining discipline and imagination, means committing a crime. It means: being arrested. In the 1990s, in Bristol, in southern England, remaining anonymous meant to survive the persecution of non-compliant forms of expression.

23. Since the end of the 1990s, Banksy is an artist that has produced, and is still producing, images and signs in public space, visual art works, installations, performances, communication actions, films, books, poems.

24. "I think becoming a brand name is a really important part of life, it's the world we live in. It's got to be addressed, understood and worked out, as long as you don't become your own idea of yourself, you don't start making Damien Hirst" (Hirst, 2000).

25. Since the end of the 1990s, Banksy is a brand that has produced and is still producing images and signs in public space, works of visual art, installations, performances, communication actions, films, books, poems.

26. Banksy grew up in a period when Damien Hirst established himself as the most prominent artist in the world. His approach to art was so deeply affected by the brand economic ideology that he finally embodies the very idea of *Brand Artist*. The two artists met and influenced each other, to the extent that they realized some artistic collaboration. In those years, Hirst was so prominent in the art context that in 2006, the Serpentine Gallery, and later the Fondazione Agnelli, hosted an exhibition of his personal collection entitled *In The Darkest Hour There May Be Light*. The artist standing out among the ones exhibited was Banksy, who, on that occasion, created a version of *Napalm* with bloodstains shown in this exhibition.

27. Banksy draws on the lesson by Hirst, he vandalizes the idea of Brand that in his systematic practice of relexicalization becomes *Brandalism* (Banksy, 2005).

28. "Brandalism: Any advertisement in public space that gives you no choice whether you see it or not is yours. It belongs to you. It's yours to take, rearrange and reuse" (Banksy, 2005).

29. Banksy's vandalism starts very early. In 2006, during an interview to the *Swindle* magazine made by Shepard Fairey, he declares "When I was about 10 years old, a kid called 3D was painting the streets hard. I think he'd been to New York and was the first to bring spray painting back to Bristol. I grew up seeing spray paint on the streets way before I ever saw it in a magazine or on a computer. 3D quit painting and formed the band Massive Attack [...]. Graffiti was the thing we all loved at school—we all did it on the bus on the way home from school. Everyone was doing it" (Banksy, 2006).

30. Banksy's name for his first vandalism raids was Robin Banks, sounding like "Robbing Banks". If you call yourself Robin Banks in Great Britain, it is plausible that your friends end up calling you Banksy.

31. While Robin Banks becomes Banksy, the world is changing. The countercultural and libertarian ideology animating the Silicon Valley nerds looks at the World Wide Web as a unique opportunity in the world's history to share knowledge and skills, a better world that IT engineers want to make accessible to everyone, creating phenomena like Apple and Microsoft, whose dream is one person-one computer. This is Web 1.0, followed, later on, by Web 2.0 with its platforms: Facebook, Twitter, Amazon, Paypal. We know how it ended.

32. Banksy's education goes from the end of the twentieth to the beginning of the twenty-first century. This period witnesses the rise in the Western world of heterogeneous and fragmented counter-cultural demands, finding a common ground in criticism to the neo-liberal economic system, against which new ideas and proposals come to light. According to historians this sort of unity of the above demands, which later became a movement, dates back to 2000 and takes place in Seattle, on the occasion of the WTO (World Trade Organization) ministerial conference. This movement whose slogan is "another world is possible" meets in Porto Alegre, Brazil, for the World Social Forum in opposition to the World Economic Forum held in Davos. Then, in July 2001, the movement participates in Genoa G8, to express its dissent, but here the idea that another world is possible suffers a fierce repression, leaving on the ground of illusions the body of Carlo Giuliani. In September 2001, the Twin Towers collapse.

33. The No Global movement demands can be briefly described as criticism to multinational companies, exploitation of child labour, facilitation of wars, domination of banking systems, copyright, social control, environmental sustainability. Each of these demands was turned into images by Banksy.

34. "Copyright is for losers ©™" (Banksy, 2005).

35. By raising his vandal graffiti practice to the next level, through a systematic work of epistemic vandalism, Banksy shares the bustling idea of another possible world and addresses the issue of the truth of our "real", by reprocessing the ethic and aesthetic imaginary aspects already informed by reality, subverting and reversing its meaning, creating an art without an instruction manual, just as Steve Jobs dreamt the Apple products would be.

PART THREE.
WE, THE PEOPLE

36. The paradigm combining the idea of art with the idea of street is simple: to do something beautiful, I do not have to ask for permission. The detonating substance of street art is all here, there is the recovery of an aesthetic idea followed by an appropriate ethics.

37. The idea of combining art and street is not new, but Banksy systematizes it by grasping more than any other its intrinsically ostensive capacity and the communication potentiality of public space. Through his systematic practice, he turns the wall into a mass medium and the artist into mass media.

38. "Medium is the Message" (McLuhan, 1964).

39. The relationship between our world and art is realized within the exhibition spaces. It does not affect our ordinary, but our extraordinary. Visiting an exhibition is not generally an item on our to-do list, such as paying bills and picking up children from school. Our everyday life is not related to art in any way. Yet the art we produce will speak for us to posterity.

40. "Art is not like other culture because its success is not made by its audience. The public fill concert halls and cinemas every day, we read novels by the millions, and buy records by the billions. We, the people, affect the making and quality of most of our culture, but not our art" (Banksy, 2005).

41. The artworks are located only in two places: museums and galleries, which are exhibition spaces, and the mode to enjoy these works is contemplative. What can you do in a museum besides contemplating artworks? Nothing.

42. Is public space an exhibition space? Yes, it is. Two institutions use it legally: the State and the market. The State exhibits street signs to regulate public space. The market shows advertising that is a form of persuasive communication intentionally aiming at changing our inclinations. According to the Global Advertising Spending data, in 2010 the total amount spent on advertising in the world was about 399 billion dollars while in 2019 it reached about 563 billion dollars.

Advertising really works. It does change our inclinations, otherwise investments would not grow. What about the third institution, the one that Jurgen Habermas calls "lifeworld" (Habermas, 1986), in other words us? In addition to the finalistic images, public space also shows non-finalistic signs and images: graffiti, stickers, drawings, paintings, but this visual material is not authorized. It is abusive. The lifeworld is not allowed to exhibit in public space, unless your scribbles are worth a dizzying amount of money.

43. "Since its emergence, society has a spatial configuration, just as space has a social configuration. Socialization and spatialization have always been intimately intertwined, interdependent and in conflict" (Marramao, 2013).

44. Road signs and advertising in public space convey univocal messages. There is nothing to be interpreted, on the contrary, the remaining visual material is represented by clear hermeneutic images.

45. "For the first time with New York graffiti, (...) media have been attacked by their own form, in their own way of production and diffusion" (Baudrillard, 1976).

46. If the cognitive stimulus of a finalistic image is a dart thrown towards a specific point in our brain, the stimulus of a hermeneutic image can be compared to an aimless blossoming involving all our decoding system. This should at least stimulate a reflection over images legitimacy in public space.

47. The enjoyment mode of an artwork in public space is not contemplative at all. Indeed, it could be contemplated as well as rubbed, challenged, modified, deleted, tore, or taken, if you want. What can you do in the street after admiring an artwork? A lot.

48. "It is not aesthetic properties that transform an object into a work of art but relational properties" (Danto, 2013).

49. Very little remains of Banksy's public works; he often shows the duration of his artwork in his publications. Three days, six minutes, two hours.

50. When it comes to Street Art, the idea of ephemeral art is often recalled. However, rather than ephemeral, it seems to be merely temporary.

51. Unlike the established and historical idea that art should traverse time, Banksy's art steals time (commodity), an art with limited availability. So, all we have to do is admiring its reflex in museums, as in this exhibition.

52. "I don't think the hand of the artist is important on any level because you're trying to communicate an idea" (Hirst, 2000).

53. Each emerging idea of art is essentially a way to open up a new space of freedom.

54. Banksy's successful systematic conversion of public space into exhibition space for art led to the affirmation of the idea associating art and street and labelled by the public debate as street art, thus releasing many generations of young artists from any traditional artistic practices and allowing them to re-imagine it.

55. "A lot of people never use their initiative because no-one told them to" (Banksy, 2005).

PART FOUR.
I DON'T BELIEVE IN ANYTHING, I'M JUST HERE FOR THE VIOLENCE

56. "This is not a resource manual for fucking advertising agencies" (Banksy, 2002).

57. Banksy uses communication strategies of big brands, and this should not surprise us since marketing owes a lot to graffiti. Actually, for over twenty years, most of the graphic designers, creatives, and advertising operators were former graffiti writers who took and reworked the ethics and aesthetics of vandalism changing them into some of the most effective and innovative marketing techniques. Just look at the success of the methods used by global brands that were conceived and described by Jay Conrad Levinson (1984) in his book *Guerrilla Marketing*. He understood them observing the practices put in place by the New York writers in the 1980s.

58. No one knows how to grab attention in public space better than a graffiti writer.

59. "We do not live in a neutral and white space; we don't live, die, or love, within the rectangle of a sheet of paper" (Foucault, 1994).

60. It is marketing that borrows vandalism and not the other way around, and Banksy's work looks like marketing just because we are more exposed to advertising than to art. Banksy's artistic agency, therefore, is not marketing but pure vandalism, thus leading us to think that, in the end, marketing and vandalism are the same thing.

61. "I don't believe in anything. I'm just here for the violence" (Banksy, 2005).

62. Banksy's first documented exhibition of works for sale dates back 1998 and was organized by him in the house (and garage) he shared with two roommates in Easton, a Bristol suburb. From 1998 to 2019, Banksy took part in about twenty years of activity in 37 documented exhibitions, both solo and group. Among these, 33 have been held between 1998 and 2010, 33 exhibitions in 12 years, hence an average of over three exhibitions per year. An activity that any artist would define at least intensive.

63. "I like [the art market]. Very much. I know a lot of people see it as a problem. Integrity issues, I think. But I've always thought that being an artist, doing something in your studio and waiting for someone to come and see and take them away... it doesn't make sense [...] if art is about life, and inevitably it does, and it is able to stay that way even if people buy it and invest money in it until it becomes a consumer good, well, it's exciting for me" (Hirst, 2004).

64. While organizing an incredibly intense traditional exhibition activity, Banksy produces an endless number of wall paintings in Bristol, London, Berlin, Naples, Palestine, New York and many other cities as well as actions in the zoos of Barcelona, London, Melbourne, in Longleat Safari Park in Great Britain, and exhibition incursions in the most important museums in the world. He hangs his works illegally at Tate Gallery, Natural History Museum and British Museum in London, at MoMA, Metropolitan Museum and Brooklyn Museum in New York, and then Louvre in Paris.

65. "My sister was throwing away loads of my pictures one day and I asked her why. She said, it's not like they're going to be hanging in the Louvre" (Banksy, 2005).

66. Banksy had a photographer to document his activity, several P.Rs. to promote his actions. He publishes at least

five books and starts a print house in London called Pictures On Walls where almost all of his silkscreen works were printed, he organizes authorized and unauthorized festivals, an abusive art residence in New York challenging the whole NYPD, and a myriad of other activities and initiatives. He is not precisely twiddling his thumbs.

67. Restricting Banksy to street art and stencil seems at least unsuitable to decode this artist's reach. He uses countless languages to convey his messages, often taken from other artists, rats and stencil from Blek le Rat, installation and performance practices from Brad Downey.

68. "The bad artists imitate, the great artists steal. ~~Pablo Picasso~~ Banksy" (Banksy, 2009).

69. *Girl with Balloon* is definitely the artist's most representative work in audience's heart. The image that defies the tacit art prohibition of painting hearts is used by Banksy to give form and color to disillusion, the feeling that most embodies the emotional condition of young generations inhabiting our time. He made it on the wall in various places and then printed it in a silkscreen edition in 2004-2005. It was offered for sale for 65 pounds.

70. "There is always hope" (Banksy, 2005).

71. In 2017, Samsung ordered a survey to ask the British which artwork they loved the most: it turned out was Banksy's *Girl with Balloon*.

72. Banksy's work with the most media coverage is the shredded *Girl with Balloon* or the public destruction of a painted on a canvas version of the *Girl with Balloon*. Like the musicians bored by their major piece everybody ask, the *Girl with Balloon* suffers a kind of revenge. He comments on this action by quoting Mikhail Bakunin: "the passion for destruction is also a creative passion".

73. What does Banksy do when he shreds his one million pound *Girl with Balloon*? First of all, he makes a public gesture that he claims through his Instagram account —using the same procedure of an outrage—and then, he is inspired by a work of the French artist Farewell, *Bande de pub*, made in Paris, in 2004. The undamaged canvas inside the frame and the part cut into strips outside it are probably destined to be settled into the collective memory and enter into history and costume through the main door. Perrier and McDonald promptly made their communication campaigns inspired by the *shredded Girl with Balloon*.

74. This image seems to identify the syntax of the language used by Banksy in what appears to be his message about the meaning of art today: a set of practices fixing the general and shared idea that art is here and now. It should be said that this is not a real, great contemporary argument on the meaning of art. It is just a common sense for those who love beautiful things, somewhat like the *Dismaland* entry-level anarchy.

75. Banksy seems to speak to us pragmatically. He probably reads us the same way.

76. We are aware of the existence of this artist only through his communications. We have never become acquainted with his body. Although for about twenty years, Banksy has only been a one-way communication, we do not stop assigning him an anthropomorphic image, making him a man.

77. We are surprised that someone is not claiming, showing, or playing such fame. No matter how hard the artist tries not to be, we take it for granted that he is a person.

78. It seems that we love Banksy's language very much. It is not a verbal or multimodal language, like the one we use to communicate; it is a different kind of language and, whatever he says in his language, his audience is getting bigger and bigger. Any Banksy initiative ends up on international news, from CNN to Al Jazeera, to Africanews.

79. How do we read the performance of the *Girl with Balloon* destruction? The staging, indeed, is the work itself and consists of the video (2018) and its viral potential offered by real-time digital technologies.

80. Public staging is a foundational part of contemporary art. Marcel Duchamp (1915) was the one who used public staging as executive procedure of the artwork, thus presenting his *readymade* pieces according to his leading strategy, that is to say, linearly showing what is represented. This means that a urinal is only a urinal; a bicycle wheel is only a bicycle wheel; hence, Banksy's joke is only a joke, a

prank, or, more abstractly, a game. Under this perspective, perhaps we watched at the historical modernization of the notion of Duchamp's *readymade* already enjoyed by Banksy, as well as the situationist thought that affects the artwork.

81. Duchamp's *readymade* expresses a certain level of stability of the state of things in general, and of objects in particular, and in a way, is the result of historical materialism, which, however, does not adapt to the temporary nature of the state of things and objects that we are forced to accept due to the instability and progressive dematerialization of objects in our days. Hence, we could antithetically call it: historical immaterialism.

82. This is the answer to what staging represents: it performs a game shown in a sort of Banksy's *readymasking*, rather than in the Duchamp's *readymade*.

83. Is art a game? Yes, it is.

84. Unveiling the work through a short video (2018) where the artist shows the technique to get the canvas shredding, Banksy tells the story as if it were a fairy tale (ten years ago...) and quotes Bakunin. What does it mean? Why does Banksy talk to us about destruction? Finally, is it really destruction?

85. Art and destruction have long long discoursed—think of Fontana's cuts, Burri's combustions, John Reed's work. Caws and Delville dealt with creative destruction in their essay *Undoing Art* published in 2017 remarking that the destruction of an artwork (*undoing*) would be a part of the artist's construction process; in other words, when the artist destroys the artwork, he is actually building himself.

86. This analysis is confirmed, in fact, by the results of the artist's action. By destroying the artwork, Banksy obtains two effects, the first is to widen the distribution of his work (the video), and the second is to increase the value of all his artworks. It seems that the artist significantly contributes to his own formation, as Caws and Delville argued.

87. The performing aspect of an act of destruction has a spectacular side, too, since it can attract attention in a much more pervasive way than an act of construction. Creative destruction affirms a secularised and desacralized art. When Bailey Bob Bailey proposes to destroy the Christmas

tree ritual (Caws and Delville, 2017), he is staging the paganisation of a sacred rite that was finally swallowed up by the consumer civilization. Banksy does the same.

88. Creative destruction is a paradigm mostly used by modern power that has understood its economic and political potential, just think of the wars to stabilize regions of the world and to the process of reconstruction and management.

89. The relationship between art and destruction has always given back an aesthetic of entropy, chaos, and unrepeatability. So far, the destruction of artwork has been an act generating entropy, mainly the reduction of materials into pieces, or their unidirectional transformation. A process able to create an aesthetic of wreckage, of decomposed rupture that perfectly suits the informal research of one's own time.

90. Through this work, Banksy goes beyond the well-known paradigm of destruction. The object used to carry out Banksy's destruction is a real symbol of the rational and industrialized principle of destruction: the office shredder machine, the object that the administrative world appointed to destruct its secrets when it is too late to hide them. Aesthetics experiences it in a revolutionary way. The visible result of this destruction is not shapeless chaos of materials, but an orderly, industrialized, tidy, rational and logical destruction that is totally dispossessed of the power of material transformation that stays intact in the perceptive capacity of the work, increasing its dissonance.

91. The presence of dissonance in our contemporary life is so repeated and habitual that there seems to be no valuable aesthetic experience that is not veiled by pain (Iannelli, 2010).

92. Therefore, such artwork is not the result of its destruction but its refit, its reconfiguration according to a precise aesthetic canon offered by an office technology.

93. "The form of modern art will be adequate to the truth content of time" (Hegel, 1997).

94. One question has remained unanswered: what is the truth that this artist is telling us? The truth is that "society, as the collective condition that strives for order in a vain effort to defy the entropy of being, is a construction of

boundaries. As much as it is expected of artists to follow the rules like anyone else, the license we grant creativity is ultimately about giving artists some tacit permission to constantly stretch, challenge, and, if need be, defy this unending accumulation of boundaries. Even if the artist is expected to follow the general rules like all the others, he is tacitly granted the license to move, challenge—if necessary—violate these countless boundaries. Someone has to do it, and although it is to be expected that criminals, fools and children will do it, all in all we prefer an artist to do it. So, the best way to know a limit is to find someone who is pressing to break it" (McCormick, 2015).

Bibliography and sitography

Banksy (2002), *Existencilism*

Banksy (2005), *Wall and Piece*

Banksy (2006), *Intervista al Sunday Times*

Banksy (2006), *Swindle magazine, issue 8*

Banksy (2009), *Incisione su pietra, Banksy Vs. Bristol Museum*

Banksy (2018) *instagram.com/p/BomXijJhArX*

Baudrillard J. (1976), *L'échange symbolique et la mort*

Caws M. N., Delville M. (2017), *Undoing art*

Danto A. (1964), *The Artworld*

Danto A. (2013), *Cos'è l'arte*

Debord G. (1967), *La société di spectacle*

Featherstone M. (1995), *Consumer culture and Postmodernism*

Feuerbach L. (1843), *L'essenza del cristianesimo, II edizione*

Foucault M. (1994), *Dits et écrits, Volume IV, n° 360*

Groys B. (2012), *Art Power*

Habermas J. (1986), *Teoria dell'agire comunicativo: critica della ragione funzionalistica*

Hegel G. W. F. (1997), *Arte e morte dell'arte. Percorso nelle lezioni di estetica*

Hirst D. (2000), *Intervista a The Independent*

Hirst D. (2004), *Manuale per giovani artisti*

Horkeimer M., Adorno T. (1947), *Dialettica dell'illuminismo*

Iannelli F. (2010), *Dissonanze contemporanee. Arte e vita in un tempo inconciliato*

Levinson J. C. (1984), *Guerrilla Marketing*

Marramao G. (2013), *Quadranti*, Volume I, n° 1

McCormick C. (2015), *Trespass*

McLuhan M. (1964), *Understanding Media: The Extensions of Man*

Aesthetics of Realism

Going Beyond the Artwork Through Art, Going Beyond Art Through Artwork

Gianluca Marziani

Going beyond the artwork through art... In this way, it seems the conceptual statement of some Goshka Macuga encyclopaedic *monstrum*, whereas, in truth, it is the epitome of the most viral, impactful, and iconic living artist (step 1). More precisely, the most potent and universal artistic project (step 2) of this millennium: *Banksy*.

(step 1) *Living Artist...* Banksy goes beyond the biological limit, entirely removing his body image and using his own *binary system (signature + communication)* to handle the artistic chain. Usually, the origin of his projects is secret; then, they are created and finally disseminated via digital media, thus establishing the authenticity of the operation. The *social media statement* embodies his genuine signature, his identity certification, and due appropriation that starts up the mass media. These statements could conceal an individual, a couple, or a collective. We only know that the author comes from Bristol, he signs as Banksy, he was born in 1974 (?), and he is a male (?). A semantic ambiguity overturning the photographic identikit as a living artist: no face means no identity obstacles during the brand hereditary transmission, the connective handling of the project, the viral system of the process. We trust the statement, and this is enough for us, even if we do not know the operative motor, the places where decisions are made, the spaces where Banksy lives, as well as his habits and his entourage. We stick to faint rumours and common gossip that feed the myth, although the living person does not become alive. Banksy exists, in fact, through his logo-signature, and perhaps he will not even die since a logotype (step 5) does not stop breathing. Starting from a tag and passing through the logo radiant complexity, the Banksy brand has no comparison in terms of impact and consequences. Above all, the artist is one of the very few who has invested his human capital in the perfect fusion between artwork and brand. We should consider that logo the brain/heart of the creative process, able to intertwine tag (name), registered trademark (origin), and (controlled) semantic engine: Genuine Banksy.

(step 5) *Logotype...* In a world of vital and cathartic *ghost artists*, the first external appeal is the white mask of Guy Fawkes associated with the Anonymous' "hacktivism", the militant fetish erasing the individual identity to create viral, massive-scale anonymity. The difference with their horizontal approach is that Banksy expects a hierarchy with someone deciding in an armored mode outside of any exogenous influence. A waning antagonist is Subcomandante Marcos, an anonymous figure hidden in the Chiapas jungle and concealed behind viral videos and balaclava. The Zapatista Uprising had a peculiar hierarchical system that made it difficult to multiply the non-authentic news. Similarly, the Banksy system encourages unambiguous anonymity and decides what to let flow out. The commercial exhibitions are excellent examples: the artist does not authorize them but not hinder them, thus setting a system of thought distribution with a high-profit entrepreneurial intuition and no direct effort.

His logotype was transformed into a *cross-brand* that can be linked to a stencil, a sculpture, a recycled object, a multiple, an installation, a statement: the common thread among them deals with the homogeneous way of acting, the social detonation it triggers, the cultural and commercial consequences it causes. Just think of a logo like Supreme, the most proliferate comparable project to Banksy's eventualist and hypermedia philosophy. It is a case of cross-brand able to transform any object on which it is sewn, thus increasing its small preciousness and money value. The British artist prints his images on façades, shutters, vehicles, sheets, signs creating a quick value rearrangement, an exponential growth that simulates the financial speculation on derivatives and futures. Banksy is similar to a high-income financial entity but with high ethical sensitivity, a living cross-brand always seeking sensitive objectives to implode. Banksy is one of those able to produce chain reactions, and this is not insignificant in contemporary art.

(step 2) *Artistic Project.* Each of us tends to give a face to a ghostly name operating in creative fields, whether writers

(Thomas Pynchon), musicians (SBKRT, Burial), designers (Martin Margiela), or artists. Hidden identities belong to human history. The desire to disappear behind a name belongs to human nature that prefers to have a free identity, even if shared with a deeply sincere moniker. If we add the urban context where Banksy was formed, the secrecy is justified to skip the usual legal consequences and to feed the myth of a quick, autarkic night art. Hence the inflexible control of his *facial privacy*, an almost legendary ability to conceal his public identity to keep his binary system (signature + communication). Artist and project become pure fusion: someone (the artist, an assistant, or others) acts as a Cell/Matrix (step 8) and avoids the duty of being present. Banksy works through *exogenous connections* exploiting an open but directly controlled network that certifies the original versions and discredits the fakes (or at least what the artist decides to consider a fake).

(step 8) *Cell/Matrix. The artwork exists only in its ideational matrix* when Banksy creates a content in a visual form. From that moment, the artwork can have only one life in one single context, but it can also be replicated or varied upon the viral objectives set by the author's self. Imagine a matrix similar to a banknote that goes on a rotary press able to produces money in variable quantities. For Banksy each Art-operation (step 3) is similar to that precious and solid product of the Mint, even if his matrix does not need any heavy hardware but just a context and an action. Detaching a wall portion with an original Banksy (I am not speaking of a theft) is equal to taking a true/false since it is just the execution and not the matrix, an image that Banksy could use again in different ways and contexts. Hence, the peeled off artwork survives like a fetish but loses its *identity value*, even when the market certifies it and states its money value this is the constant swinging between true and false typical of finance that acts in an amoral way. It is the same for sculptures and installations, where volumes change the physical handling but not the original link with the ideational matrix. The starting point seems to be the conceptual art of the 1970s, the mental process to produce real works (wall drawings for Sol LeWitt, textual stencils for Lawrence Weiner, colored neon for Dan Flavin...). Actually, the economic value was held by the contract since the process certified the display and sale of an idea and not an artefact. Did the neon break? Just repurchase it with the same characteristics as the original neon. Did you change your home? Sol LeWitt's wall was

rebuilt in the new house, and the previous wall lost its artwork value turning into plaster without any economic reward. Banksy starts from here and from the enamel silkscreens by Andy Warhol marking out a regenerated conceptual dimension, a new entry-level in the financial connection of our liquid days being able to recreate a perfect short circuit on the artwork cryptovalue in the age of digital reproducibility (step 7).

(step 7) *Digital Reproduciblity.* The digital context of the new millennium is the point that makes Banksy unique. Technological devices are shaping the customs and habitats of the human community, succeeding in changing rituals, games, movements, and seasonal habits. Everything is linked to speed, multi-control, apparent simplification of times, and ways of living. Actually, humankind is going too fast if we consider how long it takes the brain to adapt to a new anthropological habitat. Hence the delirium of selfish excesses, obsessions, superficiality, a huge ordeal of narcissism that gives rise to addiction and makes lose sight of the real urgencies. Banksy enters the limbo between the analogue and digital culture, becoming a connecting tube, a mechanical motor with high hydraulic conductivity. His attitude towards hardware and software is in dynamic balance poised between his education (he is part of the *Pre Millennium Tension* sung by Tricky) and the liquid reality of the millennial youth. Banksy does not break up with massive projects but fully exploits the viral theme of social media. His binary system balances memory and future through methodical practice, exploiting the technological tricks but relying on physical, stubborn, and retro-maniacal operations (as with Simon Reynolds).

The *stencil* is the matrix that historically allows the street art to gain space thanks to quick execution and design accuracy. For artists like Banksy, it means acting as a team without the artist himself performing the work. From a theoretical viewpoint, he could have never made any of his known projects, just as we do not wonder if Damien Hirst or Maurizio Cattelan possess the technical skills required for the works defining the idea. The stencil is used as a political tool in an urban guerrilla identifying the artists as *aesthetic detonators*, ghost dogs working at the edges, but knowing very well the centres. Hence, the stencil becomes a predefined and conceptual grid, a sort of nomadic Warholism that Banksy has turned into a subwoofer with a

global resonance. A planetary bass tattooing the wall to make it reproduce by anyone and everywhere, in a virtual and pixelated format by the real millennium printer: our smartphones that do not use paper and send Walter Benjamin in a total philosophical short-circuit.

(step 3) *Art-operation...* For centuries, we have talked of artworks, and it will happen again in the future, although the new communication processes allow theoretical hypotheses inconceivable in the past. Speaking of Banksy, if we talk of artistic project and ideational matrix, we should use another term that includes the author's ultimate sense. I think that *Art-operation* fits best to a work understood as an iconographic object that opens its content to a dynamic process that marks it off.

Antagonism is a problematic word to handle since it deals with the attitude driving an artist, the way of approaching the world, and the involvement of the work on active themes from a social and political viewpoint. Someone mixes up some authors' success with the loss of their original antagonism as if making big money means losing the integrity of the earliest thought, thus not considering that the climax of the antagonist cult lies in the deep destabilisation of a sensitive objective. Banksy has seen his fame grow without ever changing his approach, remaining the same as he invented his attacks in Bristol twenty years ago. If anything, the chain reactions triggered by each project have increased to the point of embodying a political subject (step 4), moving the collective interests and governmental issues. Banksy frightens the power, and, equally, the power enjoys being the core of his iconic targets. It is a peculiar perversion of moguls—a kind of ethical opposite where the artist marks out the tautological facet of power itself. It could be a kind of cul-de-sac of communication. A mechanism flawlessly handled by Banksy that allows him to stay proactively out of it finding speculative systems that turn his success into a paradox against the power that buys his artworks in auctions and trades. An indicative example is the *Walled Off Hotel* that brings sensitive tourism to an area of high military risk building an economy on the crossfire line of the Bethlehem area, a stone's throw from real terror. Banksy pushes antagonism to the ultimate flexion point creating an equation between the message integrity and the audience of a world famous rock star. A unique and rare case: he is different from any other in his way of destabilizing and remodelling the rules of the artistic

aristocracy. The so-called Art System treats him with distance and snobbery but cannot avoid him since his attacks are too popular, and even Sotheby's wants him in the most prestigious auction of the season. If Tate Modern organized an epoch-making exhibition, visitors would queue for miles solving its budget problems and creating new target audiences without affecting its distinctive qualitative profile. But this does not happen—and perhaps will never happen for a long time, while any self-respecting bookshop fills its shelves with books, catalogues, multiples, and other Banksy-themed objects (Guess what the books and objects most sold in the world's best museum bookshops are?). Banksy upsets the rules of cultural conformism, becoming a British superstar not honored by the most famous museum in the United Kingdom. Everybody talks about it. Secretly, many aristo-guys collect his works. His power grows, but the System does not digest his independence, his unclassifiable reason, his lack of respect for rules. I have a doubt: if Banksy left all the trade exploitation rights to the highest bidder, would Gagosian and Hauser & Wirth jump through hoops to have him in on board, or not? We already know the answer, and perhaps we will immediately see his artworks exhibited in the Turbine Hall of the Tate Modern. Probably with his six letters name will be shown in large format: six huge rollercoasters for the most reckless, adrenaline-filled, absurd installation of the new millennium. So far, these are just small theoretical speculations, but tomorrow, who knows...

Banksy creates phenomena of hidden devotion, like the passion for porno that only a few people declare but much more pursue. I like to consider him the best practicable perversion in the artistic system. A subject of desire that mixes keen instinct and media practice, simplicity and complexity, high surface, and deep bass. Banksy practices an art where visitors adhere to contradictions, double/triple senses of the claims, unfailing irony, motivated catastrophism, cynicism of the back door, reminding us that a laugh will bury us, and that, probably, we should take ourselves less seriously. Laughing, laughing, and laughing: staying human.

So, while fashion and technology slip into our wishes through the logo perception, Banksy anticipates our desires instilling doubts on the present, on actual human needs, on pathologies of a world with too much finance and too little substance. The artist puts the spotlight on the ethical dilemma. He teases and punches us like a narrating cricket,

going where others do not go, saying what many do not dare to say. We live in a conscious bubble. We are anaesthetized by what they want us to believe. We are stunned by the survival rituals of an increasingly engulfing world. When someone like Banksy pulls out the rot around us, something strange but logical happens in us: one part understands his visionary mind and supports his talent, but the other fragile part is frightened and tries to weaken him, undermining a plausible truth that would remove meaning from the (small) sense of the most fragile spirits. It is a typical lever of those who reaffirm their value through the opponent destabilization but without opposing any real dialectic. This is what is happening in the field of artistic theory: on the one hand, the curatorial galaxy still speaking of "graffiti artist", works goods for pubs, media phenomenon (as if the rest were not), cultural-weak era; on the other, those who understand his complex dimension, his broad visionary mind, his over-sectorial ability in comparison with every possible definition.

(step 4) *Political subject.* Banksy is one of the artists clung to a *code of ethical militancy*. No one of his art-operations exists without substantial moral issues. He deals with childhood and family, war and abuse of power, old age as a resource, game as a source of salvation and inner well-being, environmentalism, and animalism for a possible future... Banksy loves the full-time exercise of individual freedom. He becomes a moral password that invites dissent, to deeply reflect, and to raise the awareness of the various collective emergencies. His action has a political nature that never asks for dramatic adherence but rather acts in the *Monty Python* way: desecrating until power is eroded, like a virus infecting institutions through a hidden and random method. Banksy distills the initial virus, cherishes it, and prepares it for the world. Just at this point, the media, the popular reactions, the indecorotent exploitation, the commercial drift, and the financial greed make it viral. The operation is completed by other players, thus giving a political density to a real visual detonator.

Post-Franchising. Banksy designs very few shows with his signature, allowing other players in the world to spread his concepts. Usually, the silkscreens (step 6) available on the market, some official findings of his projects, some rare paintings, and sculptures or scenic chips build the expositions. No officially authorized exhibitions are agreed, even if the artist indirectly feeds a system that supports him without his personal and economic commitment. Of course, his expositions are hot stuff: well-made projects alternate with wrong commercial operations. Banksy maintains an ambiguous and distant attitude towards any *exogenous projects*, silence is his usual *modus operandi*—although he sometimes highlights the expositions he considers wrong or criticises the unauthorized use of the merchandise. In the meantime, free from exposition commitments, he devotes himself to *endogenous projects*, which can be defined as his identity and distinguishing part able to mark out the main lines of his thought and, time by time, opens new conceptual paths.

(step 6) *Silkscreens.* Visitors often ask whether any original works are exhibited in addition to the framed silkscreens. In truth, nothing is more real and unique than printings holding Banksy's authentic stamp since they come from an important precedent: Andy Warhol and his enamel touch on screen prints—the first to multiply a matrix (starting photo) with an industrial logic and a new principle of serial uniqueness. Banksy has produced over forty images in his London-based print house, a sort of meta-project marking the "military" geography of his system of media engagement. In the game of chain paradoxes, silkprints become the brightest and most personal form of the Banksy's fetish, the mnemonic certification of his ephemeral way of dealing with public property. If we consider his urban operations as something really temporary, only official silkscreens become replication cells of his iconic virus feeding the popular proselytism and boosting the side effects.

Street Art. We should make clear a point of pivotal importance: Banksy is not—and perhaps has never been—a street artist in its strict sense, even when the city was his creative hunting ground. Of course, he follows the typical themes of the street language, but only because public spaces allow an epic amplification of his messages. I could consider him a street artist in the same way that I consider urban the methodology of Jenny Holzer, Barbara Kruger, David Hammons, Gabriel Orozco... i.e. artists who have created communication codes in collective places, without links to the viral method of tags. For clarity sake, his wall stencil is an urban method, but his binary system is different from anyone else. Banksy has his inspirations and urban techniques: Brad Downey, in particular, then back to the Bristolian trip-hop, Eduardo Paolozzi and

his theoretical texts, Richard Hamilton's London incursions, Futura 2000 post-writing, the early 80s trailblazers born in New York (Paolo Buggiani, Richard Hambleton, Les Levine)... but they are just small traces of a complex, anomalous, and linguistically heterogeneous sinusoid. To me, Banksy seems the most conceptual of the artists with a high collective impact, close to the curatorial practice of his friend Damien Hirst. It is no coincidence that they rejected the monopoly of gallery owners, breaking the traditional chain in favor of the managerial spam on the free market. Both blame the role played by gallery owners, their smothering speculation over their limited capacity to produce content. Banksy and Hirst have different types just because, since the 1990s, the latter acted within the mainstream system, while the former has always made things on his own, not caring about the freak control of some billionaire gallery owner. Is Hirst right? Is Banksy right? I'd rather say two sides of the same fracture in a system in crisis.

Fake Cancellation. The direct control of the chain involves a precise evaluation of every single operation. So, it becomes impossible for anyone outside the artist's entourage to declare real something not released by the Banksy house. Removing the face worship allows greater freedom of action and control. It means being able to be present without the public knowing. It means being focused on contents without worldly distractions. Moreover, Banksy is changing the very idea of genuine and fake since it is just the social media statement that decides the original value, even if there are still several ambiguities that Banksy himself does not clarify but feeds in silence, well understanding the benefit of open contradiction. The tremendous commercial chaos cancels the aura excess around the fetish, making it similar to electronic biology, a sort of fluctuating crypto-value, a sort of *Mona Lisa* with open-source recipients. After all, Banksy emphasizes today's delirium for the artwork as attendance status, a simple selfie certifying the goal achievement. And there was the photo! We could say today in the social museum fever.

Merchandise. This is the operational heart of his financial power. Banksy manages permissions, licenses, and production of objects that use images and visual claims under copyright through Pest Control. It is true, his ideas on copy-left clashes with the unscrupulous monopoly of his creative property. But the direct contradiction is another lesson taught by Banksy. A game using the same rules of institutional communication that is now able to affirm two opposite polarities as if both were true. Merchandise gains reach billionaire peaks under the logic typical of the dialectical system between the fashion system and the counterfeit products made in China and Banksy's simultaneous reinvestments in operations of high ethical value. Just take the example of *Gross Domestic Product*, a London temporary store that sells different kinds of artworks and uses the proceeds to buy a new migrant rescue ship to replace the one confiscated by the Italian authorities.

Banksy's *contradiction* is the mirroring synthesis of all of us as a motley of living paradoxes. His way of playing between high and low, mainstream and antagonism, pop and tragedy, is nothing more than the conscious mirror of our liquid status living in both physical and virtual worlds. Banksy somatises the Western present on his invisible skin. He makes it glittery and bleeding, glamorous and cannibalistic, dreamlike, and dramatically real. He plays superimposing paradoxes in the same image, setting contradiction free from its ideological constraint. Banksy is telling us that every choice we make generates an opposition where theory and practice are more and more distant from each other. We declare being ecologists, but we still drive cars in the city. We flaunt monogamy, while marketing encourages sexual polyamory. We post selfies but criticise VIPs, who do it for business... we could go on for pages and pages, but I prefer to stop at our image in a mirror. Let's look us into our eyes, in silence, thinking for a while that it is just a huge mass distraction, a financial abstraction, a world already deflagrated without contradiction. *The contradiction is the salvation of contemporary humankind.*

And from the top of his invisible declamation, Banksy puts us in front of a deforming mirror where we look at what we could or should be. The painting reflects each viewer with his or her conscience, his or her idea of the world, his or her small and big certainties. We live so many contradictions that we make the ambiguity of an artist like Banksy virtuous. We are moaning about moans, still, in a while, we fill our stomach with food and alcohol, thinking of not being directly responsible for the beggar we have just met. Hence, the awareness that only art can stigmatize the problem with a dry and impactful solution, a big blow to the face with scattered consequences, often insignificant for the future,

but sometimes triggering real effects. Banksy whispers us that art is still useful for something—not just for furnishing a beautiful house, and that its function of use is the glue between the present of the artwork and the future of the relevant reactions.

Going beyond art through the artwork... After an excursus on the topos theory defining its value and its media power, I would say that Banksy goes beyond the same art we have known so far. He rewrites rules, habits, and customs, recreating a chain that overcomes the production funnels of the traditional model. He created his own template that reinvents the existing and modulates means provided by the present technology. Banksy uses tools and materials that we all know, without losing any contact with the physical and tangible objects, with the simple and almost banal forms, with a lo-fi world without fantasy utopias. Everyone understands him because he uses the language of objects and the syntax of shared stories. He feeds on news and reality, reversing stories that move the entire humanity. No esoteric practice is present in his visual system, no difficulty in a superficial approach: everything is easy to read and impactful, just like the close-up on mundane objects defined the Pop Art. To be clear: depth exists, but it is a game of underlying layers practicable with a reflexive method. A heterogeneous complexity lies beneath the surface in an interweaving of possible readings able to drive the project towards various analytical platforms. His strength lies in having understood that in a digital world like ours, art had to stop for a while before being digitized, since it was born solid and has to become liquid. An art that appears easy but that is complex and controversial beyond its appearance, and it is empathetic by attitude and bad by nature. Art with many side effects.

Banksy: An Artist/Philosopher

Francesca Iannelli

Writing graffiti is about the most honest way
you can be an artist.
It takes no money to do it,
you don't need an education to understand it,
there's no admission fee
and bus stops are far more interesting and useful places to have
pictures than in museums.

Banksy, *Banging your head,* 2001

On the heterogeneous and multicolored landscape of the art world in our time, Banksy is without a doubt one of the most prominent and influential contemporary artists, and the one most well-known even to those not in the business. His fame is fed by an art that, although easily decipherable, does not shy away from conveying meanings highly critical of capitalism, militarism, and consumerism, or from showing solidarity with defending the environment, human rights, and every kind of freedom. His ironic, iconic, and irreverent style is always against something. As we read in the quotation from the *Evening Standard* published by Banksy on the back cover of his 2002 Black Book, *Existencilism*: "Superficially his work looks deep, but it's actually deeply superficial". His aesthetic—political, explosive, and intentionally inconsistent—is a potent and merciless expression of the dissonances of our own time, in which there is no lack of ambiguity and paradoxes, quite visible in Banksy's own art as an acute duplication of the contemporary[1].

Let us first consider the irony that pervades many of the works on display at the exhibition *Banksy Building Castles in the Sky*, such as for example 2003's *Weston Super Mare*. The screen print depicts an elderly man sitting on a bench, about to be cut by a circular saw and unaware of the danger. Banksy leaves a bitter message that invites reflection upon the uncertainty of life, death, and the dangers always lying in wait, but he does so in his own way, bringing a smile to our face.

This is the secret ingredient in Banksy's art: being able to handle hot topics, subjects that are uncomfortable, thorny, and heavy, with extreme lightness. The same irony traverses works like *Grannies* (2006) in which two little old grandmothers are knitting sweaters stitched with words singing the praises of a punk and vandalistic lifestyle, as if to say: "Never trust appearances! A punk heart can beat where you'd least expect it". Another highly ironic work is *Sale Ends Today* (2007), conceived in a composition reminiscent of the dramatic style of the depositions of Christ, but with a rather profane content: sales coming to an end, and the consumers' unbearable and inconsolable desperation. Lastly, a bitter irony flutters around the subject of the print *Visit Historic Palestine*, which depicts a disturbing tourist attraction: an Israeli guard tower transformed into a chair swing ride with the writing *The Israeli army liked it so much they never left*. The print can be purchased only in the *Walled Off Hotel* in Bethlehem, opened by the artist in 2017 in one of the world's most incandescent places: opposite the wall separating Palestine and Israel, and therefore in a lugubrious place loaded with blood and destruction.

We may now consider another distinctive element of Banksy's subversive output: iconicity. It is not a matter of building utopian castles in the air that have no hope of being built, but of spurring users to critical reflection through provocative, immediate, and highly iconic works. As Stefano Antonelli and Gianluca Marziani have observed, the approach that traverses Banksy's artistic output is "animated by the principle of reality and not by the utopian principle that illuminated creativity in the twentieth century"[2]. Banksy in fact has a very clear objective: to throw his viewers off balance, to take the ground from beneath their feet, and to lead them to fly off with imagination toward better skies. His provocative art disorients first of all for its originality. A single alienating element or an unusual pose, as in *Flower Thrower* (2003), is enough to cast doubt on everything: why not throw flowers instead of stones or Molotov cocktails? Why not aspire to peace instead of taking for granted the need for war and violence? The work's title—*Love is in the Air*—is indicative. Banksy's skies are shaken by the winds of peace, solidarity, and love, and that is why his poetics, or, better, his artistic philosophy, may be called aerial, but not in a negative sense, as if ungraspable and impalpable, and therefore ineffective. Rather, Banksy is able to lift any weight; to desacralize the symbolic figures of urban safety with *Rude Copper* (2002); to raise reflection on the hypocrisy of peace missions with *Happy Choppers* (2003); to demythologize the

use of weapons for achieving order in *Flying Copper* (2003); and to criticize the media and political rhetoric that sees all spectral conflict through a rose-tinted lens in 2003's *Bomb Love (Bomb Hugger)*. In the 2004 Black Book *Cut It Out*, his anti-militarist soul reigns supreme when he writes that bloodthirsty people should just bite their tongues.

But Banksy's art is also iconic for its ability to seduce his public with which, despite his anonymity, he has created a strong sense of complicity, consolidated through his Instagram profile that boasts no fewer than 11.1 million followers, and through his animal alter egos: above all the many rats that distribute messages everywhere and sing the praises of freedom. During the COVID-19 pandemic, the rats continued to speak for him, between reflections upon the difficulties of smart working —visually expressed by nine unrestrained mice running amuck in a bathroom accompanied by the laconic comment "My wife hates it when I work from home," posted on the artist's Instagram profile—and invitations to be properly masked in the *If You Don't Mask, You Don't Get* "performance" on the London Underground. As he confesses in his Black Book *Existencilism*, his fantasy of social revenge consists of imagining that one day, a courageous horde of vermin, of powerless losers, will gang up, get some good equipment, and change society's destiny. This revolution from below, in which the alienated are on the front lines, would involve the most disparate figures of the forgotten; some of these figures are on show: from the sentimentalist rat in 2004's *Love Rat* to the plotting ones in 2008's *Radar Rat*. But Banksy also throws us off balance with his simplicity, that lightness that is never against content, as in the most iconic and popular work *Girl with Balloon* (2004-05). There is no need to describe it: it is a piece of poetry, a perfect synthesis of human nature, made of dreams, desires, and hopes that fly away—at times to come true, and at times to be shattered at high altitudes.

It is also to be added that Banksy's art is highly irreverent and scrupulously contaminates famed faces with counterintuitive elements or destabilizing situations, as he does in *Queen Vic* (2003) with a lesbian version of the conservative Queen Victoria in garters and black leather boots, engaged in a "queening" in which she is "royally" seated on another woman's face. Or in *Turf War* (2003), depicting a punk Churchill sporting a green mohawk. The work's title alludes to the war over a piece of turf, which is to say that an eagerness for expansion always lies behind every conflict great or small. But the world

of art, cinema, and photography is also targeted: cults, legendary works and photographs that have gone down in history are quoted, contaminated, and overturned on the basis of new communicative needs; we see this in *Soup Can* (2005), with its striking resonances of Warhol's Campbell's soup cans, or in *Pulp Fiction* (2004), depicting Travolta and Jackson holding bananas instead of pistols. In the same way, in 2004's *Napalm (Can't Beat That Feeling)*, an aesthetic metamorphosis sadly overturns Nick Út's famed photograph depicting the young girl, Kim Phúc, after a South Vietnamese napalm bombing in June 1972. In Banksy's screen print, she is accompanied not by the other fleeing children as shown in Út's picture, but by a triumphant Mickey Mouse and Ronald McDonald, two pop icons of American imagery, but also two symbols of low-quality cultural and economic imperialism, globally appreciated and tasteless, serving as masks for American consumerism and capitalism whose consequences —not only ideological but social and political as well—can impact anyone's life, as took place at Trảng Bàng.

As already pointed out, there is no shortage of (albeit philosophically well-founded) paradoxes: Banksy actively combats consumerism, rebels against large corporations, and through artistic activism aims to propose an antagonistic, anti-system poetics. Yet his own name is now a brand, while his works conceived for sale bear a certificate of authenticity and can bring dizzying prices. Being an artist without a face, he has had to carefully build his mask, as clarified in the 2002 Black Book *Existencilism*: "If you want to say something and have people listen then you have to wear a mask." The brand identity is therefore well defined, potent, and highly effective. But Banksy wields it as if he were an art world Robin Hood, which is to say for his intents of denunciation and to overturning established dynamics. This also takes place in the use of copyright, mocked in the Black Books but then forcefully restated by the Pest Control company that authenticates his works.

On the other hand, his relationship with the museum institution is a rather ambiguous one, an alternation of repulsion and attraction, museophobia and museophilia. In 2003, dressed as an elderly man, Banksy invited himself into a shrine of world art, hanging his *Vandalised Oil Painting* in the Tate Britain, with a descriptive label, too; he installed a mouse with glasses, megaphone, and backpack in London's Museum of Natural History, giving it the title *Banksus Militus Ratus;* and in 2005 he continued his blitzes in some of the world's most prestigious

museums—from MoMA to the British Museum and the Louvre—where he decided to illicitly place his pieces. Here on display is a postcard documenting the raid on the British Museum, where Banksy placed *Early Man Goes to Market,* a block of cement with a drawing in marker of an early man pushing a shopping cart towards a bison killed by two arrows. The work was removed by the museum, but when Banksy became world famous, a postcard of the *Peckham Trolley* was printed by the "violated" museum itself. At this point, however, Pest Control took action to remind the British Museum that it had no right to that work, given that its placement in the museum had taken place by "self-proclamation"—a gesture in neo-Duchampian style that clearly mocks the (pseudo) sacrality that marks the boundaries of the museum institution, and the delirium of omnipotence that devours the gurus of the contemporary art world who think they can establish in solitude what art is and what it is not, based on the logic of economics and on self-referential languages. To the contrary, as art philosopher Arthur C. Danto has masterfully shown[3], the art world is a highly complex system: an ongoing texture, in which past and present are in continuous synergy and where contemporary production cannot be understood without considering it in accordance with artistic and philosophical criteria. And Banksy does have a philosophy, which may be defined as a "philosophy of conditional release", poised between rebellion and officialdom. His game of seduction with museums bears witness to this, bringing him to the Bristol Museum for his first official show in 2009 (three different posters for which are on display), entirely self-financed to guarantee free admission. More than a decade later, it may be stated that this now legendary graffiti writer no longer needs to play hide-and-seek with the museum establishment; it is now the museum directors that need him, with or without authorization, recognizing him as a media star and ingenious communicator capable of attracting crowds of viewers where usually only experts and a handful of enthusiasts circulate. This element alone would suffice to demonstrate the communicative power of graffiti. In his Black Books, however, Banksy launches additional messages in this sense, starting first of all from a rather eloquent observation that contradicts Wilson and Kelling's famous "broken windows theory" by which a "vandalized" area encourages other criminal acts and incites decay. To the contrary, the areas adorned with graffiti or the houses upon which the "pieces" appeared are worth quite a bit more on the real estate market. Of course, this situation can only raise reflection upon the contradictions in Western society, given that it prosecutes "artistic vandalism" while indirectly legitimating it, encouraging it, and exploiting it by speculating on it.

Last but not least: all the works on show come from private collections, reminding us that Banksy's space of action is not exclusively the urban, but also the snobbier and more voracious one of global collecting. Although knowing—as he states in 2001's *Banging Your Head Against a Brick Wall*—that there is nothing more honest than to pay homage to society with graffiti, Banksy winks at the official and elitist art world, striking it with its own tools as he did in 2018 during an auction bringing millions at Sotheby's in London, by destroying with a document shredder-like system a canvas version of one of the most poetic of his works: *Girl with Balloon*. On the other hand, anyone who collects Banksy should accept that the purchased work—even though it will reach an insane commercial value—will never have that same spirit of protest, of grievance, of hope for a "piece" made in and for the urban space, shared with anyone in order to spur the critical conscience of the community, and abandoned to the uncertain destiny of the street: subjected to ravenous "detachments", collective veneration, iconoclastic acts, and tagging. Any show dedicated to Banksy can therefore have an undeniable and valuable documentary value. It can raise reflection upon the infinite themes and contradictions traversing his art and our society. It can augment the Banksymania of his most devout fans. But the "other" Banksy—the hero of "criminal" communication, mindful of the importance of the intangible value of his works, of the detonating charge of walls and the democratic and viral power of the social media—remains the Banksy of urban raids. Free, rebellious, ungraspable, and ethereal, he prefers a corner of sidewalk posted on his Instagram profile over any institutional display case and, with the philosophical load of his stencils, reminds us—as he did in the summer of 2021 at Oulton Broad—that, willingly or unwillingly, whether snobs or dressed in rags, *We're all in the same boat*: one that is contaminated, sick, and requiring urgent care.

[1] I use the term "duplication" in the sense of Hegelian *Verdopplung*, by which art is a form of critical doubling of one's own time.

[2] S. Antonelli, G. Marziani, *Banksy*, Giunti, Firenze 2021.

[3] From 1964's *Artworld* to 2013's *What Art Is*.

Banksy and the Emancipation of the Spectator

Chiara Canali

In the roots of Banksy's works, we can see constant reference to a philosophical and sociological movement that developed in the late 1950s, advocating a new form of artistic action and active viewership: *situationism*.

To "draw the spectator to the activity and diminish the passive role of the public,"[1] the group's main theorist, Guy Debord, claimed the autonomy of subjective experience through the creation of situations in which individuals might rediscover their own active role. Essential to this is the concept of *détournement*: decontextualizing a work in order to introduce it into a new context that assigns it values and meanings different from the original ones.

Détournement also plays a central role in the messages launched by Banksy: to take "something" that is familiar to all, and to subvert the linearity of the discourse in order to relocate it to a perspective far from the original one. A sort of oxymoron applied to the field of the visual arts, it has the ability to shake viewers out of their apathy, making them capable of totally new mental associations.

The most blatant example of the use of this tactic aimed at estrangement was the creation of *Dismaland* in the summer of 2015.

Dismaland was configured as a giant "bemusement park," a dystopian alternative to the golden "Disneyland." In it were eighteen counter-attractions, such as a Ferris wheel showing clear signs of deterioration; an anti-riot vehicle turned into a children's slide; a merry-go-round overseen by a butcher; a pond with boats filled with migrants; and the Castle of Beast and the Beast (the theme park's official symbol), left incomplete. While public was enthusiastic over Banksy's installation, official criticism decried it as ugly, boring, and sarcastic art[2].

On the other hand, Banksy's intent was likely achieved: to load the message with sarcastic, critical, and subversive values in order to reawaken minds from their media-induced torpor.

In situationist thought, the concept of *détournement* indicates the datum's deviation from the context in which it is generally placed. This operation has the precise purpose of liberating people from the dominant ideology that takes possession of their critical sense. In fact, according to situationism, the geographical context in which one lives has profound repercussions on the individual's psyche, and the principal place in which to see the demonstration of *psychogeography* is the metropolis. Bombarded with advertising and continuous media pressure, its inhabitants are guided towards the same lifestyle, the same impulses, and the same, single thought. The situationist *dérive*, configured as a sort of "loss" of thought necessary for people to rediscover themselves, takes place thanks to the practice of *détournement*: citations are made, but in contexts far from the original one. The final result lies in a deviation of meaning that leads to the building of new meanings.

Although *détournement* operates in the background in all of Banksy's works, there are four categories of production in which its effects become particularly visible: in *Brandalism*, in his pranks in museums, in his temporary modification of the urban landscape through performance and installations, and in his artistic residency in New York.

1. BRANDALISM: WE ARE PEOPLE, NOT TARGETS[3]

The term "Brandalism" was coined in England in 2012, when a group of 25 independent artists decided to sign the movement's manifesto. The purpose was to create history's biggest anti-advertising campaign: the term *Brandalism* was in fact created by fusing together the words "brand"—which is to say the trademarks and logos of the large industries manufacturing consumer goods—and "vandalism," or all acts aimed at damaging material goods. On its website, the *Brandalism Manifesto* reads: "This is our battle-cry, our semiotic war, our rage against consumer mis-philosophy, and the machines of predatory corporatism, that block out the sun burn our atmosphere. We steal this space (from capitalism), and we give it back to you for free for the communication of possible futures"[4]. According to the movement's adherents, who draw on the

concept of situationist-style psychogeography, overexposure to media in public places adversely modifies the individual's behavior. Moreover, this modification takes place unconsciously—and thus without the subject being able to express consent or opposition. *Brandalism* is a "revolt against the corporate control of culture and space,"[5] a revolt that must take place through the practice of "subvertising"— that is, the art of subverting advertising in order to retake control over society from the visual standpoint.

While Banksy is not among the artists who explicitly joined the movement by signing its manifesto in 2012, he stated, with regard to *Brandalism:* "Any advertisement in public space that gives you no choice whether you see it or not is yours. It belongs to you. It's yours to take, rearrange and re-use. Asking for permission is like asking to keep a rock someone just threw at your head"[6].

Many of Banksy's works are glaring examples of practical adhesion to *Brandalism*, including *Napalm*, *Burger King Kid*, *Thirsty Burger King*, and *Sale Ends Today*, or the gigantic *Dismaland* installation already discussed.

2. MUSEUM PRANKS (*MODIFIED CANVAS*)
Banksy has carried out numerous pranks in museums, leaving masterfully modified works (*Modified Canvas*) and observing the public's reaction. The motivations leading the artist to this unusual practice may most likely be summarized in his criticism of official art and in the practice of *détournement* in order to "awaken tourists" from their passive torpor as spectators.

The criticism he raises against those who hold the power in artistic settings is over their deciding what art is and is not; what to show the public and what to hide; but, above all, at what cost to make culture accessible. The response to elitism is an art usable by and accessible to all: both economically and in terms of understanding the content. Art must create disturbance and movement; art is not—as is at times believed—an end unto itself: Banksy's works spur action— even if only reflection—and therefore have a purpose and a usefulness. For this reason, they cannot be written in inaccessible or cryptic artistic languages, but must speak to anyone who approaches the image, with an easily intuited lexicon. Banksy thus brings his thought into the closed environment, into museums, observing with amusement the result of his experiment.

The artist's pranks have involved some of the most important metropolitan museums, including the Museum and Art Gallery, Bristol; the Tate Modern, London; the British Museum, London; the Louvre, Paris; the Metropolitan Museum of Art, New York; the Museum of Modern Art, New York; the Brooklyn Museum, New York; and the American Museum of Natural History, New York.

3. TEMPORARY MODIFICATION OF THE URBAN LANDSCAPE
Certain initiatives of full-blown urban *détournement* bear mentioning. Banksy uses street sculpture to astound passers-by and to take in their unbelieving expressions.

The street installation in London, with the presence of traffic cones and the work in progress sign with the exclamation point and the writing "Banksy," lasted for one day, during which traffic detoured from its normal route (recalling *Iron Curtain-Wall of Oil Barrels*, done in illegal form on Rue Visconti in Paris by Christo in 1962: a barricade of barrels, one beside the other, that caused a complete blockage of road traffic and garnered a series of different reactions from the public).

Then there were the "CAUTION/No swimming/Stay away from water's edge" (with the crocodile drawn inside the warning sign) and "DANGER/Contaminated Area/Radioactive material" signs—the former near Hyde Park swimming holes and the latter in a lake in St. James's Park in the vicinity of Buckingham Palace—that kept tourists out of the water for 3 weeks and 22 hours respectively[7].

4. BETTER OUT THAN IN
On October 1, 2013, Banksy announced his one-month independent artistic residency in New York, titled *Better Out Than In*. The artist presented one work a day, announcing it over his website and his Instagram account. New York was immediately seized with "Banksy fever," with the mayor even condemning the initiative. The title is inspired by a quote by Paul Cézanne, "All pictures painted inside, in the studio, will never be as good as those done outside".

The project was to produce one work a day for the entire month of October, posting on his website a daily photograph of the just-completed work, indicating where it could be found. The works during his stay in New York were characterized by their heterogeneous nature. In fact, for each day, Banksy

developed a different idea with a different message, and his works ranged from graffiti to Video Art, from performance to installations. He started on October 1 with a stencil rather recognizable for its style: one child standing on another child's back, attempting to reach a spray can that has been inserted into a prohibition sign bearing the writing "Graffiti is a crime." On October 2, he paid homage to New York graffiti-writing of the 1970s and 1980s, recreating Wildstyle lettering. On three days (October 6, 19, 25) he published only videos on his website (the first, impactful one denounces war. The video showed a group of Islamist guerrillas who, believing they are taking out an enemy target, have actually shot down the little elephant Dumbo). He then continued his denunciations against fast food chains, intensive animal breeding and animal butchery, and his decisively cutting and ironic criticism of the art system was no less interesting. On October 13, Banksy installed a stand in Central Park, with his works put up for sale by an elderly man for sixty dollars apiece, without indicating who the artist was.

This residency in New York engendered a frenzied hunt for his work by masses of fans, detractors, art experts, and police, whose actions were carried out simultaneously on- and off-line, as recounted by Chris Moukarbel in the film *Banksy Does New York*[8]. Instagram and other social media outlets served as collaborative hunting tools, since they constituted spaces in which participants were able to share information, discuss the works, and exchange thoughts on the performances. When a new project appeared, people were immediately informed online and encouraged to interact with it and discuss it virtually on the social media, and to track the work down physically in the city's space. This physical and virtual sharing also went viral, because it encouraged the participants to further disseminate the works in different modes, from selfies with the work to photographs documenting its removal—in both cases then reposted via social media. Drawing on the perspective of Monachesi and Turco, we might even say that the vitality of Banksy's online work, and of his actions, may be considered as a characteristic sort of persistence of this art form, which is by its very nature transitory and ephemeral[9].

Better Out Than In introduces us to a reflection upon the relationship between Banksy and the social media as privileged channels in which he now guides all his actions of *détournement*. Many of his recent projects have linked distant participants together, intertwining physical and digital spaces. According to Queisner's theory[10], it is precisely the advent of social media that brings physical space back into play, and back to the centre of political and cultural action. The new technologies facilitate control over physical space and at the same time provide the cities' inhabitants with new tools of emancipation and communication.

The value of Banksy's images therefore resides in the global effects that the messages produce in the public sphere, by virtue of his ability to mobilize a worldwide network of participants.

[1] Guy Débord, *OEuvres*, Gallimand, Parigi 2006, p. 325.

[2] Dan Brooks, *Banksy and the problem with Sarcastic Art*, The New York Times, 10 September 2015.

[3] http://brandalism.ch/manifesto/

[4] Ibidem.

[5] www.brandalism.ch

[6] Banksy, *Wall and piece*, L'Ippocampo, Milano 2011, pp. 194-195.

[7] Ivi, pp. 218-219.

[8] Chris Moukarbel, *Banksy Does New York*, HBO, New York, November 2014.

[9] Paola Monachesi, Marina Turco, *New Urban Players: New Urban Players: Stratagematic Use of Media by Banksy and the Hong Kong Umbrella Movement*, International Journal of Communication, N. 11, 2017, pp. 1448-1465.

[10] Ibidem.

Banksy Removes the Mask for Us

Acoris Andipa

In our world we have put great stress on being authentic. But what does this actually mean? Especially as we have discussed for centuries in darkened corridors that we are almost never our 'true' selves. No, we all wear masks of one kind or another and some of these masks are so well-fitting that we do not even realise we are wearing them at all. Yet wear them we do, in fear of being naked to others and, perhaps more disconcerting, naked to ourselves.

So what happens to us when we engage with an artist such as Banksy who literally wears a mask at rare public interviews or in his film, *Exit Through the Gift Shop*, so that he can say and do things that we all wished we could say and do ourselves. Could this be one reason why so many people around the world have made a hero of this artist? Is this a form of admiration like "I wish I could do that, but I can't, so thank heavens someone has and is taking us along for the ride?" When we add to this that "a picture speaks a thousand words" we can more clearly see the attraction that this artist offers us all. Addressing challenging and ever-present issues with poignant and humorous one-liner artworks, Banksy makes us first laugh then wince, as we consider what is actually being presented before us: poverty, injustice, inequality, war, politics and a whole spectrum of social issues, historical and present day.

Of course, we warm to such a person who cleverly mastermind's artworks, installations and public events that draw us, mostly unknowingly, into looking at and hearing some worldly truths. If we go further and allow 'me' to go deeper within myself than our busy lives normally permit, we could begin to see some personal truths too.

Truth, or trueness, has a tough time in our society. Firstly, we struggle with taking our own masks off and being true to ourselves, and then just when we start believing that we can find ourselves in those glimpsing moments, we are hit with the juggernaut of relentless advertising, social media and the pervasiveness of information. Again, Banksy cuts through much of this noise by delivering us statements of ugly truth: commercialism being the new religion (*Christ with Shopping Bags*), the dogmatism of traditional faiths (*Toxic Mary*), the longing for love and security (*Girl with Balloon*), the schizophrenia of our media (*Paranoid Pictures*), etc. The more one looks at the art the artist offers us, the more we can see the freedom this artist who wears a mask allows us to fleetingly remove our own and look within. In that moment we are in stasis: we may realise that we do each wear a mask, and we can, from time-to-time, allow ourselves to take it off and see ourselves and the world more clearly. If it is difficult for us to differentiate between who we really are and what we present to the outside world, then similarly, the world suffers the same fate: it is difficult for us to distinguish between what is real and what is fake out there. With the easy manipulation of social media, newspapers and TV channels, and the sheer volume they relentlessly spew out, we increas-ingly find ourselves lost or unable to distinguish between the two. How often we ask ourselves "but is it true?".

The question of truth and lies is not a new one. These ethical debates have been going for millennia: from ancient Greece, Rome, Egypt, Persia and beyond. What is perhaps more astounding is that in the 21st century we find the need to describe (or excuse) the vastness of grey between what is right and wrong, truth and lie. Misleading people by telling another and irrelevant truth (but not answering the actual question) has become so pervasive in our lives that psychologists have given it a term of its own: paltering. We experience paltering every day of our lives, not least, in the comedic interactions of politicians who respond to difficult questions by giving another truthful fact without actually answering the question they have been asked. Through the ages, artists have responded to such nonsense in their own ways. Subtly in the past, more brazen now; making use of their position which affords them the privileged opportunity to criticise, argue and mock such behaviour.

Banksy does just this, an artist who cleverly fuses satire with poignant imagery that slices open the ridiculousness of what is clearly questionable with our world. The frustrations that we all share when we see stupidity in politics, the human cost of war, or the injustice of child labour. Banksy tackles such topics both through his art and his projects. His undertakings with *Dismaland* in England and the

Walled Off Hotel in Israel are just two such examples. These grab the attention of the global media, though here too the media often misses the truth, focussing more on the satire and less on their truthful poignancy.

Here too there is also some irony, the very tool that distributes the nonsense of fake or useless news to our phones, tablets and TV's now becomes a conduit for Banksy to carry his images and messages back to us. He is the envy of many an advertising executive or social media PR as his artwork or latest stunt goes viral in minutes. Why? Perhaps people see a truth which they already know deep down but still have the need to be jolted or reminded, or perhaps they take solace from something that finally feels authentic and clear from the streams of noisy digital feeds. Of course, there is also paradox here and it has been much debated before. How can an artist remain authentic, especially when involved with such themes as poverty and social issues, whilst selling art to celebrities, controlling the issuance of certificates of authenticity and undertaking public stunts at auction that results in increasing the value of the artworks? The explosion in demand to satisfy buyers, collectors (I distinguish the two as very separate) and museum shows is furious. Selling art for a few thousand pounds is one thing but selling publicly for £10 million pounds changes the game significantly. Yet, Banksy, being a one-way communicator to his constituency, and refusing to be represented by an art gallery, continues to break the rules, removing the mask of the art market itself. By the artist "lying" to the market: bringing with him his own set of rules and conditions, perhaps this rebalances our belief in authenticity. As for the vast monies being generated, we can accept this dichotomy if Banksy continues to give us future projects, public street art and further opportunities to remind ourselves of some truths.

So, is he a private school boy, champagne socialist, Robin Hood hero, or an artist who was in the right place, at the right time? Actually, does it really matter? ...through his "lies" he elbows the door open to truths we all need to be reminded of, and he gives us a chance to remove our own mask, if only for a moment.

Aesthetics for a Realistic Market

Street Art, the Publicity of Art

Stefano Antonelli

In Banksy's work the traditional art aesthetics—in terms of art thesis—and the vandalic, and anti-artistic practice of *writing*—in terms of art antithesis—coexist in a productive way, fuelling the necessary contradiction that Boris Groys (2008) identifies as modernity of art constitutive element.

His "ways of doing" (Jacques Rancière, 2004, 13) emerges in the indefinable perimeter of an idea which combines "art" and "street" and which, at the beginning of the 21st century, puts at the center of its reflections the systematic placement of images in public urban space, given back to us by the media-oriented public discourse with the label of *Street Art*. The contemporary debate on this topic raises fresh questions whose answers would have different purposes, including determining whether it is art or not, shaping a definition and identifying its specificity.

Nicholas Alden Riggle (2010) argues that "an artwork is *street art*, if and only if, its material use of the street is internal to its meaning" (Riggle, 2010), while Andrea Baldini (2016) singles out *street art* specificity in the illegality of the practice that would establish its constitutive paradigm, in other words: its subversiveness.

We believe that asking whether *Street Art* is art or not is like asking whether Dada is art or not, the excess of sense and influence over the visible regime that the lemma presents, makes it appear a useless question for its own purpose. We also believe that wanting to define *Street Art* is like wanting to define Fluxus, still a useless activity for its own purpose, no matter how you try to delimit it, something always remains out. Identifying in illegality the essence of *Street Art* appears to be simplistic, misleading and too easily refutable, moreover, the whole art history from modernity to the present day is dotted with subversion without being *Street Art*.

Instead, it seems that this specific "way of doing and making" (Rancière, 2004, 10), radically changes the way of production of the artwork itself.

In *Street Art* practices, the artist's studio is no longer the place of creation but the public space, the outcome of creation does not appear as an object that, therefore, cannot be exposed to the market, however, even when objectified, the Artworld (Arthur C. Danto, 1964) uses it to present *Street Art*. So what is the *télos* of this way of producing art? Federico Vercellone (2013) reminds us how modernity is a succession of "symbolic murders" (Vercellone 2013), the death of God announces that "there is no power in the world that could be perceived as being infinitely more powerful than any other" (Groys, 2008, 2), modernity is therefore where the only possible belief is the balance of power.

It's precisely by celebrating the modern state based on balance of power, that Hegel announces the death of art, according with Groys, "he couldn't imagine that the balance of power could be shown, could be presented as an image" (Groys, 2008, ib.).

To the thesis of a twentieth century producing an art that has increasingly withdrawn from the public and from the dialectic with the power to identify itself only with its own market, that recedes from taking part in "what is common" (Rancière, 2004, 40) and stops having any kind of influence over the real—so that withdrawing from its own mandate of truth—the twenty-first century opens responding with the antithesis of an idea of art that seems to affirm how in the era when dream becomes sleep, economic culture becomes destiny, time a commodity and "tout ce qui était directement vécu s'est éloigné dans une représentation" (Debord, 1992), the truth of art is replaced by the publicity of art.

This is the way *Street Art* practices turns the civic space established by architecture and urban planning into a "distribution of the sensible" (Rancière, 2004, 12).

Bibliography and sitography

Baldini A. (2016), *Street Art: A Reply to Riggle, The Journal of Aesthetics and Art Criticism, Wiley on behalf of The American Society for Aesthetics*, Volume 74, n° 2, pp.187-191, visitato il 03/04/2020 17:52 UTC.

Danto A. C. (1964), *The Artworld*, "Journal of Philosophy", Volume 61, Issue 19, American Philosophical Association Easter Division, pp. 571-584.

Debord G. (1992), La société di spectacle, 3e édition, Paris, Les Éditions Gallimard, p. 10.

Groys B. (2008), Art Power, Cambridge, London, The Mit Press, p. 2.

https://www.jstor.org/stable/40793266

https://www.jstor.org/stable/44510496

Rancière J. (2004), The Politics of Aesthetics. The distribution of the sensible, New York, Continuum International Publishing Group, pp. 10-12-13-40.

Riggle N. A. (2010), *The Transfiguration of the Commonplaces*, "The Journal of Aesthetics and Art Criticism", Wiley on behalf of The American Society for Aesthetics, Volume 68, n° 3, pp.243-257, visitato il 03/04/2020 17:52 UTC.

Vercellone F. (2013), *Dopo la mortè dell'arte*, Bologna, il Mulino (my translation).

Banksy and the Amazon Multiple

Gianluca Marziani

The way Banksy produces and sells his works deserves careful consideration. The viral strategy that shortens the old supply chain and bypasses exclusive galleries needs to be examined. These are no random steps, but calibrated actions that follow precise distribution rituals. Banksy starts with an orientation to the fluid movements of e-commerce. He follows the strategic waves of *special* and *limited* objects, the temporary key of *capsule collections*, the timing of *countdown sales*. This means orientating the production to online business models, to systems that push goods around individual users. It means thinking in a new light the dialogue between artist and audience, work and collectionism, access and consistent value creation. Banksy invites the individualistic logic of the unique object, creating *cluster works* that multiply sales while evoking a sense of attraction, of morbid fetishism, of obsession to own in a context of transnational clouds. The single work (which Banksy builds up with the structure of a complex operation stretched out over time and space) preserves the aura of uniqueness while avoiding the exclusive logic that in the past favoured economic power over the democratic sharing of content. With Banksy, there are many unique pieces *splitting* the work into a digital logic with a fluid profile; the specific subject is reproduced in a stamped and numbered series that is not limited to the old graphic culture but becomes the new idea of Multiple 3.0. In the past, affordable graphic arts of high-priced artists were produced on canvas: they played with the logic of alternative surrogates, furnishing the bourgeois living history without aesthetic strategy. The world of fluid commerce turned the system of artistic surrogates upside down and changed the language and management profile of valuable objects. The graphic art of the 1970s has been transformed into an autonomous format that is no longer an alternative to the unique piece, but part of the artist's conceptual strategy. The old-school multiple now becomes a multiple that forms itself on the commercial domains of the web. From now on, for the sake of simplicity and synthesis, it could be called the AMAZON MULTIPLE (with reference to Amazon for the functional value that archetypes have).

While museums and galleries rewrite their status, exit strategy artists are feeding the Amazon object in bulk. No longer just graphic arts on paper or Fluxus-style multiples, but objects for global fetishism with prime delivery, beautiful and possible gadgets, to experience and wear at a modest and guaranteed price, fragments of an inclusive e-commerce that makes art viral on metamorphic surfaces. In the past, posters of famous paintings were produced, offering the cheap surrogate of an impossible property; today Banksy distributes his silkscreen printings in large editions at reasonable expense (with the discriminant of a limited number of pre-orders) while offering the possibility of a gigantic investment profit, the big coup that only digital democracy makes possible. On the internet, one pays a hundred dollars for an object or a silkscreen printing with a high edition, which is resold after some time at much higher prices. This is not the new rule, to be clear, but an extreme limit (where speed and digital skills count) that art offers to an ever-wider audience and fewer and fewer "insiders".

The Amazon forest of author multiples creates an audience of users with new expectations, disciples of a less explained and much more visual art, many small collectors chasing the global energy of social media content. The art of multiples is linked to the typical production of unique pieces (which lubricate the financial engine and satisfy systemic collectionism), a strategic lesson that Damien Hirst, Jeff Koons and Maurizio Cattelan made a school.

The artist's gadget owes much to the distribution rules of fashion and the industrial rules of design. Capsule collections, the flowing culture of gender-fluidity, special editions, storytelling, the new retail chain, attractive packaging... the usual fashion thinking, *fashion thinking* that is not limited to clothing but extends to the entire habitus, to the world of gadgets (useful and above all useless but beautiful) that surround the individual user, a trickle of viral stimuli for our senses, sensitized by algorithms geared to widespread taste.

Banksy relies on viral actions rather than the old rules of commitment. The Bristol artist avoids the divine model of

producing a few works at exorbitant prices, preferring operations where the idea becomes a matrix that can be reproduced in heterogeneous ways. A wall stencil may be a silkscreen printing, but also gadgets of various kinds, a multiples shop can be an extreme travel experience (the pieces on the *Walled Off Hotel* can be bought at reasonable expense, but only if you stay at this hotel in Bethlehem). Each process triggers a circular and morbid communication, as if it were a play that sets the cycle of events in motion, a domino effect with prolonged release where the image is the cue to connect people, places and objects. Banksy simultaneously provokes unstoppable consequences; he actually activates his visual editorials to raise the volume of the news, desecrating the moral sense of humanity in the process.

As *Boris Groys* wrote in his "*Going Public*": "Any project arises from the desire to be resynchronized with the social context, and it is successful when the synchronicity thus gained space in steering people in the desired directions". Where will art go in the years to come?

In all probability, it will go towards the construction of other dialogues, towards better informed and more aware audiences, towards cities that will resemble extensive museums, towards digital places that will house the communities of a new creative species. There will be more and more heterogeneous proposals, less dogmatic divisions between high and low, more openness between the work and the real world, many more people in the management of the new 3.0 chain...

The cultural revolution has just begun...

Entry Point 1: Punk

Punk

Stefano Antonelli and Gianluca Marziani

Interviewed by Steve Wright for the magazine *Venue Bristol* on the occasion of his first show at the restaurant Severnshed in 2000, Banksy stated that the exhibition's theme was "punk fucking rock." Often abbreviated to "punk," punk rock is a genre that developed between 1976 and 1979, taking its inspiration from previous forms of music derived from garage rock. Punk group songs had fast rhythms and a raw sound; the tracks were almost always short, with bare-bones arrangements and provocative, violent texts characterized by political angles. Punk culture embraced the "Do It Yourself" (DIY) ethic, creating a circuit of self-produced recordings and distribution alternative to the mainstream. Punk marked a fundamental transition in the British people, a phenomenon that was born with music but extended to dress, graphic style, gestures, and a whole way of living in the world. It was a lineage that brought together Malcolm McLaren, Vivienne Westwood, Johnny Rotten, and Joe Strummer, but also David Bowie, Tricky, and Goldie; it went back all the way to William Shakespeare and Oscar Wilde, passing by way of Derek Jarman, Howard Marks, Guy Ritchie, Alexander McQueen, Richard Branson,

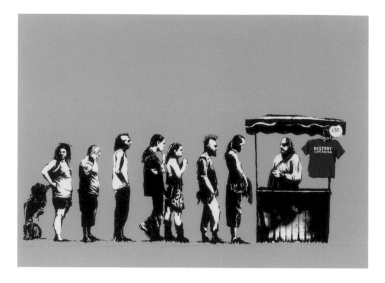

Festival (Destroy Capitalism)
2006
Silkscreen print

and Damien Hirst. Banksy, too, belonged to this brash and volatile lineage.

The most well-known mark of Banksy, that crude, black-and-white line—do you know where it comes from? Have a look at the works by Jamie Reid, the graphic designer who made headlines for his Sex Pistols album covers. He was among the champions of a punk aesthetic that had conquered Britain's young rebels. When observing works by both of them, you will see that Banksy was clearly inspired by Reid. Consider his most famous cover, for the album *God Save the Queen* that made the Sex Pistols legendary. Reid disfigures the Queen's face, inserting the band's name and the album title in place of her eyes and mouth, all set upon the garish colors of the Union Jack. The effect is shocking to the eye, a stick of political dynamite that empties the monarchy of its symbolic power, shouting into the work all the rage of an antagonistic generation. *God Save the Queen* is a track of profound inspiration for Banksy, an archaeological act that contains the graphic commandments with which the artist was to develop all his stencils.

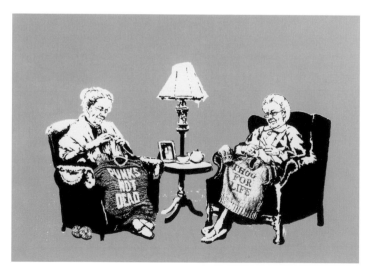

Grannies
2006
Silkscreen print

Turf War
2003
Silkscreen print

Entry Point 2: New York Graffiti

New York Graffiti

Stefano Antonelli and Gianluca Marziani

New York graffiti, investigated with baptismal vision by Francesca Alinovi during their discovery in the 1980s, is one of two points of access to the study of Banksy. The other is Punk (as discussed above).

American photojournalist Martha Cooper was born in Baltimore in the 1940s. She worked as a photographer for the *New York Post* in the 1990s, and is noted for having documented the birth and development of *Style Writing* in New York in the 1970s and 1980s. In 1984, Cooper and Henry Chalfant published the book *Subway Art*, considered the *graffiti bible* to this day.

In the 1990s, New York graffiti encountered the British punk that had conquered the hearts of the previous decade's young rebels. This encounter took place in a mixed and quarrelsome Bristol, a southern port city strongly influenced by the Jamaican community that lived there—a place where Britain's imperial pragmatism appeared to wilt, submerged by a *cool* life lived to the slow rhythms of pot and reggae. It is no accident that Bristol saw the birth of the trip hop of Tricky and Massive Attack, a slow, nocturnal rhythm coming from the B-side instrumentals of Kingston reggae.

New York graffiti and British punk share an ethic of vandalism, a critical spirit, an antagonistic impulse, and a countercultural stance: two vandalisms that became cultural phenomena, two ways of being that presented different aesthetic representations. While music produced a hybrid form of rock in Great Britain, in the United States it gave rise to rap; in the visual arts, however, America saw the birth of the Style Writing phenomenon, while graphic design exploded in Great Britain, with the album covers for the Sex Pistols, The Clash, and the other incendiary practitioners of political sound. Banksy represents the point of intersection between these vandalistic dimensions of modernity, providing a precise imagery for the critical impulses of the young generations.

Rodeo Girl
2008
Giclee print on paper

Lying to the Police is Never Wrong
2007
Spray paint and mixed media on board

Timeline

1998

Walls on Fire

Joined by Inkie, Bristol's graffiti king in the 1990s, Banksy organizes *Walls On Fire*, the biggest style-writing event ever staged in Great Britain. Over a long weekend, artists from the United Kingdom and all of Europe work on a wall 365 metres long, around Harbourside, Bristol.

1999

The Mild Mild West

On the wall in front of the Subway Records record shop, Banksy paints what we may consider his first work of contemporary street art: *The Mild Mild West*. The work shows a teddy bear hurling a Molotov cocktail at some policemen. Preserved by the municipality of Bristol, the work can be seen to this day.

2000

London

Banksy moves to London and his *rats* begin showing up in the northern part of the city, where mostly the working classes live. Banksy himself explained his choice of subject: "They're small, hated, persecuted and despised; they live underneath the city, in sewers and landfills. Yet they're able to bring entire civilizations to their knees, to colonize areas and dictate laws".

First exhibition in Bristol

By late 1999, Banksy has already left Bristol, but returns a few months later for his first exhibition at Severnshed, a floating restaurant along the river crossing through Bristol. All the works are sold during the inauguration. The curator Robert Birse observes: "It was the first time he had done work on canvas. He didn't have a clue how to make canvas stretch or prepare the artwork."

2002

Existencilism

On July 19, 2002, Banksy opens his first exhibition in Los Angeles, at 33 1/3 Books & Gallery. The exhibition is called *Existencilism*, combining the words "stencil" and "existence". The show's subtitle is, "graffiti, lies and deviousness". *Existencilism* is where the artist presented some of his most popular images, like *Love is in the Air*, *Queen Vic* and *Laugh Now*. *Existencilism* is also the title of one of the three now-rare Black Books published by the artist.

2003

Turf War

In 2003, a million people demonstrated through the streets of London against the War in Iraq, and Banksy organizes what may be considered his first, real exhibition in London. About the war, of course, and titled *Turf War*, it is clandestinely staged in a warehouse in Kingsland Road, on London's East End. Shortly before the public opening, Banksy issues a message signalling the presence of forty bottles of cheap, red wine and telling visitors not to go to the show without bringing their own.

Flower Thrower

The most famous "flower thrower" is made by Banksy this year. The large-scale stencil work is located in Ash Salon Street in the Bethlehem area, on the side wall of a garage opposite a well-known local car dealership.

2004

Girl with Balloon

Banksy paints her for the first time with the stencil technique, in uncommissioned form, on a wall at the side of a bridge in London's Southbank area in 2004. The artist signs his work on an electrical box located at the bottom right of the work, and accompanies the image with a text that reads: "There is always hope." In his Black Book *Cut It Out*, in which the artist publishes the work in 2004, he adds: "When the time comes to leave, just walk away quietly and don't make any fuss."

Banksy of England banknotes

Banksy produces a series of 10 pound banknotes, replacing the face of Queen Elizabeth with Princess Diana and modifying the words "Bank of England" to "Banksy of England". Some report seeing wads of these banknotes in the crowd at the Notting Hill Carnival, even attempting to spend them in various stores as if they were authentic. Banksy also uses them as invitations for the exhibition *Santa's Ghetto*, promoting the association Pictures on Walls, during which an entire page of fifty uncut notes is on sale for 100 pounds to commemorate Diana's death. The banknotes appear in October 2007 at the Bonhams auction house, where one is on sale for 24,000 pounds, and at the Reading Festival, thrown into the middle of the crowd.

Museum invasions

Banksy goes into some of the most famous museums in the world. The Louvre is the first museum hit: the video cameras capture him attaching a portrait of the *Mona Lisa* plastered with a smiley face. In March, he goes to the MoMA, the Met, Brooklyn Museum and American Museum of Natural History in New York. Later, he shows up at the Tate Gallery, and in May, the British Museum in

London. Banksy goes in dressed as a retiree with his face covered by a hat; undeterred, he attaches paintings to the walls that he brought with him in a bag. The CCTV cameras capture him as he looks around and hangs his paintings between major masterpieces. At the Brooklyn Museum, he affixes an eighteenth-century general with a can of spray paint in his hand, while behind the figure are pacifist graffiti marks; at the MoMA, he unveils a Warhol style can of Tesco soup; at the Met, he installs a portrait of a noblewoman with a gas mask, and at the American Museum of Natural History, a real cockroach with missiles under its wings.

2005

Santa's Ghetto

Santa's Ghetto is a charity exhibition of various street and graffiti artists, in support of Palestine. The Palestinian land profoundly touches Banksy's feelings. In 2005, without further delay, he goes to Palestine. Banksy targets the kind of wall with a strong political connotation: and here there is the most absurd and surreal wall of separation, erected between the Palestinian and Israeli territories to combat terrorism—at least according to the Israelis. On his first journey to Palestine, Banksy does a series of paintings on the separation wall with Israel. He is also subjected to some criticism, because the Palestinian people hates the wall. Aware of this, the artist reports this disagreement in the documents he himself produces.

Crude oils

After Palestine, Banksy returns to London. His new idea is a project that involves the most classic art, and consequently oil painting. Titled *Crude Oils*, the exhibition comprises about twenty canvases: classic paintings upon which he intervenes with his own raw style. Banksy defines it as an exhibition of "remixed masterpieces," and it is here that he presents *Show Me the Monet*, the painting parodying a famous work by the French impressionist. This work would be auctioned by Sotheby's in 2020 for 7.6 million pounds. Alongside the paintings, the gallery located in Westbourne Grove is also populated by two hundred live rats running along the floor. As usual, Banksy's influence is a game changer.

2006

Telephone box

Banksy surprises London's Soho residents by leaving behind a British telephone box, tipped over and bleeding, murdered by a pickaxe. Even though the Westminster Council tried to remove it immediately, British Telecom circulates a press release describing the work as "a formidable visual commentary on the transformation of British Telecom from an antiquated telecommunications company to a modern supplier of communication services".

Disneyland

Banksy flies to Anaheim, California, where Disneyland is located. Having paid his entrance ticket, without being seen, he sneaks into the rollercoaster Big Thunder Mountain, installing a blow-up doll dressed as a Guantanamo Bay prisoner (completely orange, its head covered by a black bag, and handcuffed) next to a cactus and ensuring that it can be seen from the train car. It took an hour and a half for visitors and security to realize it was there.

Barely Legal

This is the exhibition that confirms Banksy as a rising art star: the public is welcomed by a female Indian elephant, 36 years of age, named Tai, painted with a damasked red and gold pattern, like the upholstery of the room where it is placed. Visitors are greeted at the entrance with a sign reading: "There's an elephant in the room. There's a problem we never talk about. The fact is that life isn't getting any fairer. 1.7 billion people have no access to clean drinking water. 20 billion people live below the poverty line. Every day hundreds of people are physically sick by morons at art shows telling them how bad the world is but never actually doing something about it. Anybody want a free glass of wine?" Thus Banksy aims to attract attention to the problem of global poverty. In just three days, the exhibition brings in some 75,000 visitors.

Paris Hilton

Paris Hilton asks Banksy to paint her as a true heiress, but the artist bluntly refuses. With the release of her first album, *Paris*, Banksy seizes the opportunity and buys 500 copies in forty-two music stores across the United Kingdom, modifying the cover and inner sleeve by replacing them with a parody version. A video shows Banksy entering a Virgin Megastore disguised and buying a copy of the CD. Back in his studio, he scans the cover and inner sleeve, replacing the words with letters cut from newspapers, creating phrases like, "Why am I famous?", "What am I for?", and "90% of success is showing up". Lastly, he replaces Paris Hilton's face with her Chihuahua's head.

2007

Sotheby's

Sotheby's is the first auction house to sell seven works by Banksy. Ralph Taylor, specializing in contemporary art, declares, "Banksy is the fastest growing artist ever seen".

2008

Kate Moss

In London, his piece depicting the English model Kate Moss—inspired by Andy Warhol's four faces of Marilyn Monroe—is sold for 210,550 dollars. The first version of Kate Moss's face dates to 2006, sold by Sotheby's for 50,400 pounds: in two years, the price quadrupled.

The Cans Festival

For an entire weekend, London welcomes the top stencilists in the world for the *Cans Festival*. The location was a secret until the start of the event, when it was revealed that it would be in Leake Street. The twenty-nine artists that Banksy invited to participate could design whatever they wanted, so long as they respect the other artists and don't erase other works.

The Village Pet Store and Charcoal Grill

The exhibition, organized in an animal store in New York, displays "animatronics". In the window, a hen watches her chicks-turned-chicken nuggets, a reference to Chicken McNuggets from McDonald's, pecking at a bowl of BBQ sauce, and a rabbit puts on make-up in front of a mini mirror. Fish sticks are also seen swimming in the aquarium, hot dogs hide between rocks like snakes, the hollowed-out fur of a leopard is perched atop a tree and the famous bird Tweety, now old and wrinkly, dangles in his cage.

2009

Banksy Vs Bristol Museum

The artist's first exhibition in a museum, held in his home city. The museum's director says that he accepted the artist's proposal to organize an exhibition of his artworks. For the entire duration of the show, Kate Brindley, Head of Museums, Galleries and Archives for Bristol City Council, never met the artist, and even thought that the whole thing was a hoax. Banksy made seventy pieces on site and brought in an additional thirty, for a total of 100 artworks, including sculptures, installations, paintings and canvases. The artist declared, "For the first time, the English taxpayers' money is used to hang up my works instead of destroy them". The museum added two of the pieces on display to its permanent collection at the end of the show.

Banksy Vs Robbo

In a tunnel along Regent's Canal, Banksy depicts a painter pasting white wallpaper over Robbo's large tag, there since 1985 and which no one dared to ever touch. The spray paint war begins.

2010

Pier Pressure

Near the port in Brighton, locals find a different kind of children's ride: a dolphin snagged in a net is trying to jump over a tipped can with oil spilling out of it. The image Banksy realizes aims to polemicize with the oil company British Petroil, which was held responsible for the environmental disaster in the Gulf of Mexico.

Exit Through The Gift Shop

During the 2010 Sundance Film Festival, Banksy's film *Exit Through The Gift Shop* makes a surprise appearance. As they arrive for the showing, guests are welcomed by young ladies offering spray cans instead of classic bags of pop-corn, inviting them to tag something on the side of a truck parked next to the red carpet. One of the film's protagonists is Thierry Guetta, known as Mr. Brainwash. Those hoping to see Banksy's face are disappointed. The mechanism is always the same: talk about yourself through others, without ever showing yourself. The documentary was nominated for an Oscar.

2013

Better Out Than In (Banksy Does New York)

On October 1, 2013, Banksy announces he will undertake a month-long residency in New York. The artist unveils a different artwork every day, announcing them on his website and Instagram. Banksy fever immediately takes over New York, to the point that the mayor condemns the stunt. The title *Better Out Than In* comes from a quote by Paul Cézanne: "All pictures painted inside, in the studio, will never be as good as those done outside". Only few of the works made during this time will survive. The project was narrated in the documentary *Banksy Does New York*.

2015

Dismaland

From August 21 to September 27, Banksy opens *Dismaland*, a temporary project organized by the artist in the seaside town of Weston-Super-Mare, in Somerset (England). Prepared in secret, the project is a collective exhibition curated by Banksy and featuring his works. The event takes place at the Tropicana, a disused lido, where the artist has reconstructed a sinister and wearied version of Disneyland. Banksy describes it as "a family theme park unsuitable for children". When *Dismaland* is dismantled, Banksy uses the materials to build an unauthorized village for refugees in Calais. For the project, Banksy unveils ten new pieces and invites 60 artists, 58 of which participate.

2017

Walled Off Hotel

On March 11, 2017, Banksy announces the inauguration of the Walled Off Hotel in Bethlehem, Palestine. The name mocks the famous luxury hotel chain Waldorf. The project consists of a small hotel in Bethlehem across from the Israeli West Bank barrier, offering guests "the worst view in the world", the artist's slogan for the initiative. The hotel contains works by Banksy and other artists, themed rooms and a shop where guests can buy materials to make street art.

2018-2020

The shredded *Girl with Balloon*

The last work to be sold at auction at Sotheby's in London, on October 5, 2018 is the famous *Girl with Balloon* which goes for 1.04 million pounds. The moment the auction hammer strikes the final blow to close the bidding, a beeping sound resounds in the auction hall and a shredding mechanism hidden in the mighty artwork frame starts to move, reducing the work to strips. The scene, filmed by various cameras documenting the auction and witnessed by a stunned public, goes viral and the gesture adds a new topic to the debate surrounding the relationship between art and the market. The commentary on current affairs and the representation of reality are a typical element for Banksy, who deals both with the topics included in and those excluded from the political agendas: this is testified by the recent work dedicated to the killing of George Floyd and the homage to doctors and nurses on the front line against COVID-19, *Game Changer*, showing a child discarding the figures of Batman and Spider-Man in a bin in favor of a new superhero toy: a Red Cross nurse with her arm raised like a new Superman.

The M.V. *Louise Michel*

To respond to the migratory crisis in the Mediterranean, Banksy launched a ship: The *Louise Michel*, dedicated to the emblematic anarchist writer active in the Paris Commune, is a former French Navy boat customised to perform search and rescue. It was bought with proceeds from the sale of Banksy artwork—who then decorated it with a very special version of the *Balloon Girl* in which what is carried away by the wind is not love, but a lifebelt, or rather: life.

Imaginarium

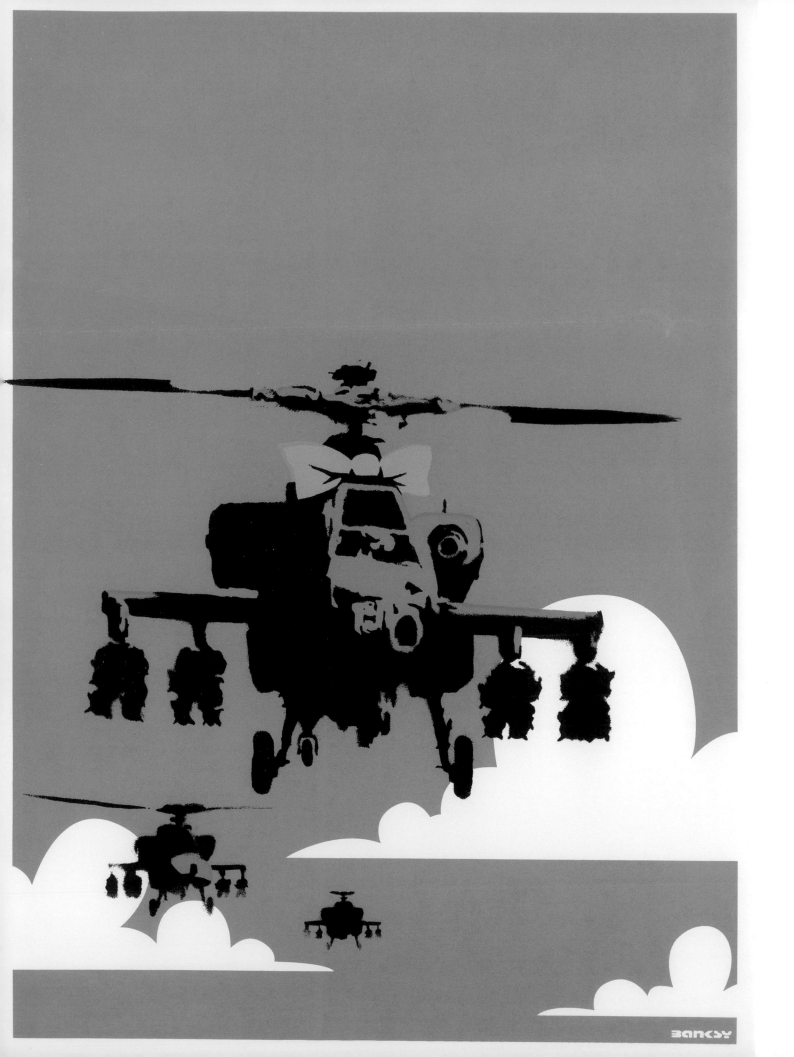

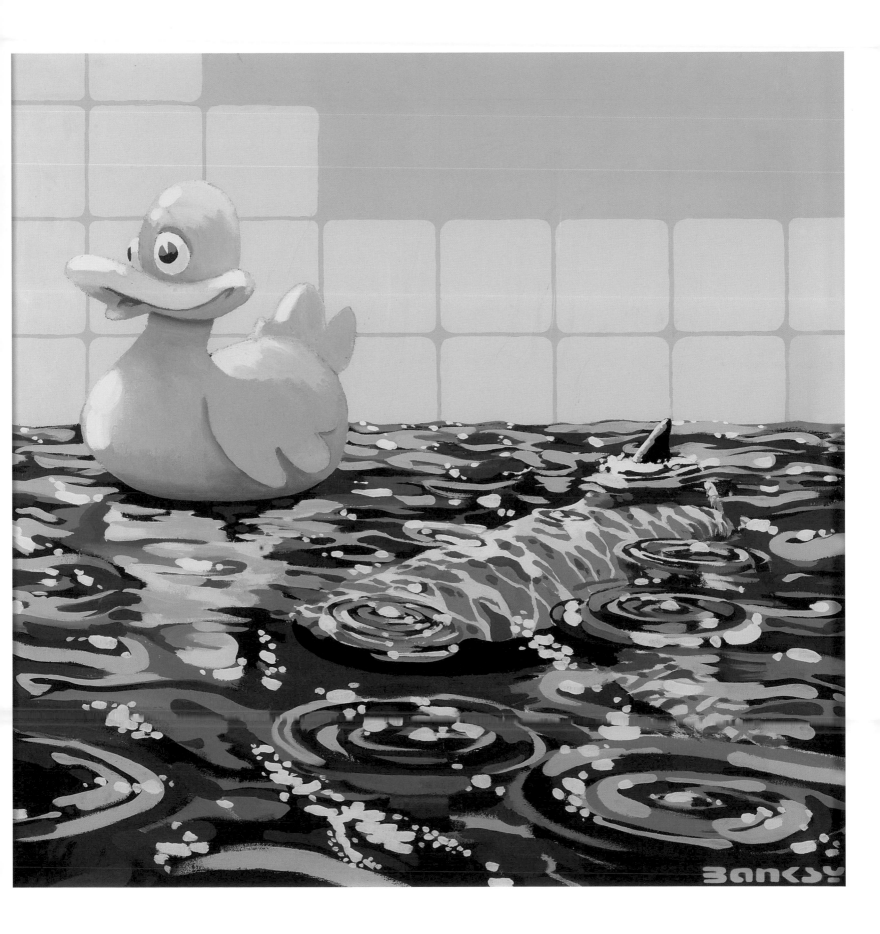

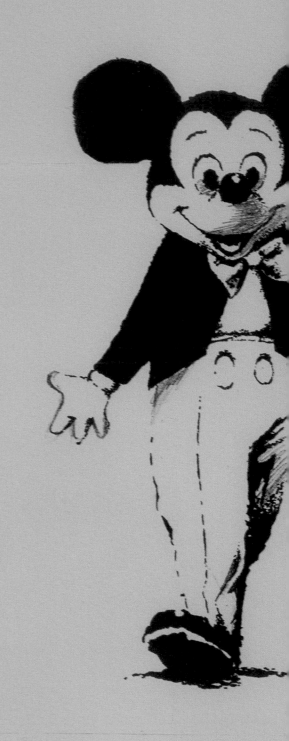

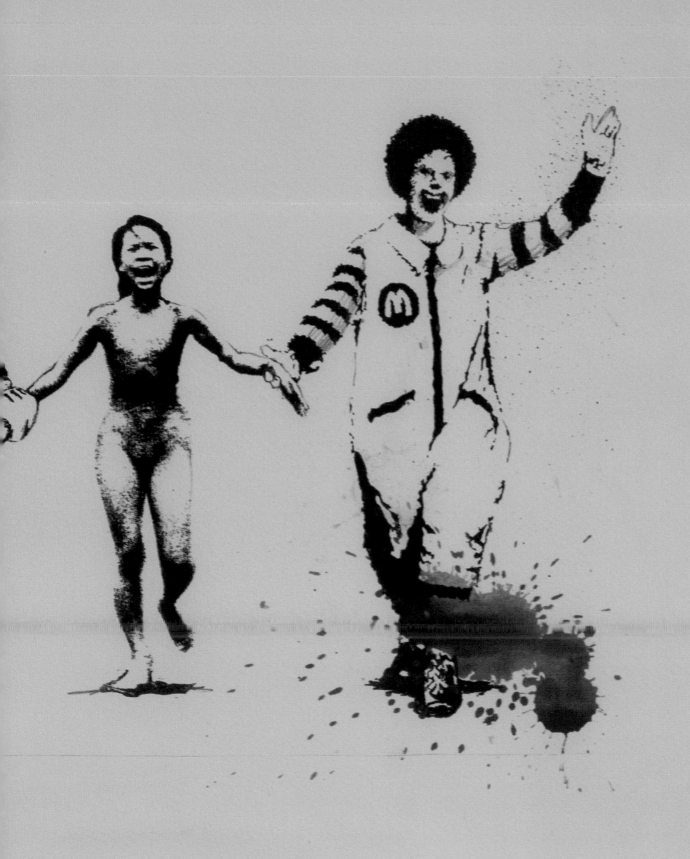

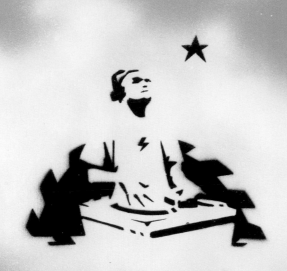

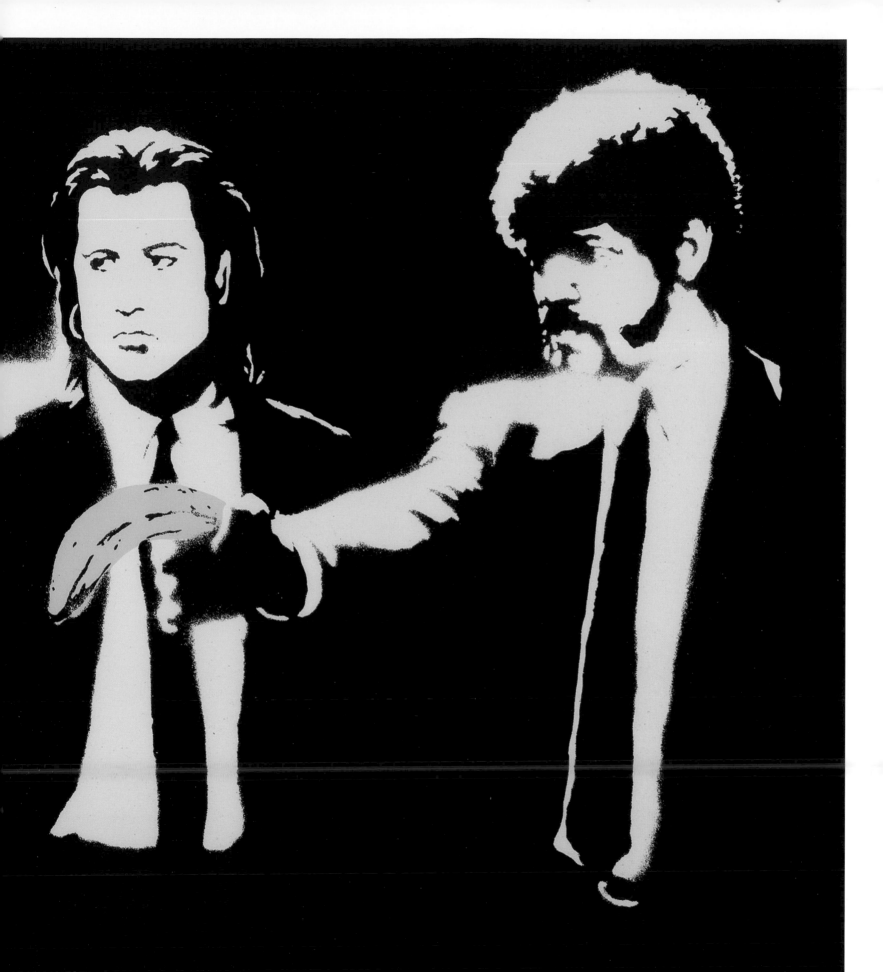

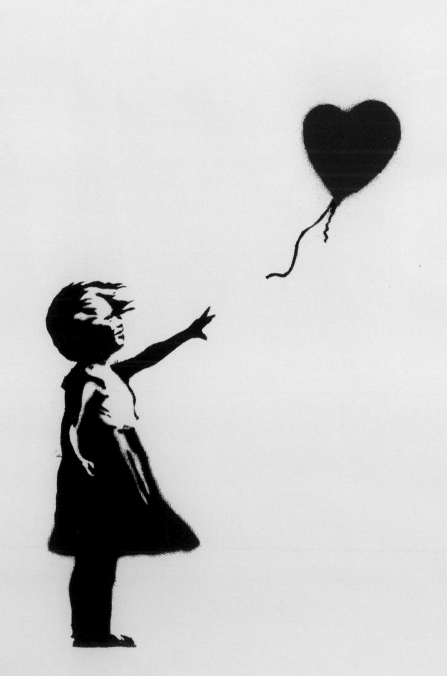

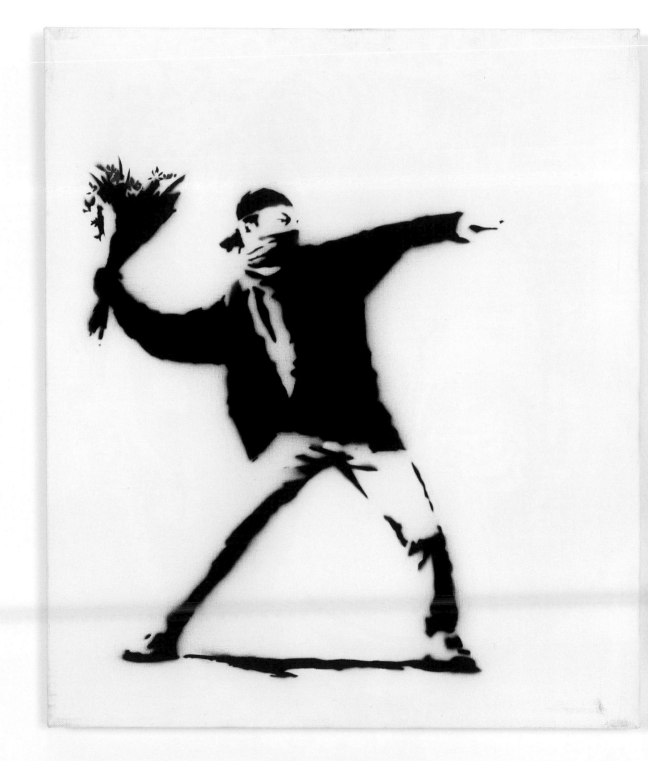

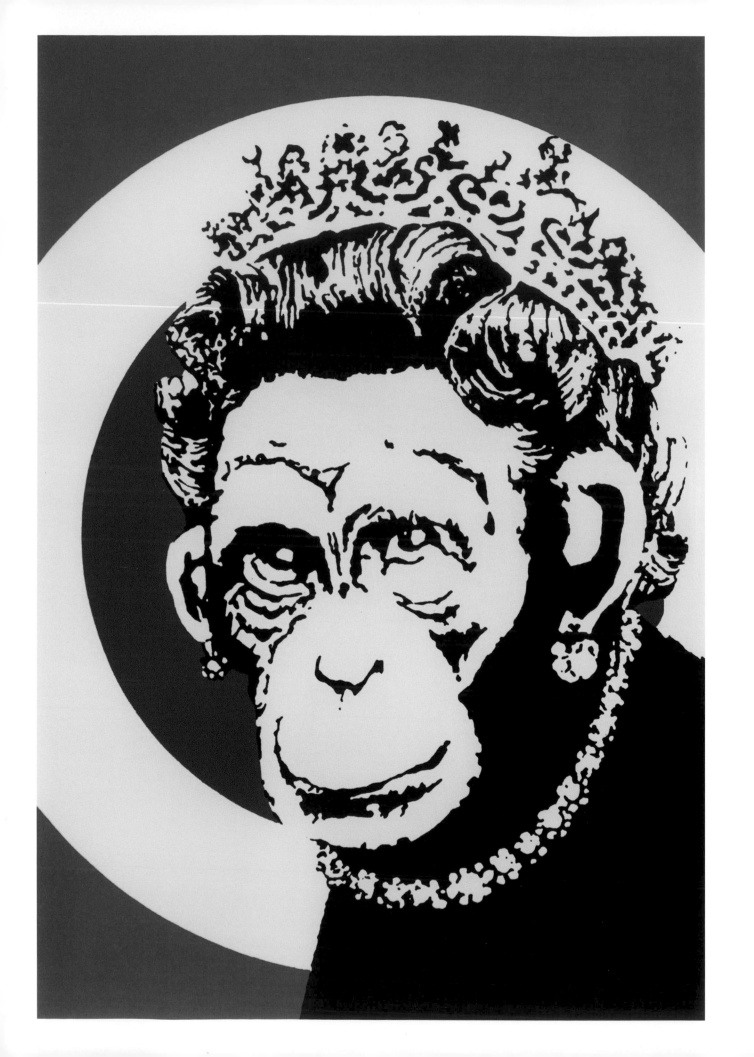

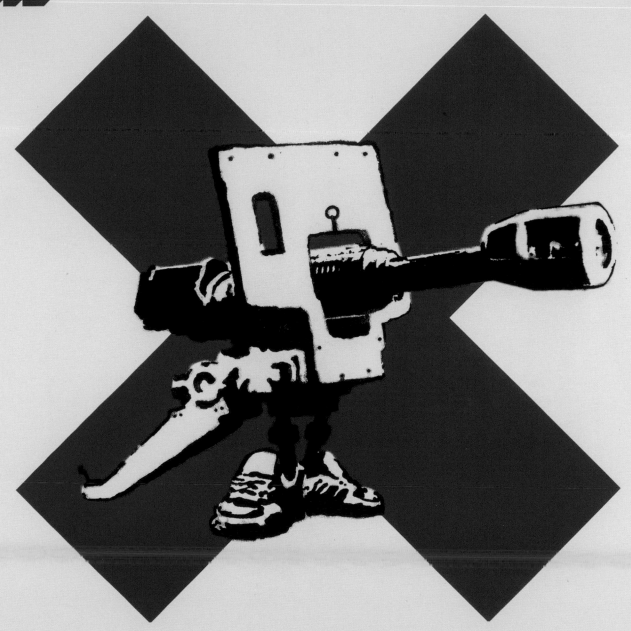

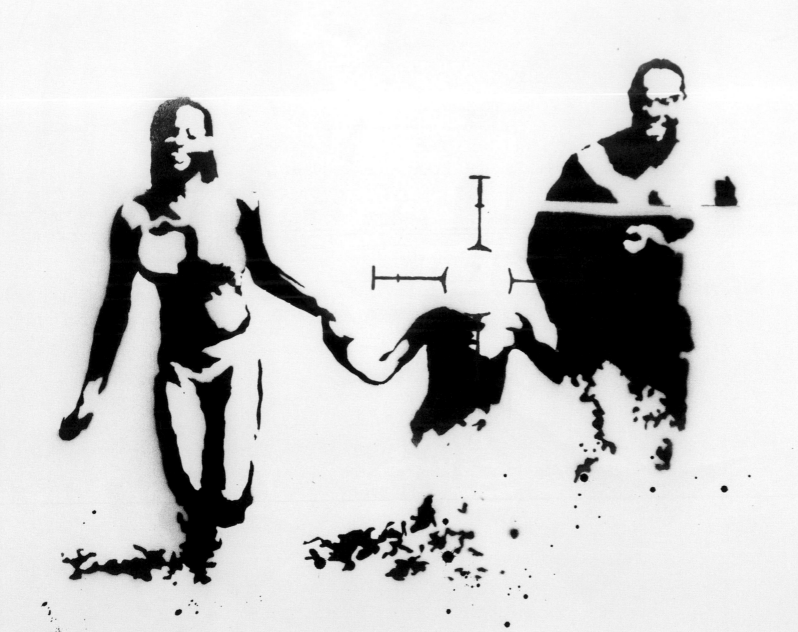

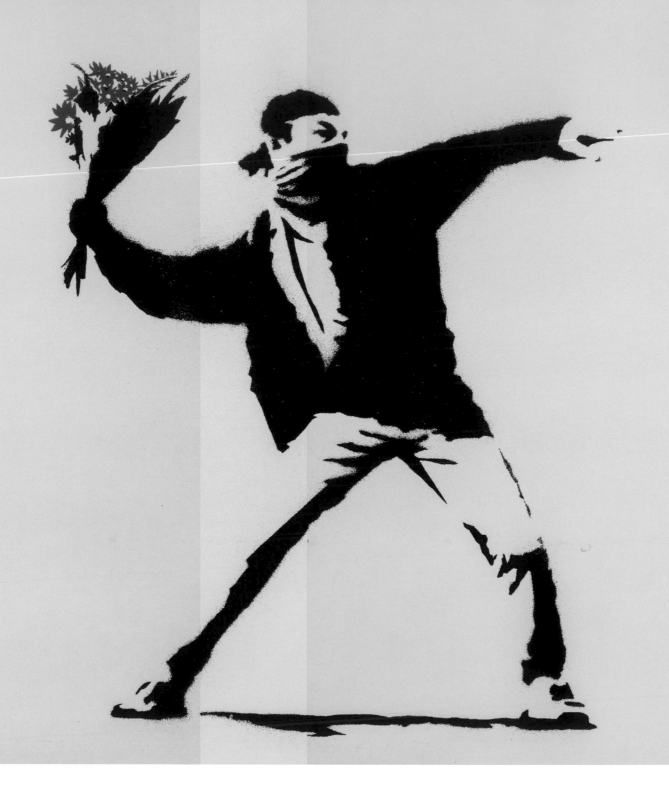

Catalogue

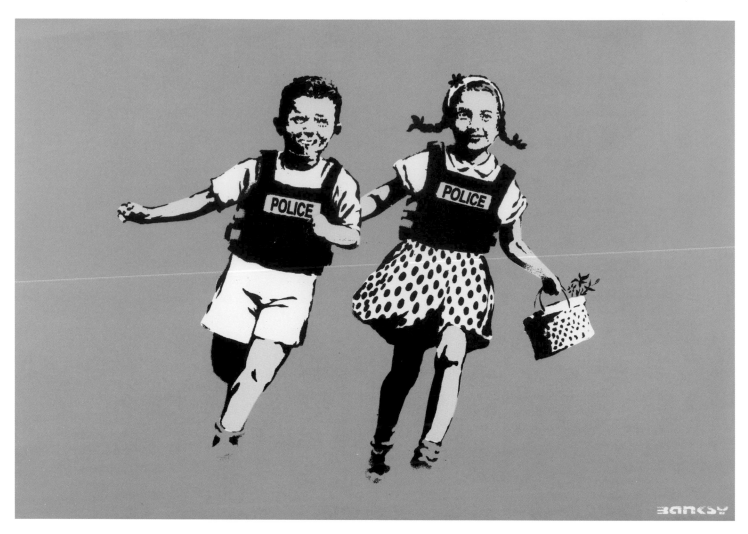

Jack & Jill (Police Kids)
2005
Silkscreen print
50x70 cm

Banksy often tackles themes tied to childhood. In his book *Wall and Piece*, he wrote, "A lot of parents will do anything for their kids, except let them be themselves." This quote is necessary to understand the meaning of this image that depicts two children jumping happily in what seems like normal water. The aspect of carefree childhood is contrasted with the kids' bulletproof vests bearing the word "Police". *Jack & Jill* focuses on the paradox that creates tension between the presumed innocence of childhood, the worries of parents and a "militaristic" society where families tend to adopt overly protective attitudes toward their children. Banksy often uses bulletproof vests: in one of his versions of the dove of peace painted in Palestine in 2007, *Armored Dove of Peace*, the bird is wearing a bulletproof vest like the figures in the series *Family Target*.

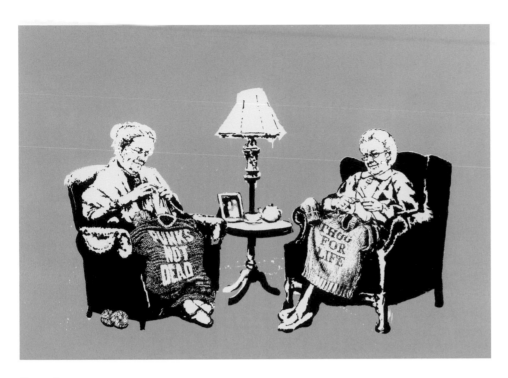

Grannies
2006
Silkscreen print
56x76 cm

Grannies appeared for the first time during the 2006 exhibition *Barely Legal* in Los Angeles, as a stencil on canvas. It was never made as an outdoor work and is one of the images that best uses typical British humor. Set against a pink background, the piece shows two friendly grannies, or grandmothers, knitting in their chairs. But look closely at the words on the shirts they're making: they've knitted subversive phrases that represent protest slogans which usually show up in vandalized streets and as tattoos. One of the grannies is making a sweater with the phrase "Punk's Not Dead", while the other says "Thug For Life". Both women have an expression of satisfaction on their faces, as if they're happy to participate in a subversive culture, or as Banksy called it, "entry-level anarchy".

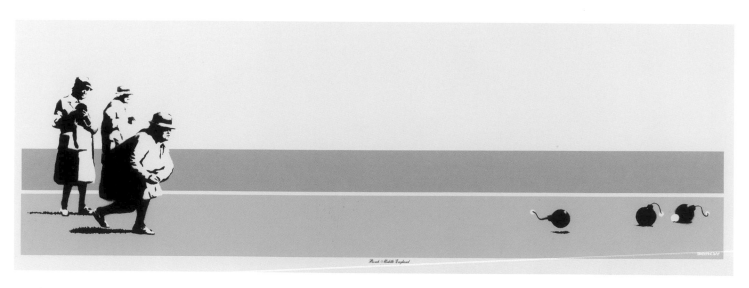

Bomb Middle England

2002
Silkscreen print
30x100 cm

Bomb Middle England is a title that doesn't seem to give much away. The image depicts a British stereotype: a group of old ladies playing bowls on the green in the English countryside. However, in Banksy's version the bowls have been replaced by cannon balls with lit fuses as a clear reference to war in a period of British military engagement in Iraq alongside US troops. The public debate around the British intervention has been lit but, according to Banksy, it does not seem to concern certain social classes. The artist seems to be criticising the British middle class for their seeming immunity to the atrocities of war, these horrors to little more than a game on a green. Other interpretations suggest that the old ladies represent the perilous nature of the superficial values and attitudes typically held by a middle class that populates central England. A further level of meaning can be read between the lines in interpreting the title as a play on words: "to bomb" is in fact also the verb used by graffiti artists to describe the act of spray painting on city walls, also known as "bombing". The artwork was printed as a serigraph edition in 2004 and in the same period the image was also reproduced in the form of a monochrome stencil on city walls in Bristol. The work became a subject of significant controversy with Canadian illustrator Cinders McLeod, the creator of a cartoon entitled "Anarchic Granny" in which an elderly lady prepares to throw a lit fuse cannonball in a typical game of bowls, when viewed side by side the two works share a great deal stylistically speaking. Here it seems fitting to recall a phrase historically attributed to Picasso "The bad artists imitate, the great artists steal" that Banksy chose to include in the pages of his book *Wall and Piece*.

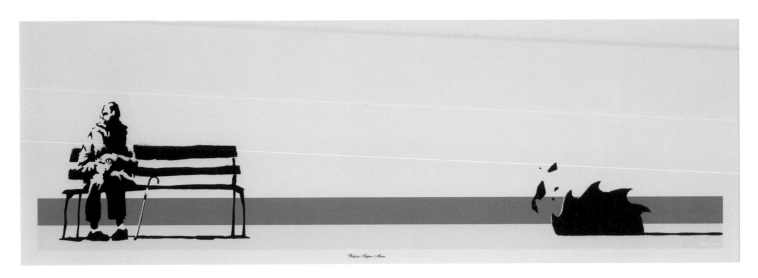

Weston Super Mare
2003
Silkscreen print
30x100 cm

The image, one of Banksy's earliest and murkiest, depicts an elderly person seated on a bench with his hands crossed over his knees and walking cane. The subject seems to be enjoying the solitude, unaware of the gigantic circular saw coming at him. Below, you can see the words *Weston Super Mare*. The image appeared for the first time in 2000, painted as a stencil on canvas, at the exhibition at the restaurant Severnshed in Bristol. The composition suggests that while relaxing, the subject is actually exposed to a single prospect: death. The work was long considered cryptic until Banksy opened *Dismaland* in 2015, his enormous installation in Weston-Super-Mare, a pleasant seaside town for families in southern England. It's likely that Weston-Super-Mare is where the artist spent part of his childhood, and the image embodies the unpleasant memory that he's had of it all these years. Some believe that one of the possible interpretations is that it's a reference to *memento mori*, an invitation to enjoy every moment as death can strike at any time.

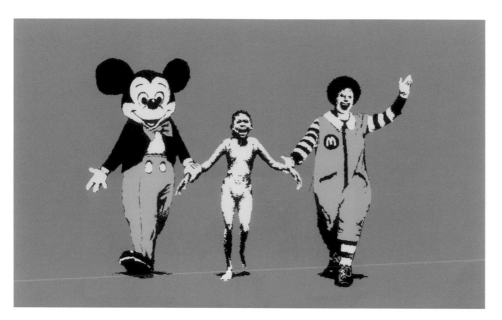

Napalm (Can't beat that feeling)
2004
Silkscreen print
56x76 cm

This piece is an altered version of a famous photograph from the Vietnam War, taken on June 8, 1972 by the photographer Nick Út, who went on to win the Pulitzer Prize. The original photograph shows 9-year-old Phan Thi Kim Phuc escaping the city of Trảng Bàng as she suffers burns caused by napalm bombs dropped by American forces. Phuc is still alive and is the main protagonist of the book *The Girl in the Picture*, published in 1996 by Denise Chong. *Can't Beat That Feeling*, the other name of the work, is a reference to the slogan Coca Cola used for an advertising campaign in the 1990s. Banksy examines the relationship between perception and reality, focusing on paradox and contradiction: in his version, the girl is standing between two icons of American culture, Mickey Mouse and Ronald McDonald. Considered one of Banksy's most unsettling images, the artist demonstrates how the United States perceives itself and how it's perceived by other cultures. The only canvas version of the work is owned by Damien Hirst.

Napalm. Serpentine edition
2006
Silkscreen print
29,7x41,6 cm

This *Napalm* version was created by Banksy in 2006 on the occasion of Damien Hirst exhibition at Serpentine Gallery, in which Hirst exhibited his personal art collection which includes several Banksy's works, called *Murderme Collection*; the exhibition was entitled *In The Darkest Hour There May Be Light*. In this version, Banksy adds blood stains.

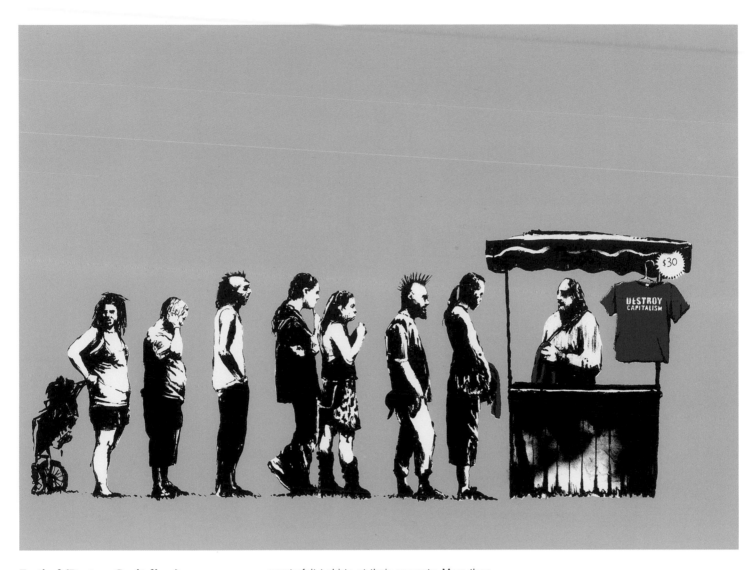

Festival (Destroy Capitalism)
2006
Silkscreen print
56x76 cm

Festival, better known as *Destroy Capitalism*, is one of the artist's darkest images. In the piece, a group of figures form a line at a merchandise stand, a typical scene at open-air music festivals like Glastonbury. During his years in Bristol, the artist repeatedly made and sold counterfeit merchandise at these kinds of festivals. During his collaboration with Blur for the cover of their album *Think Tank*, Banksy revealed that he had sold counterfeit t-shirts at their concerts. More than once, the artist has referred to his own work as an activity whose purpose is "to market the revolution". The image, which appeared for the first time in 2006 as a poster in the exhibition *Barely Legal* in Los Angeles, is a commentary on capitalism's ability to co-opt all those who try to ruin it, and references the fact that versions of it, sold for just a few pounds at Pictures On Walls, increased in value on the free market. In perfect irony, in 2013, Walmart began selling illegal copies of the print on its website. Once Banksy was informed, he filed charges against the American corporation, which was forced to pull the item.

Lying to the Police is Never Wrong
2007
Spray paint and mixed media on board
35x41 cm

The work is a text stencil on a fake-brick fiberglass wall, with the wording: Lying to the police is never wrong. The work dates to 2007, when the artist was still immersed in the vandalistic practice of graffiti writing, whose sphere of pertinence is always morality (graffiti writing deals with the issue of doing the wrong things in order to say the right things). With *Lying to the Police is Never Wrong*, Banksy provides us with a ready-made conceptual and moral package that he himself vouches for. He uses the form of the slogan ("claim") with which he tells us what is right and what is wrong.

The relationship between Banksy and *auctoritas* is mediated by his practice. In our advanced Western democracies, writing on the city's walls is considered a crime. The Bristol of the 1990s was a city in turmoil: graffiti, exhibitions, parties, hard cider, marijuana, and the new trip-hop rhythms of the future Massive Attack. However, that brazen avant-garde atmosphere ended up suffering a hard blow. In 1989, intense oppression by the British police, an action that went down in history as Operation Anderson, led to the arrest of seventy-two graffiti writers for vandalism. These included Inkie, a legend of British graffiti writing and a partner in crime at Banksy's very beginning. The graffiti writer was arrested and fined 250,000 pounds for the damage he caused; the history of Inkie's arrest and trial is recounted by the BBC documentary *Drawing the Line*. The operation caused the Bristol scene to sink back into the pure underground, and made it clear that graffiti writing had become an activity with severe legal consequences. There was little to joke about at the time; if you wrote on walls you ended up in jail and had to pay dizzying fines. And if the idea was to continue down that road, one had better become a ghost. This is what Banksy had in mind when he told us that lying to the police is never wrong.

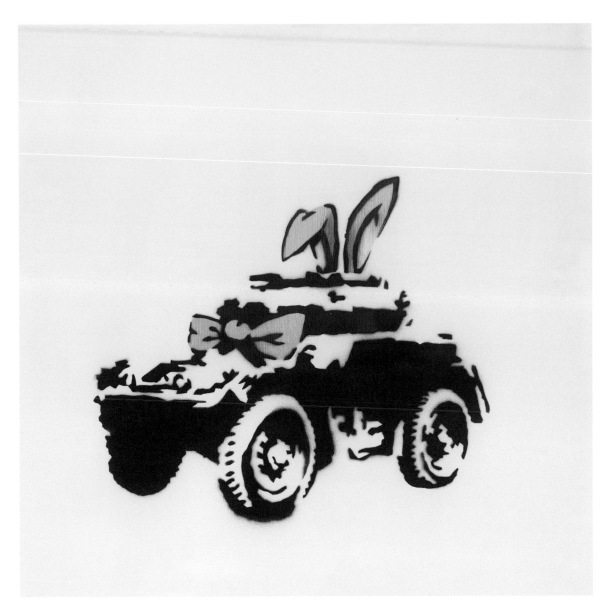

Bunny in Armoured Car
2002
Spray paint on canvas
60x60 cm

The artist did this painting in 2002 to depict a British armoured vehicle (Humber Mk IV 37mm) with bunny ears and a blue bowtie. Banksy's work includes several paintings depicting military equipment rendered ridiculous with pink bows, large hearts, bunny ears, and other mutant "exaptations" constituting the repertoire of these surreal machines in the manner of Terry Gilliam: created to entertain, love, amuse, and certainly not to kill.

It was 2002, and Banksy had recently relocated to London. The previous year he had held his first official exhibition at the Severnshed pub. In a certain way, this effort marked his "farewell" to Bristol, although he was to return as a superstar in 2009—but he did not know this yet.

It is a stencil in four levels (one per color) on canvas, done most likely in the Hoxton studio in London. One of his first paintings, it is among those that show a more hurried and punk style, those in which it is content and not form, the *why* and not the *how*, that counts.

In 2002, the artist, although still unknown to the general public, was already legendary on the London scene. He worked hard to make a name for himself in the British capital; his stencils began to appear throughout the Hoxton neighborhood, then Shoreditch, and gradually all over the city. In the meantime, while Damien Hirst lent him his former studio in Hoxton, he worked as an illustrator for some record labels, including Wall of Sound.

The image of the armored vehicle with bunny ears was the cover of the 2002 disco *Yellow Submarine* by British rapper Roots Manuva.

The theme of *Bunny in Armoured Car* is war. In 2002, the television news reported on the United States and Great Britain threatening to invade Iraq even without the UN's mandate. What we see depicted here is the artist's opinion, comment, and independent editorial on this issue.

In his book *Wall and Piece*, he maintained that "The greatest crimes in the world are not committed by people breaking the rules. It's people who follow orders that drop bombs and massacre villages. As a precaution to ever committing major acts of evil it is our solemn duty never to do what we're told, this is the only way we can be sure'.

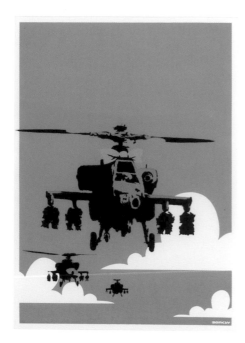

Happy Choppers
2003
Silkscreen print
70x50 cm

Happy Choppers appeared for the first time in 2002 as a work of street art in the centre of London, close to Whitecross Street Market. Since then, Banksy has revisited the helicopter motif many times, transforming it into an iconic feature of his repertoire. In 2002-2003, he reproduced the image in a variety of forms and techniques, from limited-edition silkscreen prints to paintings and stencils on canvas or integrated into his paintings. The silkscreen print was displayed for the first time in the exhibition *Santa's Ghetto*, a Christmas collective show that Banksy organized together with other artists in the early 2000s. The work depicts a squadron of attack helicopters with a pink bow on the rotor. The term "chopper" comes from the American slang word for attack helicopters during the Korean War. The image suggests, as a visual paradox, the theme of antimilitarism, important to the artist. Banksy, in his book *Wall and Piece*, wrote, "The greatest crimes in the world are not committed by people breaking the rules but by people following the rules. It's people who follow orders that drop bombs and massacre villages."

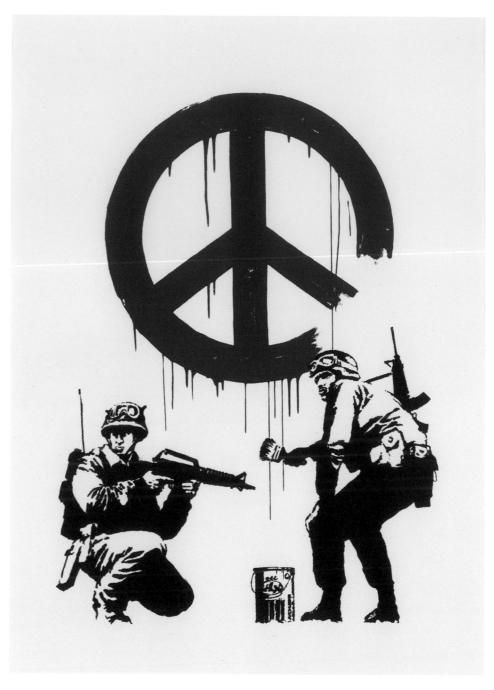

CND Soldiers
2005
Silkscreen print
70x50 cm

CND Soldiers is a stencil that Banksy created near the Palace of Westminster in 2003, which was quickly removed by the authorities. Considered his most iconic declaration against war, it represents the United Kingdom's response to getting involved in the Iraq War and attests to how London, in that period, was enveloped by a significant popular protest led by peace activist Brian Haw. The image can be seen from two perspectives: the first underlines the uselessness of the freedom of speech; it's not a coincidence that millions of people, military members included, came together to protest the invasion of Iraq. The second suggests the paradoxical use of the military, employed to spread "peace and democracy". In his book, *Wall and Piece,* Banksy wrote, "I like to think that I have the guts to make my voice heard, though anonymously, in a western democracy and to demand things that no one else believes in, like peace, justice and freedom..."

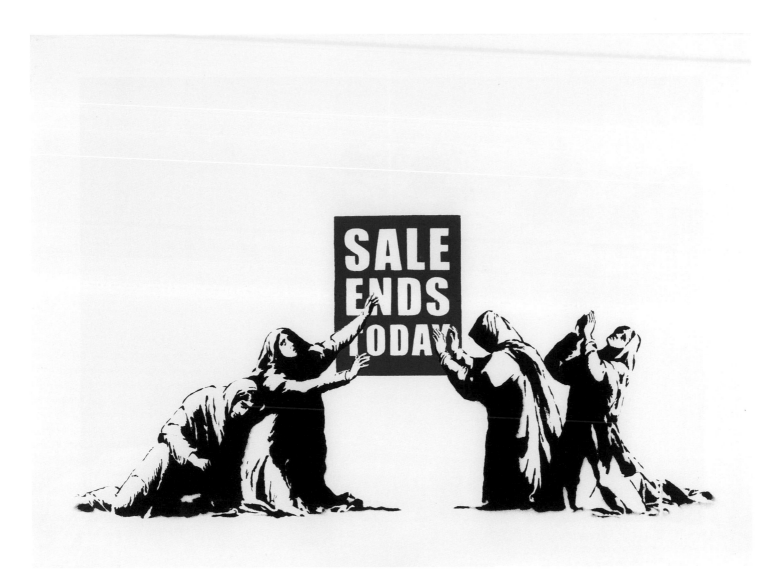

Sale Ends Today
2007
Silkscreen print
56x76 cm

Sale Ends Today is one of Banksy's least known images and where his sarcasm is most evident. The composition shows a group of women, taken from biblical scenes painted in the sixteenth and seventeenth centuries, stencilled black and white as they grieve before the Passion of Christ, but here, Christ is replaced by a banal red poster announcing the end of sales. According to Banksy, this is a true source of desperation. The image is a reference to the repercussions on collective behaviors due to the dominance of a consumer culture produced by capitalism, inviting us to reflect on the relationship between faith, religion and money, and underlining how the creation of meaning, for centuries provided by religion, is today defined by money. The image was never a work of street art, appearing for the first time as a silkscreen print. A large canvas version was auctioned at Sotheby's in London in 2008.

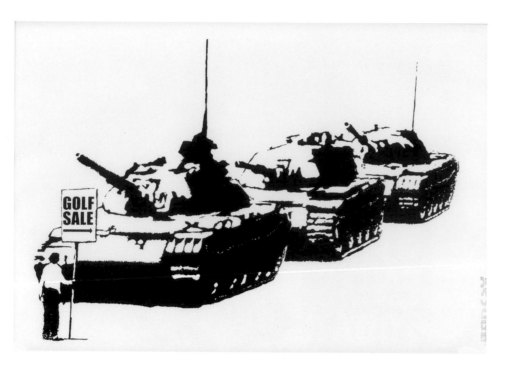

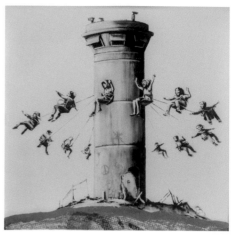

Walled Off Hotel Box Set
2017
Digital print on paper and wall section
23x23 cm

This work comes from the Walled Off Hotel in Bethlehem, a small guest house that became the protagonist of a Banksy "restyling" project when a huge wall was built right in front of its windows. The wall was built by Israel on the West Bank as a move to formally prevent Palestinian terrorists from entering its territory. Banksy oversaw the renovation in 2017 and named the guest house the Walled Off Hotel—a name that imitates the famous Waldorf hotel chain—and that is effective as a slogan to publicise "the hotel with the worst view in the world". *Walled Off Hotel Box Set* represents children intending to have fun on a carousel, but this carousel consists of a watch tower resembling those found along the entire separation wall. As in many other compositions, the artist contrasts the playful innocence of childhood with the most controversial outcomes of the adult world, seeking to underline the paradoxes and contradictions it contains. Banksy first journeyed to Palestine in 2005, and in 2007 he invited a group of artists—including the Italian artist Blu—to paint the infamous separation wall under the collective name *Santa's Ghetto*. Israeli watchtowers have also been the subject of numerous small sculptures entitled *Watchtower* produced by the artist in various materials including wood and Coca Cola cans. It is actually possible to buy this artwork for 150 euros, however it is necessary to go to Bethlehem to buy it.

Golf Sale
2003
Silkscreen print
35x50 cm

First appearing in 2003, *Golf Sale* is one of the earliest images officially published by Banksy. It was never made as an outdoor artwork, but only as a silkscreen print and as a stencil on various supports. The work modifies the photograph *Tank Man*, taken by Jeff Widener in Tienanmen Square in 1989, showing a young man standing in front of a column of tanks that had been deployed to suppress a student protest. Widener's image is considered in the West an iconic symbol of non-violent protest. In Banksy's version, the scene is in black and white—typical of his style in that period—and the protester, in addition to his physical opposition, signals to the tanks that nearby, golf merchandise is being sold. In the Black Book *Banging Your Head Against a Brick Wall*, the artist wrote, "We can't do anything to change the world until capitalism crumbles. In the meantime, we should all go shopping to console ourselves."

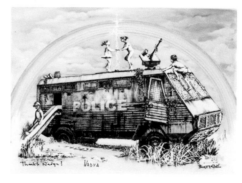

Dismaland print
2015
Silkscreen print
18x25 cm

This work was presented by Banksy on the occasion of the *Dismaland* art installation, set up in 2015 at an abandoned factory in the British seaside town of Weston-Super-Mare where it is plausible the artist spent time during his childhood. *Dismaland print* is the result of a collaboration with the anonymous Russian feminist activists collective Pussy Riot; in particular, the work shown here is the result of collaboration with the Pussy Riot member known as Nadya, who added the anarchist symbol constituted by the circled "A".

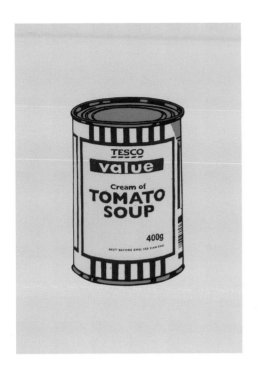

Soup Can
2005
Silkscreen print
50x35 cm

Soup Can was originally a small painting hidden by Banksy on a wall in the MoMA in New York in 2005 alongside the caption *Tesco Value Tomato Soup*. The work remained on display for six days, and in an interview the artist said, "After taking the photo, I stuck around for five minutes to see what would happen. A ton of people came up to look at it, then walked away confused and slightly offended... I felt like a true modern artist." *Tesco Value Tomato Soup* is a modified version of one of Andy Warhol's most iconic images. Bringing together the art world and the market, Warhol's images defined a historic change in contemporary art, challenging the definition of aesthetics, the artist's role and the concepts of originality and reproduction. While Warhol's *Campbell Soup* appeared lacking in social critique, Banksy's *Soup Can* is a critique on the perverse power of the market. A number of critics have drawn a parallel between Banksy and Warhol, summarized by former in his exhibition *Banksy vs Warhol* at The Hospital in Convent Garden, London, in 2007.

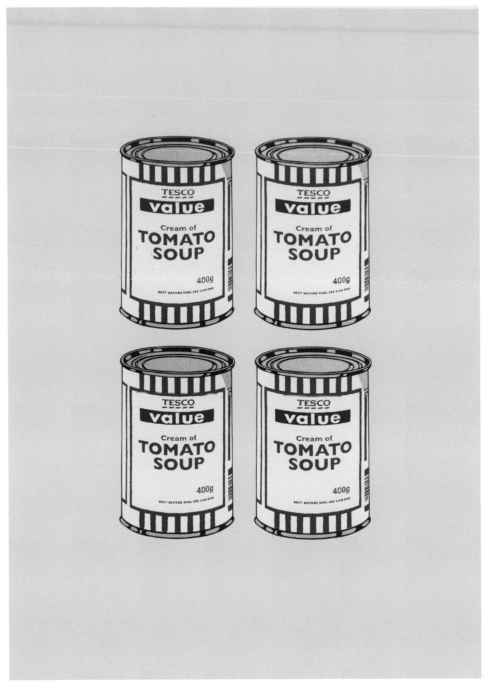

Soup Can (Quad)
2006
Silkscreen print
70x50 cm

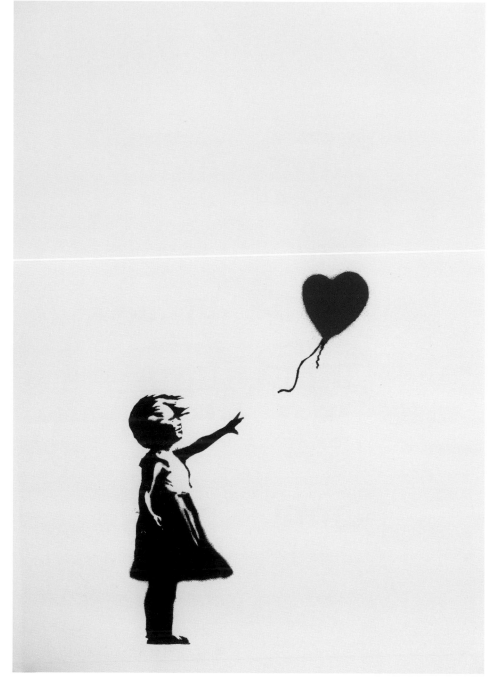

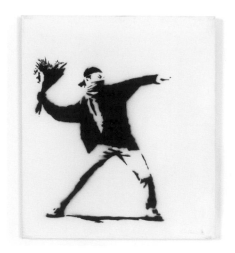

Love Is In The Air
2002
Spray paint on canvas
51x43x4 cm
Signed "Banksy LA" dated 2002 numbered 1/5 all
on the reverse

Girl with Balloon
2004-2005
Silkscreen print
76x56 cm

Girl with Balloon is probably Banksy's most popular image, voted in a 2017 survey promoted by Samsung as Britain's most beloved work. Banksy painted *Girl with Balloon* for the first time in 2004 as a stencil on the wall of a bridge in the Southbank neighborhood in London. The artist put his signature on an electrical box in the lower right-hand corner of the work, and accompanied the image with the words, "There's always hope." In his book *Wall and Piece*, he added, "When the time comes to leave, just walk away quietly and don't make any fuss." Another version of the stencil appeared in the London neighbourhood of Shoreditch, near the Liverpool Street station. The owners of the store where Banksy stencilled the artwork suggested detaching it from the wall to auction it off, but this sparked a wave of protest and the work was left there. Ten years later, hidden behind an advertisement, an anonymous group removed the stencil. The work reappeared during the presentation of the exhibition *Stealing Banksy?* and was sold shortly thereafter.

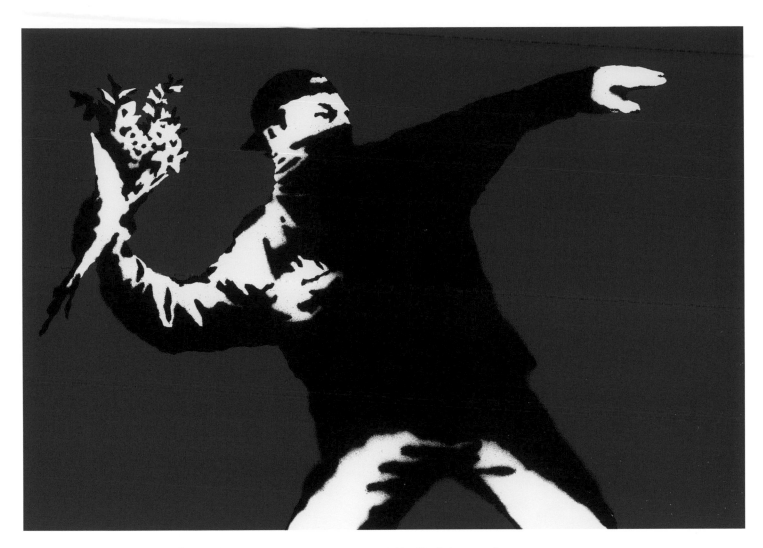

Love Is In The Air (Flower Thrower)
2003
Silkscreen print
50x70 cm

Love Is In The Air, also known as *Flower Thrower*, appeared for the first time in Jerusalem in 2003 as a stencil; it was painted on the wall built to separate the Israelis and Palestinians in the West Bank. The artist sees the wall as something that "[...] essentially transforms Palestine into the largest open-air prison in the world". The same year, Banksy made the version seen here, set against a red background. *Love Is In The Air* alludes to and transforms the typical image of activists participating in the student riots in the United States and Great Britain during the Vietnam War, and takes its title from the famous 1977 song by Australian singer John Paul Young. Banksy mutates the image and upends the violent outcome of the young activist, placing a bunch of flowers in his hand, a symbol of peace and beauty. In his book *Wall and Piece*, the artist commented that, "The biggest crimes in the world aren't committed by people who break the laws, but by those who follow the laws."

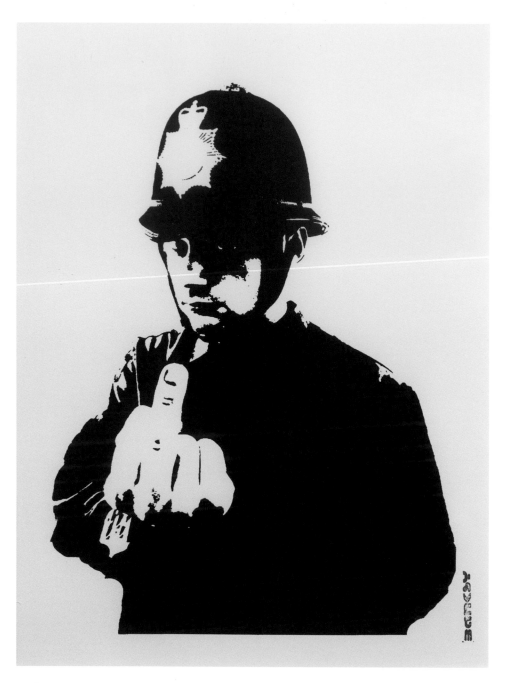

Rude Copper
2002
Silkscreen print
57x41 cm

Rude Copper is one of the first works Banksy made on paper, published by Pictures On Walls in 2002. The policeman is shown flipping off the spectator. To put his works up in public spaces, Banksy inherently challenges the local authorities, personified in British culture by a Bobby, a typical policeman who in urban slang is referred as a "copper". The artist has come across many of them, and his stories about these encounters reveal the foundational principle of street art: to make something beautiful, you don't have to ask permission. Banksy offers different interpretations, each one contradicting the other: the image gives us back an authority that, by mutating the common view, shows the policeman as "one of us;" it could also suggest an authority figure that, deviating from his role, leads others to not trust and to be more critical.

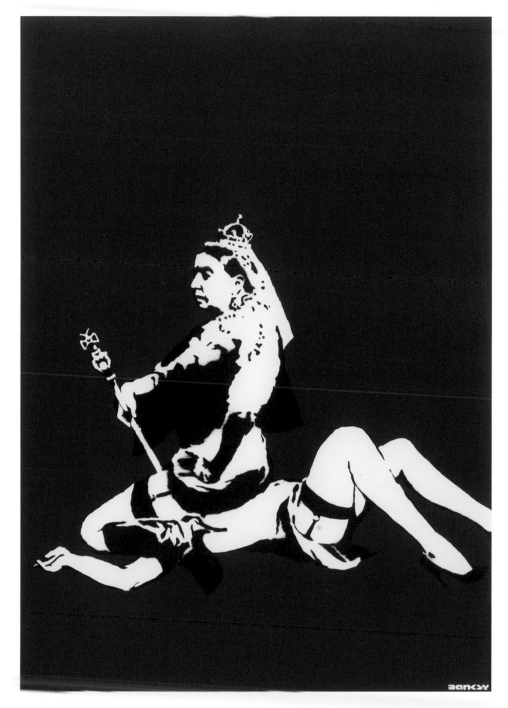

down. This ensured that the stencil was sort of protected just because of the minor fact that it could only be seen after 9 p.m." The image was displayed on a canvas for the first time in 2003 in a collective exhibition at the Vanina Holasek Gallery in New York.

Queen Vic
2003
Silkscreen print
70x50 cm

Queen Vic (Queen Victoria) is a 2003 work and one of the first images printed at Pictures On Walls, Banksy's print house, which opened its doors in 2003 at 46 Commercial Rd., London. The artist is famous for satirizing power: the image depicts Queen Victoria as a lesbian engaged in "queening". Queen Victoria once declared that women aren't able to be gay and approved laws against homosexuality. The image, which suggests the hypocrisy behind the management of power, comes from a stencil located on the rolling shutter of a store between St. Mark's Road and Brenner Street in Bristol in 2002. Banksy wrote, "Many thought the image of Queen Victoria was too disrespectful to paint in random places around the city. So I painted several of them and they were all erased, but one of these was on the metal shutter of a store that sold junk every day of the week and didn't close before 9 p.m., and only then was the shutter rolled

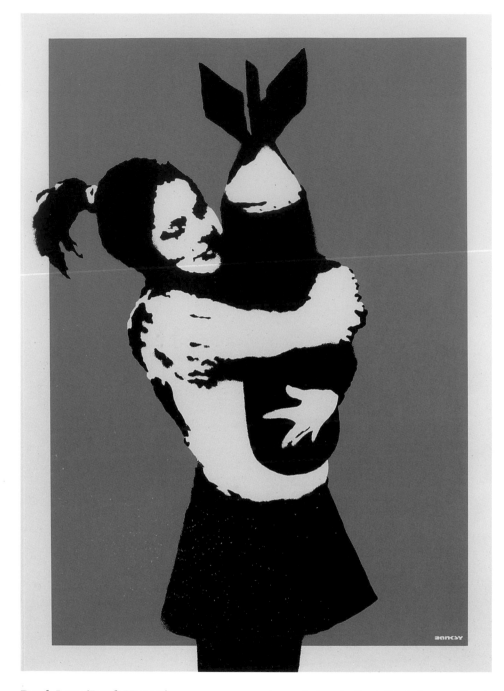

that reads: "A wall is a very big weapon, it's one of the nastiest things you can hit someone with". As is typical of Banksy, this image has been reproduced by the artist in various formats on numerous occasions, appearing on walls throughout Europe in cities like Berlin, often being created with the distinctive stencilling technique but also distributed in leaflet form to the public during anti-military protests across Great Britain. Although the image originally dates back to 2000, Banksy's archive includes some 2003 monochrome stencil reproductions of "Bomb Hugger" on public facing walls in East London and later, Brighton. In his 2004 Black Book *Cut it Out* Banksy reunites bombs and hugs, writing: "Suicide bombers just need a hug."

Bomb Love (Bomb Hugger)
2003
Silkscreen print
70x50 cm

Like many of Banksy's works, this image has an official title and one adopted by the public. The one attributable to the British artist is *Bomb Love* but the public have welcomed the title *Bomb Hugger*. It is one of the artist's most popular and iconic images, published in a series of 750 serigraph editions in 2003 by Pictures On Walls—Banksy's print house in London—in a year which saw great demonstrations in Great Britain in opposition to joint armed intervention with the US against Saddam Hussein's Iraq. Against a reassuring pink pop background, a little girl hugs a bomb as though she's hugging a teddy bear. The artist recounts the version of the war fed to the public in the stories told by the government, backed by the media during those years: carefully curated narratives formed to bathe the notion of war in a positive and reassuring light and justify the attack on Iraq in a war to "export democracy". In the pages of his 2001 Black Book, *Banging Your Head Against a Brick Wall*, Banksy associates this very image to his aphorism

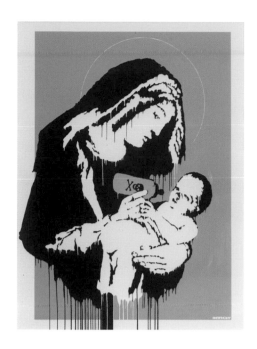

Virgin Mary (Toxic Mary)
2003
Silkscreen print
76x56 cm

Banksy's *Virgin Mary* is also known to the public by the name *Toxic Mary* due to the toxic hazard symbol that adorns little baby Jesus' milk bottle. According to some interpretations the image is an explicit criticism of the role of religion. According to others, it makes a powerful statement about how we are educating our children today. The work recalls the classical *Madonna and Child*, in a style typical of the Italian Renaissance. Reworked by Banksy the image drips downwards in a particular stylistic nod to the artist's early urban street art. The artist re-elaborates this typical popular image with a process of *détournement*. This processing of images allows to exploit images in their already crystallised state in the collective memory, manipulating them and placing elements that undermine their acquired meaning. The most famous example of the use of this artistic technique is arguably Marcel Duchamp's Mona Lisa with a moustache. The term *détournement* was introduced by the situationist philosopher Guy Debord who interpreted it as follows: "the integration of present or past artistic productions into a superior construction of a milieu..." Debord also believed that plagiarism is a necessary operation implied by progress as a means to replace a false idea with a true idea, a thought that appears to be constitutive of Banksy's *modus operandi*. The Virgin Mary was first presented as a stencil painting on canvas during the *Turf War* exhibition in a warehouse on Kingsland Road in East London during the summer of 2003.

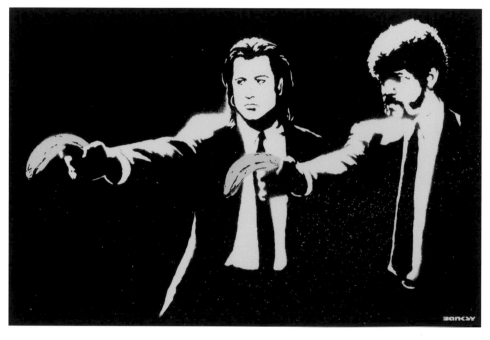

Pulp Fiction
2004
Silkscreen print
50x70 cm

Pulp Fiction is a tribute to the characters in the Quentin Tarantino's film of the same name. The artwork depicts protagonists Vincent and Jules side-by-side, holding bananas instead of pistols. Just as Tarantino defuses the violent potential of his films by rendering them exaggerative, so too does Banksy interpret the paradox as a static iconography, replacing the weapons with harmless bananas. The image first appeared in 2002 as a work of street art on Old Street in London. In 2007, the city-owned Transport for London covered the work, declaring that it conveyed an image of squalor in the neighbourhood. Banksy painted the work again on the same wall, covering the Transport for London's image, but in this version, the protagonists were wearing banana costumes and armed with real pistols. It's likely that the artist was familiar with *Monty Python's Flying Circus*, producers of the 1969 screwball comedy sketch *Self Defence Against Fresh Fruit*, about acts of violence being committed with bananas, apples and oranges. Other hypotheses are that Banksy was inspired by the cover of the Velvet Underground's 1967 album designed by Andy Warhol or that the piece is a reference to a common theme in the artist's repertoire: monkeys.

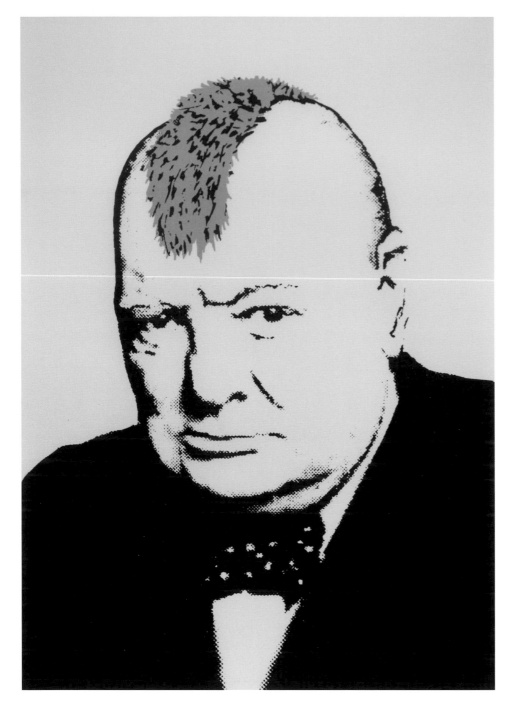

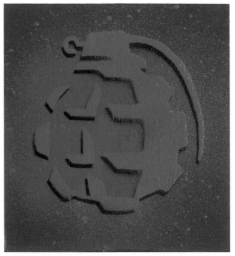

Grenade
1999
Spray paint on panel
18x15 cm

Turf War
2003
Silkscreen print
56x41 cm

The image was made by Banksy in 2003 for the exhibition *Turf War*, his first show in London, organized in a warehouse on Kingsland Road. The exhibition, opened on July 18, was meant to close just a few days later, on July 24, but the police shut it down after only two days due to the presence of live animals in the exhibition.

The piece, boasting punk influences, shows Winston Leonard Spencer-Churchill, the Prime Minister of the United Kingdom during World War II, imagined by the artist as a punk rocker. Banksy topped Churchill's bald head with a bright green mohawk like a punk, that, despite making him seem like a Mohican, is actually a reference to grass. Indeed, to decipher *Turf War*, it's important to understand the double wordplay of the title. Turf means a clump of grass, while the expression "turf war" is used to indicate a war between street gangs. Tied to the theme of war, the image and its title

seem to mean that for the artist, the essence of war is nothing more than a dispute between two sides fighting over a piece of land.

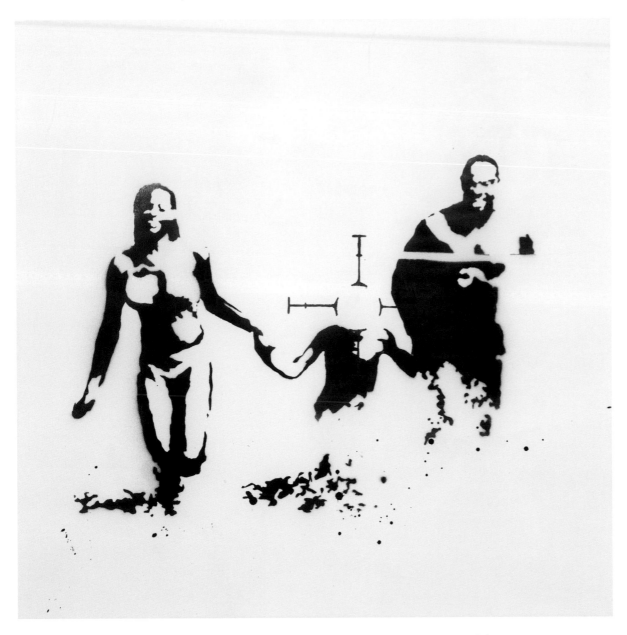

Family Target
2003
Spray paint on board
90x90 cm

In 2003, Banksy made this two-level stencil on board the same year the US and UK invaded Iraq, declaring war on Saddam Hussein. One million people poured into the streets of London demanding not to fight, Banksy himself took part in the demonstration with numerous interventions, as documented in his 2004 Black Book *Cut It Out*. Iraq was attacked and invaded, and soldiers were left with the task of explaining to us the modern equipment of a new form of warfare. Thus the term "smart bombs"—bombs capable of striking their *target* with surgical precision—entered our lexicon. The reality conveyed by our media showed the usual spectacle of war with dead children and civilians—collateral damage, according to power, and the real targets according to Banksy. Much of his work consists of producing images to unmask the hypocrisy of power, a sort of reverse advertising—counterpersuasion conveyed by images.

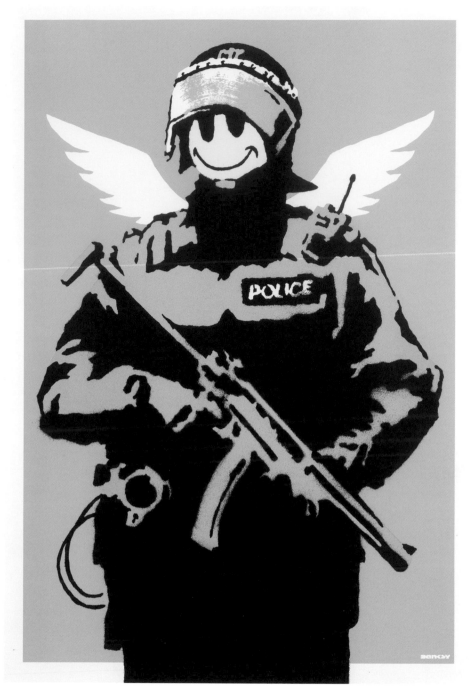

highlights the duality of the role of these custodians of peace that, at the same time, can transform into a threat to peace itself, encouraging viewers to practice a healthy dose of scepticism towards those in power.

Flying Copper
2003
Silkscreen print
100x70 cm

Banksy's *Flying Copper* is one of the artist's first iconic images, made in a public space using various techniques. An installation of the work was made using gigantic figures, created with a stencil on contoured paper and hung to the ceiling during the exhibition *Turf War*, Banksy's first major show, held in 2003 in a warehouse in London's East End.

Some of the silhouettes of *Flying Copper* were later put up around London and Vienna; an installation of the work then appeared again in London in front of Shoreditch Bridge. Part of this installation was removed anonymously and reappeared in the 2012 documentary *How to Sell a Banksy*. The image depicts a policeman in riot gear with his face covered by the artist's famous "smiley" face. We find the symbolism of the smile contrasted with the gun, that is, oppression and threat can hide behind the face of those who are supposed to protect us, highlighting the ambiguity of power. *Flying Copper*

I Fought the Law
2004
Silkscreen print
70x70 cm

The main scene depicted in this image is taken from the video documenting the March 30, 1981, attack on US President Ronald Reagan, outside the Hilton hotel in Washington. The would be assassin was a man named John Hinkley; struggling with mental health issues, he was convinced that actress Jodie Foster would have been positively impressed if he had succeeded in assassinating the President. Hinkley fired five shots with no fatalities. In Banksy's interpretation of events, however, Hinkley's hand reaches out not for a gun, as in the original video, but a brush lying immobile on the ground after having been used to write the words "I fought the law and I won" on the wall behind the crime scene. The phrase, also the title of this work, is actually the title of a song written by Sonny Curtis in 1958 of which Banksy quotes the version performed by British punk group the Clash in 1979. Through the artist's typical compositional feature, obtained by building new meanings through unprecedented relationships between references of a popular nature, the themes explored in this image refer to the works where the artist considers freedom of expression as being a powerful weapon. Among this series of works, the most explicit is arguably *Choose Your Weapon* an image which appeared in 2010 in South London, which depicts a man in a sweatshirt with a masked face leading a dog painted in style of the American artist Keith Haring: once again underlining the complex cultural mix that makes up the fertile terrain from which the artist's images spring forth.

Cloud DJ
1998-1999
Spray paint and acrylic on board
71x74 cm

Cloud DJ is one of Banksy's earliest works. The image depicted appears for the first time on the walls of Bristol documented in Banksy's self-published book: *Banging Your Head Against a Brick Wall* as an uncommisioned stencil on wall.

Rodeo Girl
2008
Giclee print on paper
30x39 cm

Rodeo Girl was created by Banksy on the occasion for the Cans Festival which he organized in 2008 in a disused tunnel in London at Leake Street, in Waterloo. The festival features artists working in the public space using stencil technique invited by Banksy himself from all over the world. From Italy, Sten Lex, Lucamaleonte and Orticanoodles were invited. To each artist participated the festival, Banksy gives one of these prints he personally signs and dedicates to each of them.

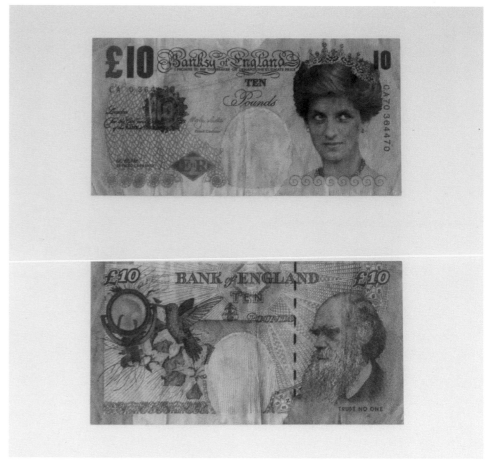

Di-Faced Tenners
2004

In 2004, Banksy printed one million pounds' worth of 10 pound banknotes, known as *Di-Faced Tenners*. The word "Tenners" is the slang used to refer to 10 pound notes, while the other part of the title is a play on words: the term "defaced" is a reference to Banksy replacing the image of Queen Elizabeth with the face of Diana Spencer, known as Lady D. In this context, "Di-Faced" can also be interpreted as "with D's face". Essentially, *D-Faced Tenners* can be seen as either 10 pound banknotes depicting Lady D and at the same time, defaced 10 pound banknotes. Above, at the centre of the note, are the words "Banksy of England" in place of "Bank of England". This project was presented for the first time at the Notting Hill Carnival in London, where the artist launched wads of banknotes into the crowd (the same year, Banksy did the same thing at the Reading Festival). Some of the banknotes were used by the public to make purchases.

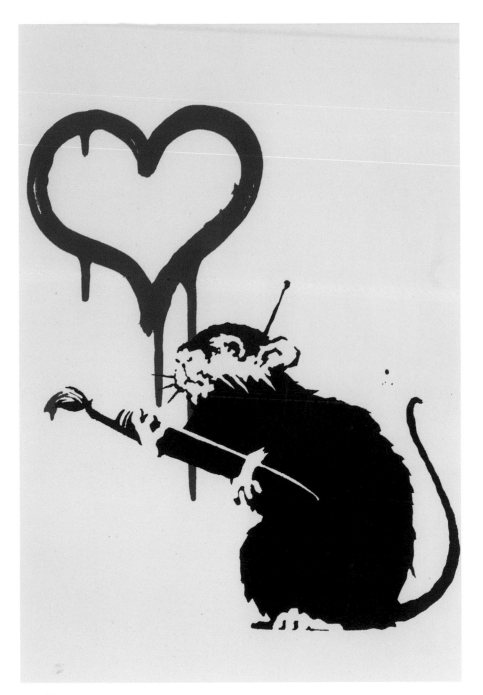

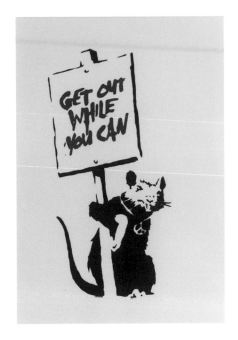

Get Out While You Can
2004
Silkscreen print
50x33 cm

Banksy draws a parallel between rodents and the condition of street artists and transforms the image of the rats designed by the French artist Blek Le Rat, who throughout the 1980s threw them up around Paris. This work is part of a series known as *Placard Rats*, which has appeared numerous times, especially in London. The *Placard Rats* series shows an indignant rat holding up a protest sign that says, in this version, "Get out while you can". Others have phrases like, "Because I'm worthless" and "Welcome to hell". Even though the rat is wearing a necklace with a peace sign, it seems to be intent on fighting against its marginalization.

Love Rat
2004
Silkscreen print
50x35 cm

Rats are one of Banksy's most oft-used motifs, "They exist without permission. They are hated, hunted and persecuted. They live in quiet desperation amongst the filth. And yet they are capable of bringing entire civilizations to their knees." The artist draws a parallel between rats and the condition of street artists, warning us against the quiet but ambiguous multitudes. Banksy's rats are often thought to have been borrowed from the repertoire of another street artist, the Frenchman Blek Le Rat, who during the 1980s disseminated his rodent inspired artworks throughout Paris with a vision similar to that of the British artist. Banksy's *Love Rat* is depicted with a large paintbrush in his hand as he finishes painting a red heart on an invisible wall. The symbolism suggests that street art—it doesn't matter how insignificant it can seem at first—is worthy of love and that these little contributions can have a positive impact on the surrounding community.

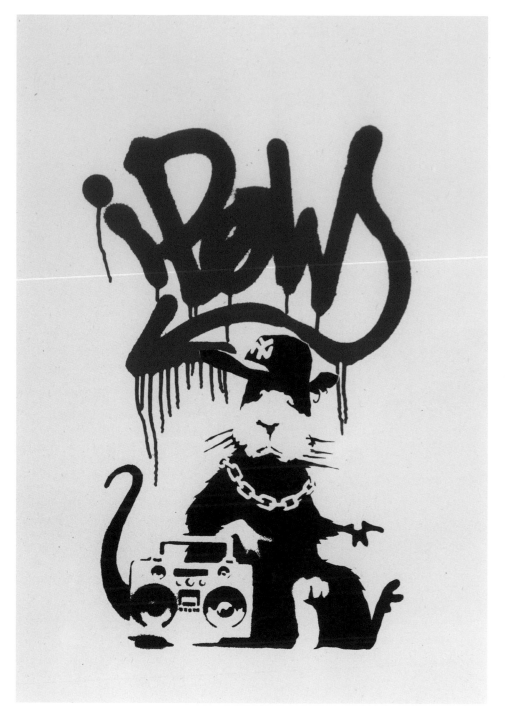

Radar Rat
2008
Offset lithograph on record sleeve
31x62 cm

Gangsta Rat
2004
Silkscreen print
50x35 cm

The Banksy gangster rat mimics the American "gangsta" (according to urban jargon) rappers of the 1990s, icons of hip hop culture who influenced the artist during his training in Bristol. The rats rank among Banksy's most depicted subjects, he writes: "They exist without permission. They are hated, hunted and persecuted. They live in quiet desperation amongst the filth. And yet they are capable of bringing entire civilisations to their knees." The artist captures a parallelism between rats and the condition in which street artists are, which also serves to warn us against quiet masses. Banksy's rats are often thought to have been borrowed from the repertoire of another street artist, the French artist Blek Le Rat, who during the 1980s disseminated his rodent inspired artworks throughout Paris with a fashion akin to that of the British artist. Banksy's *Gangsta Rat* sits next to a large portable stereo, a typical hip hop accessory also known as a "boom box". Scrawled above the rat in contemporary "style writing" are the letters "POW", a reference to Banksy's print house, Pictures On Walls, but also to the better known form of this acronym: Prisoner of War.

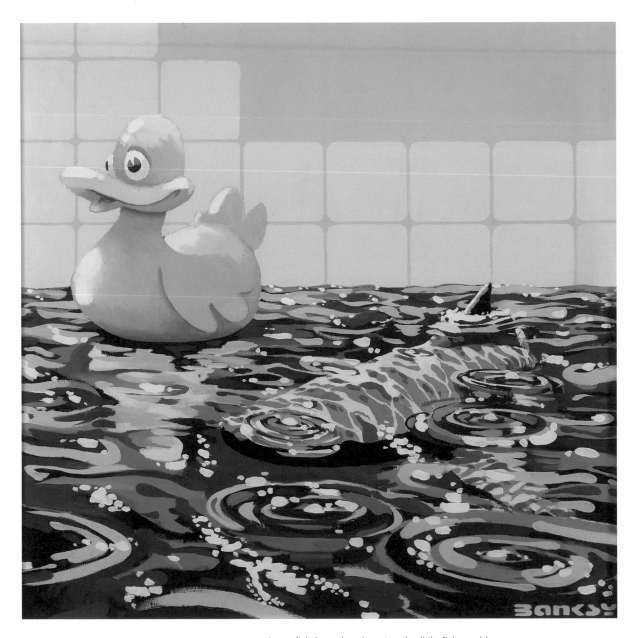

Rubber Ducky
2006
Acrylic paint on canvas
91x91 cm

Rubber Ducky. The titles of Banksy's works are almost always simple captions of what the image represents—in this case, the child's bath toy.

This is a very rare freehand acrylic painting done in 2006—one of the years when the artist produced some of his most well-known masterpieces, days when his art was welcomed by the Hollywood stars flocking to the *Barely Legal* exhibition in Los Angeles.

The scene depicts a duckling in a domestic bath setting; but we see a shark emerging beneath the surface of the water. The metaphor is clear: the large fish has already eaten the little fish, and is now turning its efforts to ducklings. Banksy is one of just a handful of artists who address the issue of protecting childhood growing in a world where it is considered a market segment, a product of global marketing. Once again, the artist produces an image to shake our ethics, an iconic soft power that spurs us towards a critical counterbalance against amoral commodification.

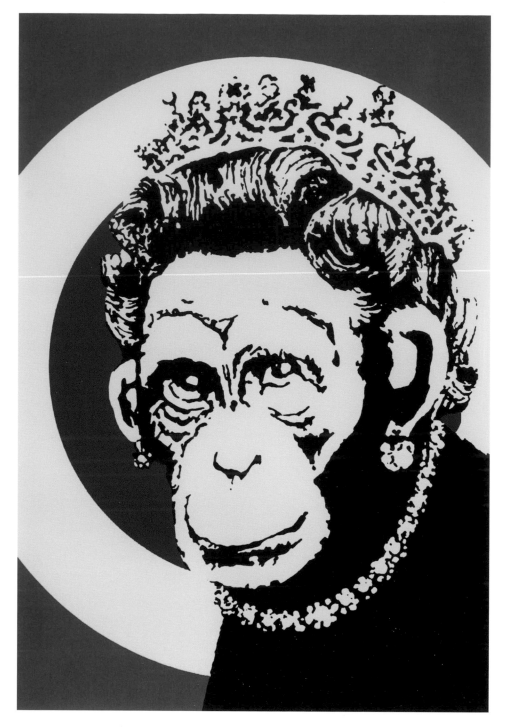

anniversary of her coronation. Along with rats, monkeys are a recurring animal motif which Banksy uses to construct meanings, serving in addition as an effective critique of power in various works. One particularly famous Banksy artwork represents the British parliament as entirely populated by monkeys. Banksy commented: "The highest position in British society is not a reward for talent or hard work, but a birth accident... God Save the Queen", emphasising how the task of making decisions on behalf of the people is not a result of commitment, but accident. It should be noted here that Banksy himself often wears a monkey mask in his public portraits.

Monkey Queen
2003
Silkscreen print
50x35 cm

Monkey Queen is an artwork that was published as a series of 750 serigraph editions in 2003 and sold during an exhibition entitled *Turf War*, which was held in a warehouse in Kingsland Road in East London in the summer of 2003. The exhibition featured a stencilled image depicting Queen Elizabeth II with the face of a monkey, framed in an oval on the background of the British flag. In the serigraph version Banksy, whilst reproducing the colors of the British flag, chose to modify the background to imply a shooting target. The Monkey Queen first appeared stencilled on the central window of the London club, Chill Out Zone. Local authorities asked for its removal on the occasion of Queen Elizabeth's Golden Jubilee on the fiftieth

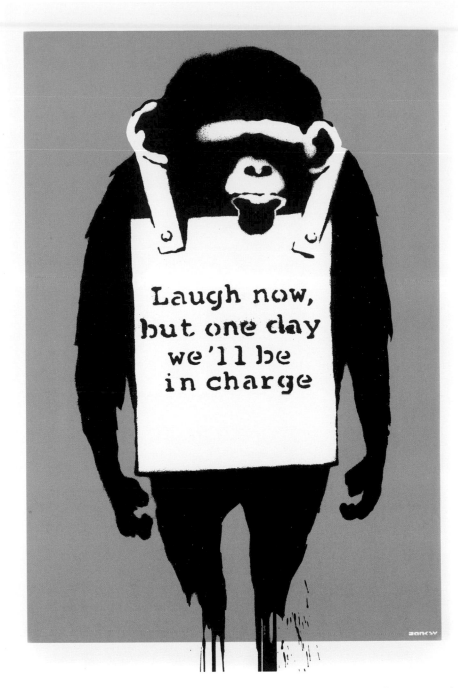

believes that street art is one of the most powerful forms of artistic expression out there today. Banksy argues, "The people who truly deface our neighbourhoods are the companies that scrawl their giant slogans across buildings and buses trying to make us feel inadequate unless we buy their stuff."

Laugh Now
2003
Silkscreen print
70x48,5 cm

Laugh Now: "Laugh now, but one day we'll be in charge" is written on the sandwich board hanging around the monkey's neck, which appeared for the first time in 2002 when it was commissioned by a nightclub in Brighton. Since then, the artist has replicated the work many times as non-commissioned street art, an installation, a silkscreen print and a stencil on canvas. As a silkscreen print, it was displayed for the first time in the 2002 exhibition *Existencilism* at the 33 1/3 in Los Angeles. Monkeys are a recurring theme in Banksy's repertoire. The artist believes that, since the publication of Charles Darwin's *On the Origin of Species* (1859), humans have done everything to ridicule their closest relatives. Banksy's monkey attests to the arrogance of humanity towards other species, drawing a parallel between man's ability to create art. Even graffiti was, not coincidently, ridiculed in disparaging ways. Banksy, however,

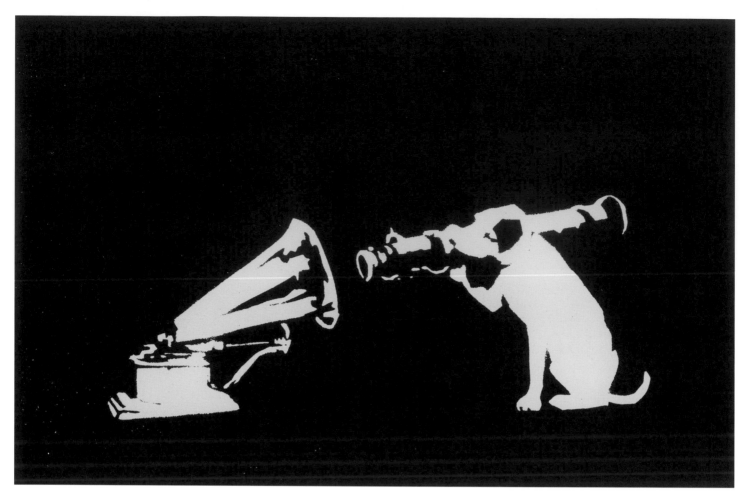

HMV (His Master's Voice)
2003
Silkscreen print
35x49 cm

His Master's Voice is one of the earliest images made by Banksy, appearing in Bristol as a stencil in various sizes and colors, and later made as a silkscreen print. *HMV* is a modified allusion to the logo of the British record label founded in 1920 following the advent of wind-up gramophones. The original logo showed a dog looking curiously at a gramophone, listening to its owner's voice. Banksy transformed the scene so that the dog, exhausted from listening, aims a bazooka at the gramophone. The humorous element to the work is open to various interpretations: on the one hand, it shows us how to confront obsolete ways to thinking, while on the other, it underlines the possible outcome of tensions over the aging western population; it could also suggest how to behave towards anyone who declares themselves to be the owner of something.

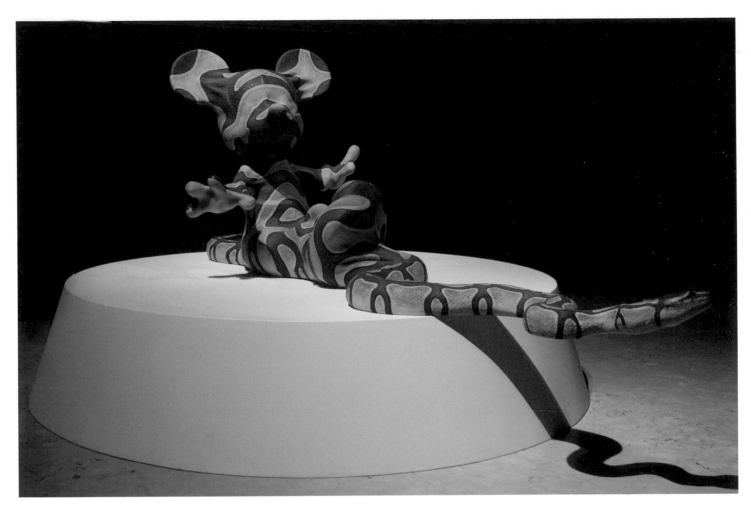

Mickey Snake
2015
Fiberglass, polyester resin, acrylic
72x82x262 cm

The snake swallowing Mickey Mouse, *Mickey Snake*, is one of the sculptures-installations presented by Banksy at *Dismaland*, the apocalyptic temporary theme park opened by the artist in 2015 in Weston-Super-Mare, south of England. The relationship between Banksy and Disney is ancient and controversial, the entertainment multinational has often been the artist's target for its intent to involve childhood in the representation of a world of fable and unreal rhetoric.

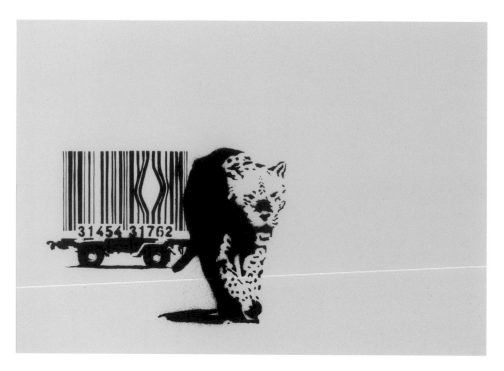

Barcode
2004
Silkscreen print
50x70 cm

Barcode was created by Banksy in 2004 and sold by Pictures On Walls that same year. The stencil was painted onto the wall of a house on Pembrock Road in Bristol sometime between 1999 and 2000. The work disappeared in August 2010 during renovations to the property, but it came to light four years later in a nearby school, when one of the teachers revealed that her husband was a builder who had worked on the house. The teacher and her husband recognized the stencil, which was marked for destruction, as a Banksy and received permission from the owner of the house to remove it. They kept it hidden under their bed for four years, when it was finally showed to the public. Another version of the same stencil went on display during the exhibition *Existencilism*, held at the 33 1/3 in Los Angeles in 2002.

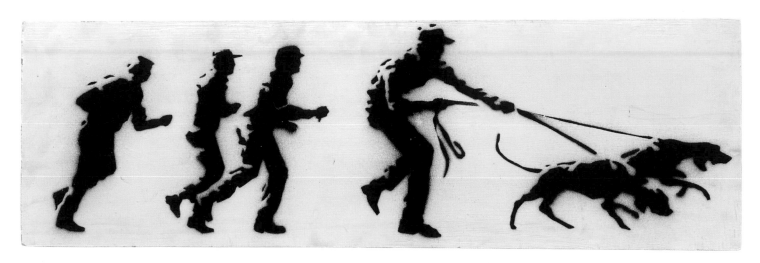

Untitled (Bloodhounds)
1998
Spray paint on heavy board
22,8x71,1 cm

Although untitled, this painting stencilled on wood in 1998 is known as *Bloodhounds*. Some sources maintain it is the first painting Banksy ever sold. With this imagery, Banksy criticizes the artists, but more generally all those who *follow* the system rather than question it, just as the *Bloodhounds* tracks a scent. The work appeared in the form of a stencil on walls around Bristol in the early 1990s, when Banksy was writing things like: "…in reality, the 30 square centimeters of your brain are trespassed upon every day by teams of marketing experts. Graffiti is a perfectly proportionate response to being sold unattainable goals by a society obsessed with status and infamy."
The painting is one of Banksy's very first stencils: essential, monochrome, accompanied in the street versions by the following quotation from British director David Terence Puttnam: "Nowhere in the world will you find a statue of a critic, or the biography of a committee."

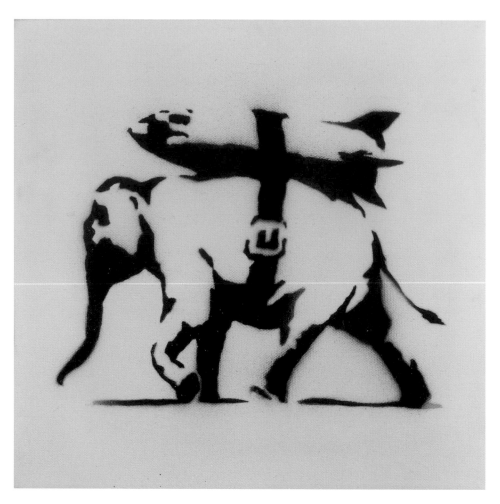

Heavy Weaponry
2003
Spray paint on canvas, signed AP 01/03
30x30 cm

In *Heavy Weaponry,* Banksy depicts an elephant with a nuclear missile positioned on its back—a composition that has appeared in the Banksian repertoire since the beginning. In the 1990s, this stencil was visible on walls around, at times accompanied by the words "What part of *thermonuclear war* don't you understand?". The elephant is an allusion to the expression "an elephant in the room," referring to an obvious problem that everyone ignores.

Banksy painted it in many versions. The first ones had a barcode in the background, with the text "London, New York, Bristol"—that is, the names of the cities where he had painted.

The image also became one of his logos; some of the screen prints show the elephant's image in the engraved stamp marking the work.

The artist makes full use of animals in his depiction of the world: monkeys, rates, ducks, sharks—all metaphors for specific social identities operating in the world.

Banksy appears particularly interested in the figure of the elephant. In a 2005 action of his at the Barcelona Zoo, he entered the elephant cage and wrote "boring, boring, boring" and "keeper smells" on the wall. In his *Barely Legal* exhibition in Los Angeles in 2006, the VIP guests were welcomed by Tai, a 38-year-old Indian elephant painted with a wallpaper pattern. On this occasion, Banksy used the elephant to bring a visual metaphor into the world of reality, with a precise purpose, saying: "There's an elephant in the room. There's a problem we never talk about. The fact is that life isn't getting any fairer. 1.7 billion people have no access to clean drinking water. 20 billion people live below the poverty line. Every day hundreds of people are made to feel physically sick by morons at art shows telling them how bad the world is but never actually doing something about it. Anybody want a free glass of wine?"

Paris Hilton
2006
CD sleeve

Paris Hilton asks Banksy to paint her as a true heiress, but the artist bluntly refuses. With the release of her first album, *Paris*, Banksy seizes the opportunity and buys 500 copies in forty-two music stores across the United Kingdom, modifying the cover and inner sleeve by replacing them with a parody version. A video shows Banksy entering a Virgin Megastore disguised and buying a copy of the CD. Back in his studio, he scans the cover and inner sleeve, replacing the words with letters cut from newspapers, creating phrases like, "Why am I famous?", "What am I for?", and "90% of success is showing up". He replaces Paris Hilton's face with her Chihuahua's head, then he puts all the 500 copies back in various stores.

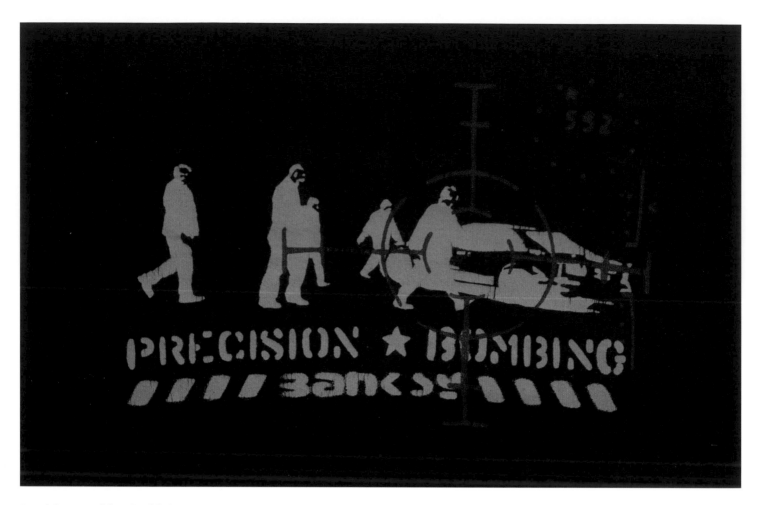

Precision Bombing (T-shirt)
1999
Silkscreen on T-shirt
60x45 cm

Keep Back
1999
Silkscreen on t-shirt
60x45 cm

Welcome (Gross Domestic Product)
2019
Mixed media
42x64 cm

The work consists of a mat stitched with the word "welcome" using the material which life vests are made with. The straps supporting the buckles are sewn along the rear edging, so it can be used as a life vest.

This limited-edition multiple work was done in collaboration with Love Welcomes, a digital company that, with a contemporary aesthetic, markets objects made by refugees in refugee camps, or by craftspeople in war zones.

The work was marketed in 2019 in the usual surprising way: in October, Banksy had a performance titled *Gross Domestic Product*, renting an unused shop in London's Croydon neighborhood to display a series of items, including the mat, in the window; he then launched a website called *Gross Domestic Products*, where the items in question could be purchased. Or more accurately, users could enter a lottery from which the people who could then purchase the items would be drawn. Some of the lucky lottery winners who had the opportunity to purchase the work put them up for sale to make a profit (and this is what happens, because Banksy sells his works to the public far below market prices). This work is from an anonymous, randomly drawn purchaser—not a collector but a typical Banksy fan. By breaking the fatal collecting/wealth dualism, Banksy demolishes this custom with new positions and roles in a world to be deeply rethought.

The content of *Welcome* barely needs explaining: the phenomenon of migrations along the Mediterranean route, addressing those who abandon their homes and their domestic memory. Not limiting himself to conceptual actions, Banksy purchased a former French warship which he refitted to carry out rescue activities at sea along the critical Mediterranean routes. The ship is called Louise Michel, in memory of a historic French activist; its flank is painted with Banksy's most popular girl holding a heart-shaped safety float, and no longer a balloon.

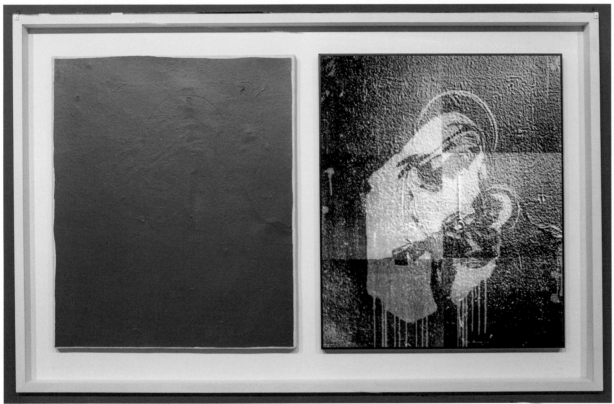

Brad Downey
Diver / TV Girl / Toxic Mary
2003-2020
Hyperspectral photography, plaster, concrete, paint,
light-box, transparency, glass
151x231x25 cm

In 2003, Künstlerhaus Bethanien, a major German public cultural institution, organized a collective show selecting the best representatives of an art movement then gaining notice, which was to become established a few years later with the name of "street art". Banksy and Brad Downey were among the invited artists. Downey, an American artist living and working in Berlin, was a seminal standard-bearer of this idea: the entire nascent street art scene looked at his work, which ironically and irreverently organized and manipulated the visual elements that make up the city, using the languages of installation and performance. Banksy also saw Brad Downey's work. Although until this time his activity had been mostly linked to the stencil, after meeting Brad Downey Banksy was to begin using the languages of performance and installation with which the American artist was besieging half of Europe. For the show at the Bethanien, Banksy was given a small exhibition room, where he produced some of his classic stencils and three large Flying Coppers topped with the words: "Every picture tells a lie". Several rooms away, Brad Downey was presenting certain installations. Eight years later, Downey was invited back to the Bethanien to present a new project; the room where he was to do so was the same one where Banksy had worked, only this time it was painted red. Downey suspected that Banksy's works were beneath that layer of paint, and the Bethanien's maintenance office confirmed it. At that point, he decided to change projects. The one he was to present would be a reappropriation of Banksy's works, presented as Downey's. What you see here are portions of the Bethanien's wall that Downey cut out in correspondence with the works done by Banksy in 2003. Banksy's works underlying the layer of red paint may be seen through the images obtained using the technique of hyperspectral photography.

The first official cover designed by Banksy was for Jamie Eastman's record label Hombré Records. He designed the cover for hip-hop band One Cut's Cut Commander 12" EP in 1998 and their remix CD album Hombrémix. There is a large amount of records illustrated with Banksy's works, among these, one part was actually illustrated by Banksy, while the others were illustrated by independent record labels simply appropriating Banksy's imagery circulating at the time, demonstrating how much he was already known and influential in British underground cultural production circles, in the first half of the 2000s. This section presents a catalog of all the vinyls and CDs illustrated by Banksy.

1998, One Cut—"Cut Commander"—12" EP on Jamie Eastman's Hombré label. Banksy and Jamie were friends and Banksy moved to London with Eastman in 1998. One Cut was a trio made up of REDS, Risky Biz and Masterchef.

1999, Capoeira Twins—"Four (4 x 3) / Truth Will Out"—Promotional 12" single in a limited edition of 100 copies with cover spray painted by Banksy, released on John Stapleton's Blowpop Record label.

1999, One Cut—"Hombrémix"—Remix album only released on CD by the Hombré label.

2000, One Cut—"Grand Theft Audio"—Double LP.

2000, One Cut—"Mr. X / Rhythm Geometry" 12" EP.

2000, Dynamic Duo—"Styles by the Dozen"—12" EP with Banksy's "Insane Clown" motif on the label.

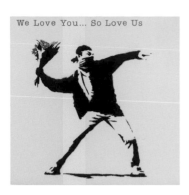

2000, Various Artists—"We Love You... So Love Us"—Released on the Wall of Sound label that would replace Hombré as Banksy's preferred label. It was released on CD and as a limited edition LP (1000 copies).

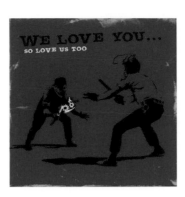

2000, Various Artists compilation—"We Love You... So Love Us Too"—CD compilation on the Wall of Sound label with Banksy's "Cop Under Fire" image.

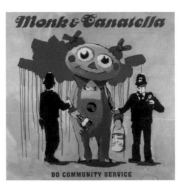

2000, Monk & Canatella—"Do Community Service"—Trip hop CD, released by Bristol duo Simon Russell and Jim Johnson under the name Monk & Canatella.

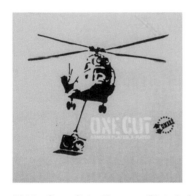

2000, One Cut—"Armour Plated, X-rated"—Promotional CD, or One Cut's album "Grand Theft Audio". The CD has a different track order from the finally released LP.

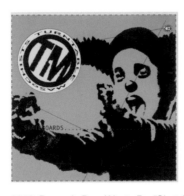

2000, Dynamic Duo / Nasty P—"Skateboards"—A promotional four-track CD released to advertise Clown Skateboards with two tracks each by Dynamic Duo (Niall Dailly, Bryan Jones) and Nasty P (Paul Rutherford). The cover shows Banksy's "Insane Clown".

2001, Roots Manuva—"Yellow Submarine"—Single-sided 12" single on the Ultimate Dilemma label by Roots Manuva (a.k.a. Rodney Hylton Smith).

2002, Roots Manuva—"Badmeaningood, Vol 2"—Compilation double LP of remixes.

2002, Skitz—"Badmeaningood, Vol 1"—Compilation double LP by Skitz (a.k.a. Joe Cole) of remixes.

2002, Blak Twang—"Trixtar"—12" single.

2002, Röyksopp—"Melody A.M." Promotional double LP with cover image sprayed by Banksy. Released by Wall of Sound Records in a numbered, limited edition of 100 copies. The first few were sprayed with dark green paint, while the later ones were sprayed with a paler green.

2003, Scratch Perverts—"Badmeaningood, Vol 3"—Double LP on the Ultimate Dilemma label by Scratch Perverts (a.k.a. Prime Cuts and Tony Vegas).

2003, Peanut Butter Wolf—"Badmeaningood, Vol 4"—Another double LP of remixes by Chris Manak (a.k.a. Peanut Butter Wolf). Ultimate Dilemma label.

2003, Blur—"Out of Time"—One of three limited edition vinyl 7" singles released from the "Think Tank" album with new Banksy design. This one on black vinyl.

2003, Blur—"Crazy Beat"—The second limited edition 7" single from the "Think Tank" album. Released on red vinyl.

2003, Blur—"Good Song"—The third limited edition 7" single from the "Think Tank" album also released on red vinyl.

2003, Various Artists compilation—"Off the Wall: Ten Years of Wall of Sound"—Triple LP with gatefold cover showing some of the artist who recorded for the label. It is said that it is Banksy himself on the cover with his back to the photographer while spraying the wall.

2003, Blur—"Think Tank"—Promotional CD in card sleeve hand stamped with Banksy's "Petrolhead" character.

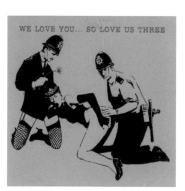

2004, Various Artists compilation—"We Love You... So Love Us Three"—A Wall of Sound compilation CD.

Love Poem

Beyond watching eyes
With sweet and tender kisses
Our souls reached out to each other
In breathless wonder

And when I awoke
From a vast and smiling peace
I found you bathed in morning light
Quietly studying
All the messages on my phone

2004, Banksy, print on paper paste up, London
Wall and Piece {Century, 2011, p.777)

The Bear and Bee

Once upon a time there was a Bear
and a Bee who lived in a wood and
were the best of friends. All summer
long the Bee collected nectar from
morning to night while the Bear lay
on his back basking in the long grass.

When Winter came the Bear
realised he had nothing to eat and
thought to himself 'I hope that busy
little Bee will share some of his
honey with me'. But the Bee was
nowhere to be found - he had died of
a stress induced coronary disease

2006, Banksy, print on paper paste up, London
Wall and Piece (Century, 2011, p. 81)

Materials

Illustrations for record sleeves

This section presents a catalog of records illustrated by independent record labels using unofficially Banksy's imagery between 1998 and 2015.

1. One Cut—"Underground Terror Tactics"—12" EP, released in 2000.
2. Various Artists—"We Love You... So Love Us Too"—Four-track compilation 12" EP with the same Banksy image as the CD on the label.
3. Blak Twang—"Kik Off"—2002 LP with cover design by Banksy by Tony Olabode under the moniker Blak Twang.
4. Blak Twang—"Kik Off"—12" single from the "Kik Off" album with different Banksy design from the LP.
5. Blak Twang—"Trixstar (Remix) feat. Estelle"—2002 remix of Blak Twang's "Trixstar" single.
6. Blak Twang—"So Rotten"—12" EP, released in 2002.
7. Blur—"Think Tank"—2003 double LP with cover art commissioned by Parlophone Records, Banksy's first designs for a major label.
8. Blur—"Think Tank"—2003 promotional four-track 12" EP with the "Petrol head" image stamped on the record label.
9. Blur—"The Observer"—Promotional five-track CDEP that accompanied the Observer newspaper on Sunday 21st September 2003.
10. Various Artists compilation—"Peace Not War"—A CD in a card cover that accompanied the magazine "The Big Issue" in February 2004 to advertise the Peace Not War Festival that month. The cover features Banksy's "Girl Hugging a Bomb". These CDs were all sellotaped to the magazine.
11. Benjamin Zephaniah—"Naked"—Digipak CD with booklet showing many of Banksy's original designs.
12. Dirty Funker—"Let's Get Dirty"—12" remix of The Knack's 1979 single "My Sharona" with front cover image of Banksy's portrait of Kate Moss against a red background and against a green background on the reverse. The first pressing, released in 2006 had no artist or record title on the cover. Dirty Funker is DJ Paul Glancy.
13. Dirty Funker—"Let's Get Dirty"—The second pressing (2006) has the artist and title on Dymo strips across Kate's eyes on the front cover and across her mouth on the rear cover. The second pressing is more common than the first.
14. Banksy & Danger Mouse—"Paris Hilton"—Banksy redesigned the cover of Paris Hilton's 2006 CD "Paris" to make her appear bare-breasted and added satirical comments inside the CD booklet, while Danger Mouse recorded new music for the CD. Five hundred copies were placed in HMV stores all across the British Isles. This is one of the original 500 copies on CD-Rom. There was a second edition of 1000 copies pressed on proper CDs.
15. Talib Kweli & Mad Lib—"Liberation"—2007 LP with Banksy's "Flag" image.
16. Me&You—"Floating Heavy Edits"—TM Juke and Robert Luis a k a Me&You remix four songs on this 12" EP from 2007. The label uses Banksy's "Grannies—Punk's Not Dead" print.
17. Danger Mouse—"From Man to Mouse"—This unofficial double LP from 2007 that uses a modified "What Are You Looking At?" Banksy design which he made for Danger Mouse.
18. Dirty Funker—"Future"—five limited edition covers for his 2008 EP "Future" showing Banksy's "Radar Rat" with the ripples in different colors on white, grey or brown covers.
19. Banksy—"The Banksy Years"—Limited edition (1000 copies) interview album released in 2008.
20. Queen & Cuntry—"Don't Stop Me Now"—Unofficial, limited edition 12" single covering Queen's "Don't Stop Me Now" With Banksy's "Queen Victoria" on the cover.
21. Kate Bush (Ashley Beedle Remix)—"Running Up That Hill". Unofficial, single-sided 12" single with Banksy's "Good Song" design.
22. Hot Chile / Anarchist—"Sin Da Da Da / Anarchy 2008"—12" split single from 2008 with Banksy's "Rage-Flower Thrower" on one side and "Radio Mouse" on the reverse.
23. Dirty Funker—"Flat Beat"—Unofficial, limited edition 12" single from 2009 with Banksy's "Happy Choppers" on a blue background on the front and against a yellow background on the reverse.
24. Danger Mouse—"Keep It Real / Laugh Now"—Unofficial, limited edition 12" single with four different color variations; gold, silver, brown and green.
25. Danger Mouse—"Keep It Real / Laugh Now"—Promotional 12" single with plain white background.
26. Terrance K—"Hot Line"—Digital only release EP from 2013 showing Banksy's "Massacred Telephone box". This is a digital reproduction of the cover image.
27. Junichi Masuda—"Pokémon"—12" test pressing of his "Pokémon" LP using Banksy's "Rage-Flower Thrower image, but throwing a Pokémon ball instead of flowers. Limited edition of 100 copies.
28. Boys in Blue—"Funk tha Police"—Unofficial, limited edition 12" single with Banksy's "Rude Copper" image on the cover. 100 unnumbered copies.

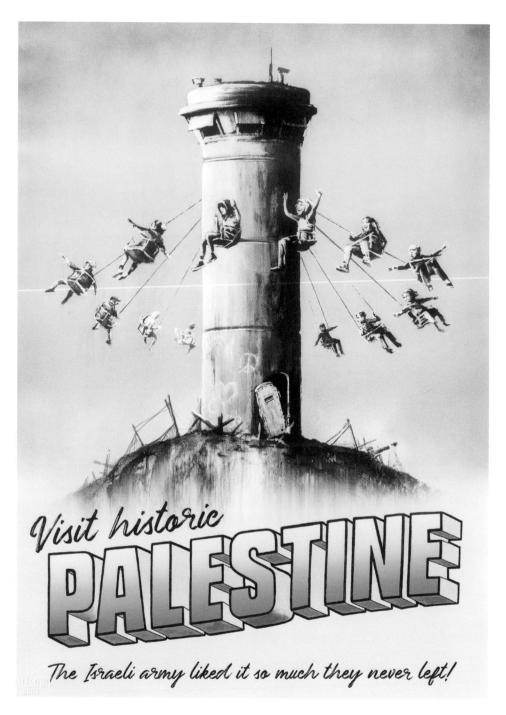

Visit Historic Palestine
2017-2018
Offset lithograph on paper
60x42 cm

Visit Historic Palestine comes from the Walled Off Hotel opened in Palestine by Banksy in March 2017. Hotel's name sounds like the famous Waldorf luxury hotel and consists in a small venue in Bethlehem, in front of which Israel government build a wall to separate Israel from Palestinian territories, contributing to give the hotel "the worst view in the world", a slogan with which the artist publicizes his initiative. The hotel contains works by Banksy and other artists, themed rooms, a souvenir shop where you can buy the poster and a shop where you can buy paint and tools to make your own street art.

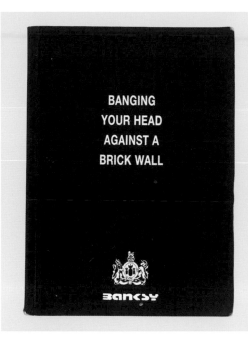

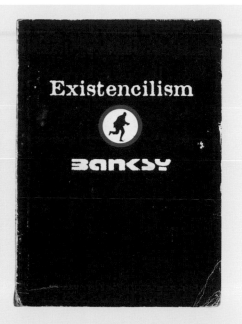

Black Books
2001-2004

Between 2001 and 2004, Banksy published three small volumes known as *Black Books*. The title of the first volume, released in 2001, is *Banging Your Head Against a Brick Wall*, its cover featuring a declaration of his intentions: "the quickest way to the top of your business is to turn it upside down". In 2002, for the namesake exhibition at the 33 1/3 in Los Angeles, he published *Existencilism*, dedicated to "all people with a vicious disregard for common sense". In 2004, he published *Cut It Out*, dedicated to Casual T, the American musician and producer. The three books contain images, text, aphorisms, poems, fairy tales and the artist's general thoughts.

Peckham Trolley, Postcard
2016-2017
Offset lithograph on shaped board
12x18 cm

In 2005, Banksy introduced himself as a visitor to British Museum to illegally install on a wall a piece of cement drawn with a felt-tip pen depicting a primitive man pushing a supermarket trolley. Just like other museum pieces, the artist places a caption: "Wall art. East London. This finely preserved example of primitive art dates from the Post-Catatomic era and is thought to depict early man venturing towards the out-of-town hunting grounds. The artist responsible is known to have created a substantial body of work across South East of England under the moniker Banksymus Maximus but little else is known about him. Most art of this type has unfortunately not survived. The majority is destroyed by zealous municipal officials who fail to recognize the artistic merit and historical value of daubing on walls". In the book *Wall and Piece*, Banksy accompanies images documenting the action: "TV has made going to the theater seem pointless, photography has pretty much killed painting, but graffiti has remained gloriously unspoilt by progress". As documented by Banksy himself, the intervention lasts eight days. Museum staff notices the intruder, remove the piece and store it in museum's warehouses. Banksy will comment: "now it is housed in the permanent collection". Thirteen years later, in May 2018, British Museum curator Ian Hislop organizes an exhibition about story of dissent, subversion and satire. For the occasion, Banksy is asked to exhibit the piece and produce a celebratory postcard. *Peckham Trolley* card is sold out in a few days.

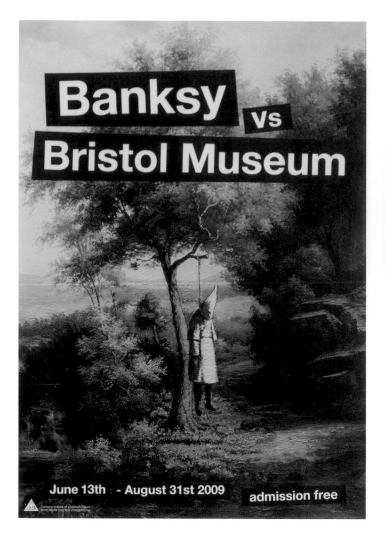

Banksy Vs Bristol Museum poster
2009
Offset print on paper

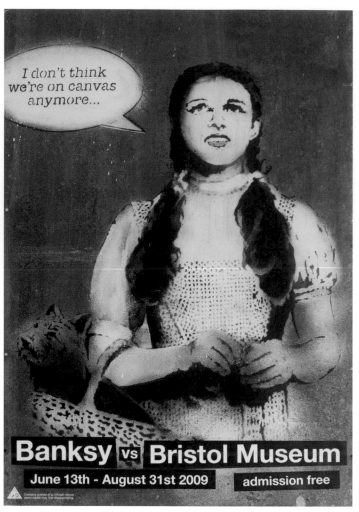

Banksy Vs Bristol Museum poster
2009
Offset print on paper

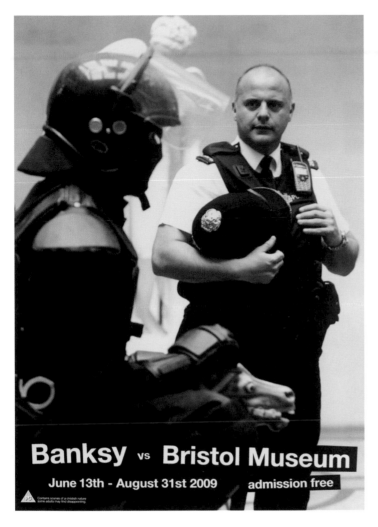

Banksy Vs Bristol Museum poster
2009
Offset print on paper

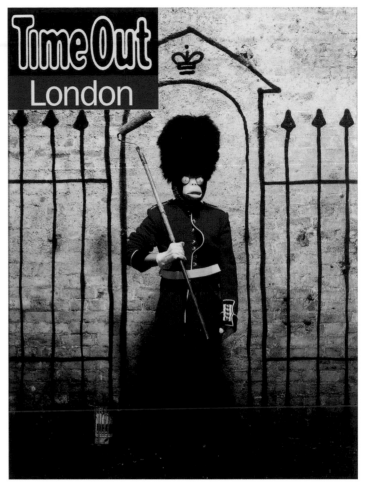

Self-Portrait
2010
Offset lithograph on paper
66x51 cm

Er...
2015
Print on linen teacloth
40x60 cm

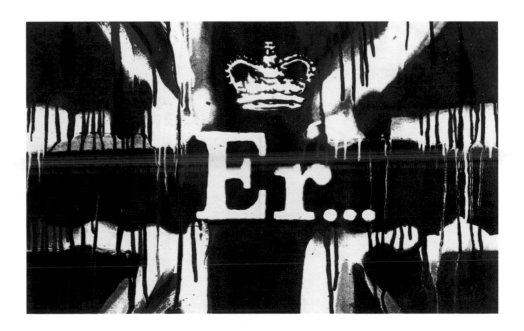

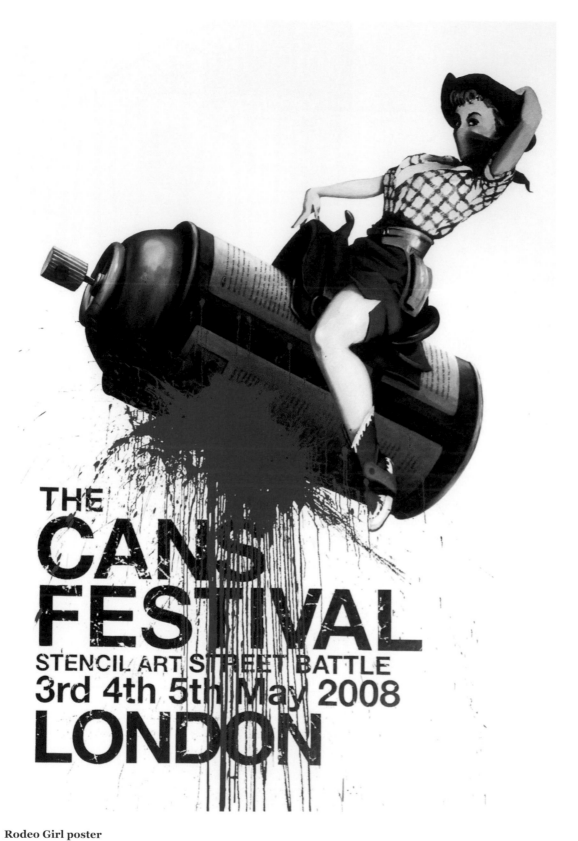

Rodeo Girl poster
2008
Offset lithograph on paper
70x50 cm

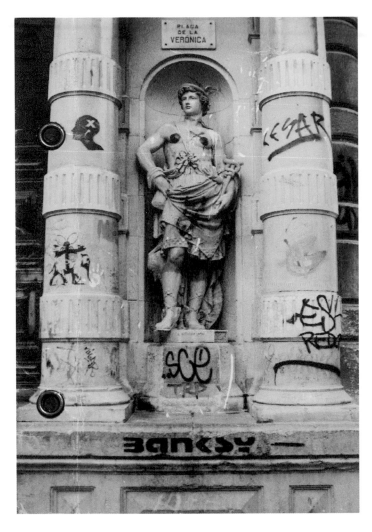

T-shirt Dismaland
2015

T-shirt Catalog
1999
Printed booklet
21x14,8 cm

Videos

Since his earliest artistic activities, Banksy has used the audiovisual medium for different purposes and in a variety of formats. He immediately distributed content of this kind online, both on his own website (banksy.co.uk) and via YouTube. In 2013, he opened an Instagram account on which he has published various filmed works (Instagram is his only social network presence), although he holds at least two other YouTube accounts: banksyfilm and Banksy NY. His prevalent form of using the medium is of the descriptive type; he initially released videos with the purpose of documenting actions or installations, as in the film documenting the 2006 urban work *Murdered Phone Booth*; later, in 2015 he began to practice a different, more narrative and authorial use of the medium. Filmed works like *Make this the year YOU Discover a New Destination* or *Dismaland* no longer had the purpose of documenting the work or showing the process, as he did with the two videos released after *Shredded Girl with Balloon*, but of promoting projects and initiatives. Banksy no longer needed to stage a description, but a narrative: to do this, he chose precise videographic aesthetics, rhythms of editing, quotations and sampling, and unusual structures of sound and music, working on social stereotypes, models of family happiness, and other archetypes with a marked sense of "retromania," as the critic Simon Reynolds was to say. Let us not forget that Banksy is after all an Oscar-nominated director; he appears at ease in using the audiovisual medium, although he has stated that he will never again make a film. Another contradiction ready to be proved wrong?

List of Banksy's audiovisual production

2021
A t-shirt for removing the Colston's Statue in Bristol
Video, Color, 2'35", Instagram.com/banksy, @banksy

2021
A Great British Spraycation
Video, Color, 3'16", Internet, Instagram.com/banksy, @banksy

2021
Create Escape
Video, Color, 2'53", Internet, Instagram.com/banksy, @banksy

2020
The M.V. Louise Michel rescue lifeboat
Video, Color, 0'55", Internet, Instagram.com/banksy, @banksy

2020
London Underground Undergoes Deep Clean
Video, Color, 0'54", Internet, Instagram.com/banksy, @banksy

2019
God bless Birmingham
Video, Color, 0'33", Internet, Instagram.com/banksy, @banksy

2019
Gross Domestic Product closing
Video, Color, 1'00", Internet, Instagram.com/banksy, @banksy

2019
Stormzy backstage at Glastonbury
Video, Color, 0'59", Internet, Instagram.com/banksy, @banksy

2019
Street Art in Venice Biennale
Video, Color, 0'59", Internet, Instagram.com/banksy, @banksy

2018
Season's greetings
Video, Color, 0'55", Internet, Instagram.com/banksy, @banksy

2018
Shredding the Girl and Balloon
Video, Color, 2'56", Internet, YouTube.com

2018
Sotheby's
Video, Color, 0'59", Internet, YouTube.com

2017
GOGGLEBOX on channel 4
Video, Color, 1'00", Internet, Instagram.com/banksy, @banksy

2017
Watch Elton playing the opening party (remotely)
Video, Color, 0'51", Internet, Instagram.com/banksy, @banksy

2015
Dismaland
Video, Color, 2'07", Internet, YouTube.com

2015
Make this the new year YOU discover a new destination
Video, Color, 1'56", Internet, YouTube.com

2014
Better Out Than In—The movie
Video, Color, 2'51", Internet, YouTube.com

2013
Staten Island
Video, Color, 0'15", Internet, Instagram.com/banksy, @banksy

2013
Rebel Rocket attack on Dumbo
Video, Color, 0'14", Internet, Instagram.com/banksy, @banksy

2010
Invader Bombs Tinseltown
Video, Color, 1'44", Internet, YouTube.com

2010
Royal visit
Video, Color, 1'49", Internet, YouTube.com.

2010
Pier Pressure
Video, Color, 0'35", Internet, YouTube.com

2010
Simpsons
Video, Color, 1'44", Internet, YouTube.com

Banksumentary

Gianluca Marziani

Everyone will recall those intimate moments when teenage irreverence constructed the absurd at arm's reach: as when one would imagine a shocking gesture during class at school, a small "anti-regime" act to throw a spanner at acquired normality with an anomaly that rearranged the entire principle of reality. The social game was in fact the fuse that lit the spirit of Dadaism and Fluxus—the same spirit that gave life to the irreverent Monty Python, to the Mario Monicelli of *My Friends*, to Squallor's comedy records. Marcel Duchamp invented the "anti-regime" seed of iconoclastic acts: taking a white, porcelain urinal and affirming its value worthy of a museum pedestal. It became the tsunami of the iconographic gaze, the first *environmental short circuit* (schools and cities resemble each other in rules and the desire to break them) that would then go on to generate multiple *masters of monsters*, along a unitary line of vision in which the monster (in its original meaning of "portent") created methodical alterations of figurative and textual conformism, conceiving displacements of meaning in which the work itself embodied the social "monster" born from an anomalous (but inescapable) master of pertinent gazes.

Amateur video has asserted itself as the right language for building a narrative around the Dadaist short circuit: thus it was in the elastic days of the European, Brazilian, and American strains of *Nouvelle Vague*, but also in the 1980s with the first portable video cameras, before being transferred to inside history's best film camera: the smartphone. For several decades, the video format created the amateur line of cinema, generating the best-ever distribution success: porn movies with their secular sociology of a revolution of mores. Between the folds of social vices both soft and hard, the visual avant-gardes always return to the fore: an aesthetic glue and conceptual binoculars acting upon the engine of linguistic synaesthesia. Consider the videographic calibration of Andy Warhol, the techno-shaman of a Factory where endless filming was, to be sure, a diktat of semantic narcissism, but was also a project of historiographic clairvoyance, thirty years ahead of the continuous recording models of the social media. The Factory circle was frequented by such figures as Jonas Mekas, a filthy and unstable, wild and poetic videomaking guru, confirming how much visionary authorship there was in the hand-held cameras of the New American Cinema Group. Their videos were full of fantastic "monsters" that belonged to the twilight of the real world, the parallel line that was reflected in the norm in a way that was poetically formless, but regenerating, baptismal, and revolutionary. Banksy's amateur culture owes a great deal to the parents of the underground cinema, to the dystopian worlds of Chris Marker, to the Baroqueisms of Kenneth Anger, to the incoherent montages of Stan Brakhage, to that whole, messy way of capturing the real in its multiplicity that was often unheeded and marginal, yet fiercely alive.

Let us imagine the "monstrum" cinema as a machine that filters any reality, even that of the most documentary nature, in order to bring the text back to the dimension of the sideways glance, that fateful, shocking factor that distinguishes the courageous fool from the silent conformist. If we look at the Banksian model of film engagement, we might imagine a schoolboy scheming pranks with the most absolute collective mimicry, the only student to remain unpunished due to a triple merit: strategic vision, a panoramic overview, and the management of multiple moves, as a sort of chess player in sneakers who used the city (including the classroom) as his chessboard, and stencils as pawns in an endless game. Many will wonder what our Robin Gunningham was up to at elementary school; certainly he saw Bristol with the attitude of the young children out of an Alan Parker movie, thinking of a firecracker beneath the teacher's seat, of an explosive but non-lethal stuffed animal, of a stencil above the women's toilet… In actuality, accounts tell us a great deal of his history of urban antagonisms, but little about his career as an abrasive and filthy video maker. There is, however, a long list of shorts, clips, trailers, promos and other materials that Banksy developed with a digital voracity not unlike Warhol, giving us a YouTube page that is the most surprising (and free) film program on the new millennium's most important hyperartist. Scroll through his videos and watch them carefully: while the grammar and syntax are identical to the process of the urban installations, here you will perceive a silent trace, in which the artist seems to split into his alter ego filming his own absurdity, hiding behind a paradox without response. By remaining a ghost of identity, Banksy offers us his subjective tactics in the spaces of his

urban artivism. The camera is set up as an amateur gaze on his own manners and trades, a public portal available to users, synthetic in duration, ironic in approach, and simplified in style. And yet, those videos contain an *urban glitch*, live traces of guerrilla marketing that overturn the norm of conformity and distil short circuits continuously, as if the artist were playing with the avant-gardes in his accelerated postmodernism, experienced as a child in the 1980s but now as a father in the digital era. It is a *digital Dadaism* that sows cynical grass to generate splendid, black flowers in the alleyways of the outskirts and places in social decay. His amateur imperfections distil contagious linguistic seeds, like chapters in a gigantic *mockumentary* on the Banksian tactics of the person who invented the "new art public." Let us call this approach a BANKSUMENTARY, and let us use it to establish the historic claims of an aesthetic in which Banksy reinvents film languages, within the appearance of a continuous, semantic dialogue with the traditional and digital media.

Each video establishes parameters of verification of the twentieth-century avant-gardes: Dadaism to outline the initiatory point, Pop Art as the keystone, Punk as an epic phenomenon of urban anthropology, New York Graffiti to identify his own parameters at their roots, underground cinema as linguistic liberation, and rock music as an emotional and sentimental tuning fork: look at each video and you'll find at least a couple of these comforting seeds, at times fused into a digital orgy with its own beginning and end. Our hyperartist has understood an inescapable fact: that the public is a real and complex entity, to be included in the telling of a story that is inside a stencil or video, an illegal installation or a web project. To do this, a linear and progressive approach is needed, in which prologue and epilogue contain the dense layer of the narrative continuum. Banksy conquers margins of consensus thanks precisely to his entry-level access— simple but not only in the initiation phase, messy as global hip hop cultures like, amateur as TikTokers like, ironic or comic as demanded by the culture of the meme aesthetic, and absurd and irreverent in accordance with the actions of a capitalist realist. Beyond appearances there circulates the blood of a video maker who manages cinema in speculative fashion, within a play of quotations and reversals of meaning, with the same emotional grasp as his urban-scale projects. I think the time has come to speak of his conceptual breath, of his irreducibility to a superficial judgment, of his chaos as a linguistic environment. As some would put it, Banksy is truly "a lot."

Banksy Cultural Analytics

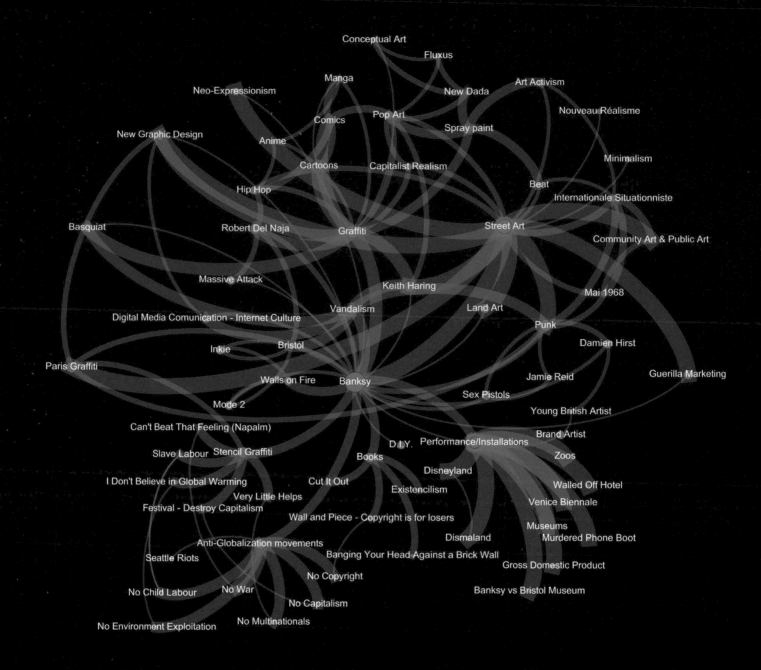

There are traditionally only two forms of expression to take account of artistic facts, or cultural ones in general: images, and discourse (text) production. However, in the mid-2010s, Lev Manovich instituted the Cultural Analytics Lab at MIT in Boston (lab. culturalanalytics.info), with the purpose of giving impetus to a science found in the point of intersection between data science, media studies, and cultural studies, presenting concepts and methods for the computational analysis of cultural data. The digital technologies of AI and machine learning are increasingly capable of helping us extract knowledge from large quantities of apparently indecipherable data; at the same time, the conditions of possibility for collecting enormous quantities of data on creators and their practices have seen extensive growth.

The form that this approach adds to the possibilities of taking account of cultural facts is a graphic one, obtained by using interpretative algorithms to spatialize the data. This visual dimension can show patterns, schemes, recurrences, correlations, and occurrences among data of different kinds, revealing to our eyes structures that articulate and underlie cognitive processes like the signification and production of meaning and in this sense opening the way to a perspective of digital curation that lays the groundwork for a new epistemology in the setting of Digital Humanities.

This section presents some experiments based on analytic techniques and tools developed by Lev Manovich, applied here to the study of Banksy's expressive action and artistic production.

The representation we present has the purpose of making visible the complexity off the cultural system from which an artistic exception like Banksy emerges. It is a network that connects and develops events of different kinds, through which the origin of certain of the artist's forms and intents of expression—like the conditions of possibility that made these expressions possible—can be retraced. In the final analysis, this representation seeks to show the profound ecological dimension of a setting and its power over the person traversing it.

The image on the left was "imagined" by the *Force Atlas* algorithm on *Gephi 0.9.2* interpreter. It makes it possible to visualize both the relationships and the relational values of the factors of influence that marked the artist's path, which is to say the historic events, individual facts, people, artists, and the aesthetic, ethical, moral, and ecologic events the artist traversed and by which he was traversed. The data originate from the reconstruction of a biography of Banksy

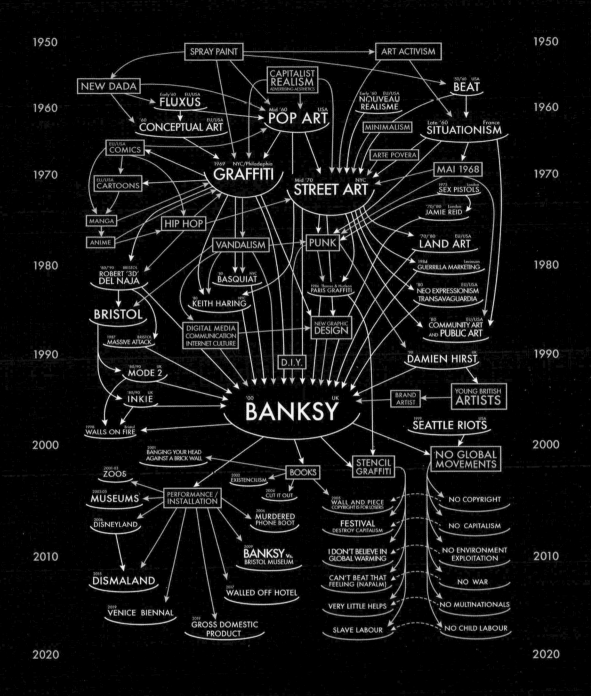

1950

1950

1960

1960

1970

1970

1980

1980

1990

1990

2000

2000

2010

2010

2020

2020

SPRAY PAINT
ART ACTIVISM
NEW DADA
CAPITALIST REALISM
ADVERTISING AESTHETICS
BEAT
'50/'60 USA
Early '60 EU/USA
FLUXUS
Early '60 EU/USA
NOUVEAU REALISME
'60 EU/USA
CONCEPTUAL ART
Mid '60 USA
POP ART
MINIMALISM
Late '60 France
SITUATIONISM
EU/USA
COMICS
ARTE POVERA
1969 NYC/Philadephia
GRAFFITI
MAI 1968
EU/USA
CARTOONS
Mid '70 NYC
STREET ART
1975 London
SEX PISTOLS
MANGA
'70/'80 London
JAMIE REID
ANIME
HIP HOP
PUNK
'70/'80 EU/USA
LAND ART
VANDALISM
1984 Levinson
GUERRILLA MARKETING
'80/'90 BRISTOL
ROBERT '3D' DEL NAJA
'80 NYC
BASQUIAT
1986 Thames & Hudson
PARIS GRAFFITI
'80 EU/USA
NEO EXPRESSIONISM TRANSAVAGUARDIA
BRISTOL
'80 NYC
KEITH HARING
'80 EU/USA
COMMUNITY ART AND PUBLIC ART
1987 BRISTOL
MASSIVE ATTACK
DIGITAL MEDIA COMMUNICATION INTERNET CULTURE
NEW GRAPHIC DESIGN
'90 UK
DAMIEN HIRST
'80/'90 UK
MODE 2
D.I.Y.
'80/'90 UK
INKIE
'00 UK
BANKSY
BRAND ARTIST
YOUNG BRITISH ARTISTS
1998 Bristol
WALLS ON FIRE
1999 USA
SEATTLE RIOTS
2001
BANGING YOUR HEAD AGAINST A BRICK WALL
STENCIL GRAFFITI
NO GLOBAL MOVEMENTS
2001-03
ZOOS
2002
EXISTENCILISM
BOOKS
2003-05
MUSEUMS
PERFORMANCE / INSTALLATION
2004
CUT IT OUT
NO COPYRIGHT
2006
DISNEYLAND
2005
WALL AND PIECE COPYRIGHT IS FOR LOSERS
NO CAPITALISM
2006
MURDERED PHONE BOOT
FESTIVAL DESTROY CAPITALISM
NO ENVIRONMENT EXPLOITATION
2009
BANKSY VS. BRISTOL MUSEUM
I DON'T BELIEVE IN GLOBAL WARMING
NO WAR
2015
DISMALAND
CAN'T BEAT THAT FEELING (NAPALM)
2017
WALLED OFF HOTEL
VERY LITTLE HELPS
NO MULTINATIONALS
2019 VENICE BIENNAL
2019
GROSS DOMESTIC PRODUCT
SLAVE LABOUR
NO CHILD LABOUR

outlined by deconstructing his path of expression, and based on available factual data (interviews, publications, reliable testimonies, etc.). The representation shows a network and at the same time this network's shape, suggesting from simple observation, correlations, recurrences, and occurrences that in fact constitute a new kind of knowledge, or cultural datum, that no other form of analysis can take account of.

The image at left makes it possible to visualize the shape of the relationships among the processed data, by virtue of a gravitational principle. Taking account of the fact that each item is a node and each connection a relationship, the algorithm spatializes the data, assigning each node a value of attraction or repulsion based on the number of connections among individual nodes.

The network visible on the right side shows the gravitational representation created by *Force Atlas*, subjected to a vertical time scale, arranging the events on a linear directional axis. This last network was then hand-drawn, borrowing the style used by Alfred H. Barr to graphically trace the birth and development of modern art on the occasion of the 1936 *Cubism and Abstract Art* exhibition at MoMA.

Interpreter application: Gephi 0.9.2
Released by: Gephi (Consortium (FR, 2010))
Algorithm: Force Atlas

Force Atlas is a force-directed algorithm developed by Mathieu Jacomy in 2017, able to simulate a physical system spatialized in a network. The data structure consists of nodes (events or facts) and links (weighted relationships among events or facts). The nodes repel one another like charged particles, while the borders attract their nodes like springs. These forces create a movement that converges in a state of equilibrium, thus permitting the spatial visualization of the network itself.

Matsutake Art Curation Lab — Digital curation

Force Atlas settings:

Inertia: 0.1
Repulsion strength: 50000,0
Attraction strength: 7.0
Minimum displacement: 10.0
Auto stabilize function: ON
Auto strab sensibility: 0.2
Gravity: 30.0
Attraction distribution: OFF
Adjust by size: ON
Speed: 1.0

Banksy time-based generative network design by Stefano Antonelli and Giulia Buonanno, 2020.

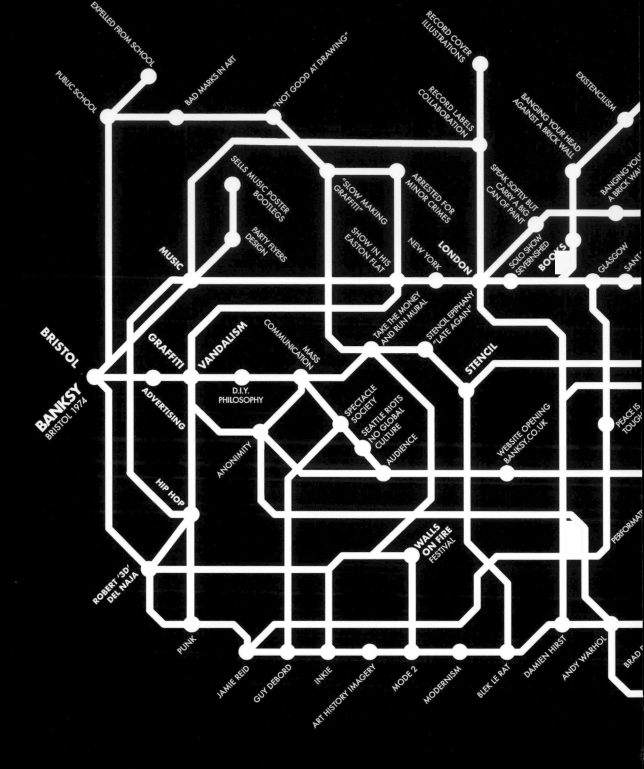

Banksy: life & art

The diagram above represents a realistic Banksy's life in the form of an underground map.
The representation was obtained using same datasets processed in Banksy's Generative Network diagram
(p. 154) using factual data extracted from verifiable sources. Under Gephi 0.9.2 interpreter environment,
spatialisation algorithm used for this representation was the Fruchterman Reingold able to "imagine" a
stable network capable to simply visualise data connections based on undirected relations. Network result
from this process was then submitted to the Event Graph Layout algorithm able to spatialise data within
specific timeframes. The final image network was then adapted modulating the visualization parameters
to privilege orthogonal movements on the x and y axes, finally, the result has been manually designed as

CUT IT OUT

WALL AND PIECE

STENCILISM

GIRL WITH BALLOON

CRUDE OILS

UK JACK OK!

SPANK THE MONKEY

IN THE DARKEST HOUR THERE
MIGHT BE THE LIGHT
BY DAMIEN HIRST

MARKS & STENCILS

ART IN THE STREETS

TURF WAR

BARELY LEGAL

THE VILLAGE PET STORE
AND CHARCOAL GRILL

BETTER OUT THAN IN
NY RESIDENCY

BERLIN

PALESTINE

PARIS

LOS ANGELES

CANS FESTIVAL

THE SIMPSON

NEW YORK

PARIS

VENICE

BACKJUMPS
LIVE ISSUE

PAINTINGS ON
SEGREGATION WALL

SANTA'S GHETTO

GAZA
PAINTINGS

WALLED OFF
HOTEL

INSTALLATIVE
PRACTICE

MURDERD
PHONE BOOT

EXIT THROUGH
THE GIFT SHOP

GROSS DOMESTIC
PRODUCT

PICTURES
ON WALLS
OPENING

BYE BYE LAZARIDES

BANKSY Vs. BRISTOL
MUSEUM

PICTURES ON WALLS
CLOSING

MUSEUMS

ZOOS

THEME PARKS

DISNEYLAND

DISMALAND

GALLERY

NATURAL HISTORY
MUSEUM LONDON

LOUVRE

MOMA NY

METROPOLITAN
MUSEUM NY

BROOKLYN
MUSEUM NY

NATURAL HISTORY
MUSEUM NY

BRITISH MUSEUM

INSTAGRAM

SHREDDED GIRL
WITH BALLOON

Interpreter application: Gephi 0.9.2
Released by: Gephi (Consortium (FR, 2010))
Spatialization algorithm: Fruchterman Reingold

Fruchterman Reingold is a force-directed algorithm able to simulate a physical system spatialized in a network. The
data structure consists of nodes (events or facts) and borders (weighted relationships among events or facts). The
nodes repel one another like charged particles, while the borders attract their nodes like springs. These forces create
a movement that converges in a state of equilibrium, thus permitting the spatial visualization of the network itself.

Matsutake Art Curation Lab - Digital curation

Acknowledgements

1. *Jack & Jill (Police Kids)*, 2005, Private collection

2. *Grannies*, 2006, Private collection

3. *Bomb Middle England*, 2002, Private collection

4. *Weston Super Mare*, 2003, Roberto Simeone collection

5. *Napalm (Can't beat that feeling)*, 2004, Private collection

6. *Napalm. Serpentine edition*, 2006, Brentwood (UK), John Brandler, BGi/16

7. *Festival (Destroy Capitalism)*, 2006, Private collection

8. *Lying to the Police is Never Wrong*, 2007, Brentwood (UK), John Brandler, BGi/13

9. *Bunny in Armoured Car*, 2002, Brentwood (UK), John Brandler, BGi/01

10. *Happy Choppers*, 2003, Private collection

11. *CND Soldiers*, 2005, Private collection

12. *Sale Ends Today*, 2007, Roberto Simeone collection

13. *Golf Sale*, 2003, Private collection

14. *Dismaland print*, 2015, Brentwood (UK), John Brandler, BGi/14

15. *Walled Off Hotel Box Set*, 2017, Private collection

16. *Soup Can*, 2005, Private collection

17. *Soup Can (Quad)*, 2006, Genoa, Private collection

18. *Girl with Balloon*, 2004-2005, Private collection

19. *Love Is In The Air*, 2002, UK, Private collection

20. *Love Is In The Air (Flower Thrower)*, 2003, Private collection

21. *Rude Copper*, 2002, Private collection

22. *Queen Vic*, 2003, Private collection

23. *Bomb Love (Bomb Hugger)*, 2003, Private collection

24. *Virgin Mary (Toxic Mary)*, 2003, Private collection

25. *Pulp Fiction*, 2004, Private collection

26. *Turf War*, 2003, Private collection

27. *Grenade*, 1999, London (UK), Private collection

28. *Family Target*, 2003, Brentwood (UK), John Brandler, BGi/32

29. *Flying Copper*, 2003, Private collection

30. *I Fought the Law*, 2004, Private collection

31. *Cloud DJ*, 1998-1999, Brentwood (UK), John Brandler, BGi/09

32. *Rodeo Girl*, 2008, Brentwood (UK), John Brandler, BGi/15

33. *Di-Faced Tenners*, 2004, Private collection

34. *Love Rat*, 2004, Private collection

35. *Get Out While You Can*, 2004, Private collection

36. *Gangsta Rat*, 2004, Private collection

37. *Radar Rat*, 2008, Brentwood (UK), John Brandler, BGi/25

38. *Rubber Ducky*, 2006, Brentwood (UK), John Brandler, BGi/07

39. *Monkey Queen*, 2003, Private collection

40. *Laugh Now*, 2003, Private collection

41. *HMV (His Master Voice)*, 2003, Private collection

42. *Mickey Snake*, 2015, Brentwood (UK), John Brandler, BGi/30

43. *Barcode*, 2004, Private collection

44. *Untitled (Bloodhounds)*, 1998, Bristol (UK), Robert Clarke

45. *Heavy Weaponry*, 2003, Private collection

46. *Paris Hilton*, 2006, Stockholm (Sweden), Richard Forrest Collection of Record Cover Art

47. *Precision Bombing (t-shirt)*, 1999, London (UK), Andipa collection

48. *Keep Back*, 1999, Brentwood (UK), John Brandler, BGi/18

49. *Welcome (Gross Domestic Product)*, 2019, Private collection

50. *Diver*, 2003-2020, Courtesy Brad Downey

51. *TV Girl*, 2003-2020, Courtesy Brad Downey

52. *Toxic Mary*, 2003-2020, Courtesy Brad Downey

53. *Illustrations for record sleeves*, Stockholm (Sweden), Richard Forrest Collection of Record Cover Art

54. *Visit Historic Palestine*, 2017-2018, Brentwood (UK), John Brandler, BGi/34

55. *Black Books*, 2001-2004, Private collection

56. *Peckham Trolley, Postcard*, 2016-2017, Brentwood (UK), John Brandler, BGi/27

57. *Banksy Vs Bristol Museum poster*, 2009, Private collection

58. *Banksy Vs Bristol Museum poster*, 2009, Private collection

59. *Banksy Vs Bristol Museum poster*, 2009, Private collection

60. *Self-Portrait*, 2010, Brentwood (UK), John Brandler, BGi/28

61. *Er...*, 2015, Brentwood (UK), John Brandler, BGi/29

62. *Rodeo Girl poster*, 2008, Brentwood (UK), John Brandler, BGi/26

63. *T-shirt Catalog*, 1999, Brentwood (UK), John Brandler, BGi/08

64. *T-shirt Dismaland*, 2015, Private collection

Authors

Paola Refice
Archaeology, Fine Arts and Landscape Superintendent, Ministry of Culture, Italy

Stefano Antonelli
Art Curator, Adjunct Professor Roma Tre University, Italy

Gianluca Marziani
Art Curator, Former Director of Palazzo Collicola Arti Visive, Spoleto, Italy

Pietro Folena
President of MetaMorfosi, Author, Former Deputy at Italian Parliament

Francesca Iannelli
Professor of Aesthetics Roma Tre University, Italy

Chiara Canali
Art Curator, Adjunct Professor eCampus University, Milan, Italy

Acoris Andipa
Art Advisor